We would like to dedicate
this book in memory of Dean
Miller, a brilliant young art-
ist whose promising career
came to an untimely end at
the age of twenty-five. He
will be missed by us all.

Dynamic Airbrush

Cincinnati, Ohio

NORTH LIGHT BOOKS

DAVID MILLER & JAMES M. EFFLER

ACKNOWLEDGMENTS

We would like to express our appreciation to those who contributed to this book, with special thanks to Diana Martin and David Lewis, without whom it would not have been possible.

Dynamic Airbrush. Copyright © 1987 by David Miller and James M. Effler. Printed and bound in Hong Kong. All rights reserved. No part of this book may be reproduced in any form or by any electronic or mechanical means including information storage and retrieval systems without permission in writing from the publisher, except by a reviewer, who may quote brief passages in a review. Published by North Light Books, an imprint of F&W Publications, Inc., 1507 Dana Avenue, Cincinnati, Ohio 45207. First edition.

94 93 6 5 4

Library of Congress Cataloging-in-Publication Data

Miller, David, 1956-
 Dynamic airbrush.

 Includes index.
 I. Airbrush art—Technique. I. Effler, James M., 1956- . II. Title.
NC915.A35M55 1987 741.6 87-15416
ISBN 0-89134-190-0

Edited by Diana Martin.
Designed by Frank Satogata.

CONTENTS

PART 1

Choosing an Airbrush 2
All airbrushes are not created equal; here you'll discover why they're not and what makes some better suited than others for your illustrative needs.

Textures 4
Don't limit yourself to just the airbrush for rendering texture within your artwork. Discover the special uses for liquid frisket, erasers, gauze, window screening, and more!

Edges 7
When used with different masking materials and techniques your airbrush can create a full range of soft and hard edges. Learn these techniques.

Brushes and Their Uses 8
The airbrush isn't the only brush you need to create illustrations.

Board Surfaces 9
There are good board surfaces, and there are better board surfaces. Learn which you should use when.

Mediums 10
There are specific uses for each type of paint, with some more suited to airbrush illustration than others. Learn the advantages and disadvantages for using gouache, watercolor, dye, acrylic, dye over gouache, and colored pencil.

Using Reference Materials 13
Good reference materials are essential to good airbrushing. Find out what to include in your files and how to use it.

Lead Pickup Technique 16
This trick will prove a real time-saver for transferring a drawing to board.

PART 2

A Day in Eden 18
Vortex Logo 28
Bike Tour 44
Crush Soda Display 54
Soccer World 72
Statue of Liberty 86
GPA Brochure 96
Dynamic Airbrush 104
Timothy Hutton 114
Banana Split 120
Champagne Fantasy 126
Moeller's Football 132
Music City USA 136
Zapped! 142
Science Fiction Fair 146
Ryland Homes 150
The Planets 156
Tropical Computer 160
Signs of the Times 162
Index 168

TOPIC INDEX

PLANNING AND DESIGN

Refining the Concept: A Day in Eden 19
Working with Your Client: Vortex
 Logo 30
The Pencil Drawing Stage: Bike Tour 46
Developing a Systematic Approach
 to a Complex Job: Crush Soda
 Display 55
Maximizing Your Design Options:
 Signs of the Times 163

REFERENCE MATERIALS

Originating Your Own References:
 Bike Tour 45
Using a Sequence of Photos: Banana
 Split 121
Making a Color Study: Champagne
 Fantasy 128
Using a Photostat: Science Fiction
 Fair 149

METAL AND WOOD SURFACES

Shiny Steel: Vortex Logo 34
Reflective Lettering: Vortex Logo 41
Tarnished Copper: Statue of Liberty 89
Matte Chrome: Dynamic Airbrush 109
Fine Wood Grain: Music City USA 140
Polished Chrome: Zapped! 145

LETTERING

Reflective Lettering: Vortex Logo 41
Computer Graphics: GPA Brochure 100

REFLECTIONS

On Shiny Steel: Vortex Logo 38
On Reflective Lettering: Vortex Logo 41
On Matte Chrome: Dynamic
 Airbrush 109
On Glass: Champagne Fantasy 129
On Polished Chrome: Zapped! 145
As Detailing: Signs of the Times 167

ARCHITECTURE

Window Masking Technique: Bike
 Tour 52
Siding, Shingles, and Brick: Ryland
 Homes 152

NATURE

Animal Fur: A Day in Eden 22
Clouds: A Day in Eden 24
Creating Trees with Liquid Frisket:
 Bike Tour 48
Rainbow: Crush Soda Display 68
Grass and Trees: Crush Soda Display 71
Creating Grass with Dry Brush:
 Ryland Homes 153
Quick Trees: Ryland Homes 154
Starbursts: The Planets 158

SPECIAL EFFECTS MASKING

Creating Trees with Liquid Frisket:
 Bike Tour 48
Liquid Frisket Shoe Laces: Soccer
 World 81
Window Screening: Statue of Liberty 93
Making a Crowd with Liquid
 Frisket: Moeller's Football 133
Using a Stencil Burner: Tropical
 Computer 161

DRY TRANSFER MASKING

Shoe Leather: Soccer World 82
Computer Graphics: GPA Brochure 100

DEVELOPING TONE

Building Steel: Vortex Logo 34
Rendering Landscape: Bike Tour 51
Creating Form and Contour with an
 Eraser: Statue of Liberty 90
Developing Facial Values: Timothy
 Hutton 118

DESIGNING WITH LIGHT

Action: Moeller's Football 133
Drama: Zapped! 145
Mood: Science Fiction Fair 148

REFINING WITH DETAILS

For Scale and Realism: Vortex Logo 42
Skin Texture: Dynamic Airbrush 111

SPECIAL EFFECTS

Translucent Objects: A Day in Eden 26
Vibrant Fruit: Crush Soda Display 58
Building a Montage: GPA Brochure 98
Computer Graphics: GPA Brochure 100
Floating Brushstrokes: Timothy
 Hutton 116
Banana Texture: Banana Split 124
Ice Cream and Toppings: Banana
 Split 125
Flowing Liquid: Champagne
 Fantasy 131
Flying Glass: Music City USA 139
Liquid Flowing through Tubes:
 Science Fiction Fair 148

PERSPECTIVE

Preliminary Planning: Bike Tour 45
Aerial View: Moeller's Football 133
Manipulating Perspective: Music
 City USA 137
Rendering Siding: Ryland Homes 152

INTRODUCTION

When we began working as professional airbrush illustrators we wanted nothing more than to practice our craft all the time, yet this was impossible because we worked in full-service studios where our responsibilities extended beyond the airbrush. By starting up our own studio in 1982, we were able to specialize in airbrush illustration and photo retouching and at the same time expand our skills and bank of techniques at a more satisfying rate.

By necessity, our skills did improve. As we strived to satisfy each client's needs, we discovered and shared new ways to create textures, surfaces, special effects, and more, many of which you'll learn in this book. As our business grew, and still grows, we can afford to bring new illustrators into the studio, and with these artists come more challenging questions and ideas.

Through this book we want to offer you the same opportunity for creative and professional growth that surrounds us daily, and that you would experience working side by side with us at A.I.R. Studio. We've written and designed this book so it takes you from the brief stage of seventeen actual client assignments through planning and design to finished art. We'll discuss the problems and challenges faced in these jobs and the decisions we made to solve them, such as using window screening to give texture to a microphone or renting an airplane and shooting our own photographs for an aerial illustration of a long distance bike tour. This ability to think of innovative ways for solving the challenges inherent in every illustration assignment is a must for the professional airbrush artist.

This book won't teach you the basics of airbrush. What it will show you is how to use and combine these basics with more advanced techniques to create the special effects your illustrations require. The artwork that results will satisfy your client's needs and be a high quality piece of airbrush artwork.

The way to come up with new ideas consistently is to combine what you already know with what you can learn from other illustrators, such as what we'll show you in *Dynamic Airbrush,* also what you can see in illustration annuals, magazines, and in advertisements. By continuing to expand your understanding of airbrush capabilities you'll stay ahead of your competition, and draw much closer to achieving your potential as an airbrush illustrator. Use these illustrations and methods as the catalyst for creating your own exciting and dynamic artwork.

There *is* tremendous satisfaction to be derived from simply learning how to control the airbrush. But the greatest satisfaction, regardless of the techniques you use, comes from transforming and communicating your thoughts and ideas into illustrations that excite the mind and eye, and make your clients happy.

The future of the airbrush for the illustrator is in its *purposeful* application. The airbrush is a tool, just as the paintbrush or palette knife is, and the continued popularity of airbrush illustration among clients will depend upon how you use this tool to apply your skills and talents to the challenges at hand.

The cogs that make A.I.R. Studio run, beginning front and center moving clockwise: Jim Effler, Thomas Chung, Martin Roper, Toby Lay, Mark Rohling, Derek Rillo, Dean Miller, and Dave Miller. Not present, Maurice Mattei.

PART I: VISUAL GLOSSARY

Advanced airbrush illustration is as much a question of choices as it is the skillful execution of basic techniques. Before beginning a piece, you're faced with many decisions that need to be made. Are there any special textures needed? How can you best render them? Is there any really fine detailing to be done? If so, should you use a double-action or turbo airbrush? Do you need to create any unusual edges? Maybe this is the time to utilize a stencil burner?

The key to answering questions such as these is in knowing the best *uses* of the different types of airbrushes, textures, edges, boards, masking materials, and mediums. To help you in your decision-making we want to share with you how *we* use them—knowledge that we've picked up through years of doing professional illustration.

What follows is a "visual glossary" of airbrushes, textures, edges, hand brushes, boards, mediums and reference materials. It's by no means all-encompassing, but its strength for you, as an illustrator, is as a reference upon which you can build your own library of "uses."

CHOOSING AN AIRBRUSH

On these two pages you see the object that gives us both satisfaction and, at times, disappointment—the airbrush. Our intention isn't to promote a particular brand, although in the photographs you can see which brands we use. Selecting and buying an airbrush is a personal thing, dependent not only on how you plan to use it, but also on which style feels right in your hand.

What we can recommend, though, are the uses we feel each type brush is best suited for, in addition to a rundown of the advantages and disadvantages of each. This information will help you know which tool to use to create a specific effect.

DOUBLE-ACTION AIRBRUSH

This is the most versatile of the three types of airbrushes. By controlling the air flow, the amount of pigment released, and the distance between the needle and the board surface, you can render the greatest range of effects and textures that can be achieved with any airbrush. The key advantage of the double-action, which separates it from the single-action or turbo, is your ability to control the air flow and amount of paint. Because of this, you can use the double-action to spray everything from broad, gradated areas to fine detailing. You can create speed lines, such as in Music City USA, page 136; shade clouds as in A Day in Eden, page 24; or gradate tone to shape objects such as a cone or sphere.

While the double-action can handle the finest detail spraying, it is not quite as well suited to detail work as is the turbo. Its spray is less consistent and it's more likely to clog as you spray a long line, thus breaking the line.

ADVANTAGES

- More versatile than other types of brushes
- Air and paint ratio can be controlled while you spray
- Can vary width of sprayed line while in use
- Delivers a fine spray
- Good for detail work
- Easy to repair

DISADVANTAGES

- Paint consistency must be thinner than in a single-action to prevent clogging
- Requires more time to cover large areas than a single-action

SINGLE-ACTION AIRBRUSH

The single-action airbrush isn't designed for use in professional illustration. Its large nozzle or tip opening limits its use in professional applications because the enlarged opening means it can only spray rather broad lines—from one-half to five inches wide. This is compared to the double-action with line widths from $1/32$ of an inch to four inches. Also, the single-action doesn't spray a very smooth pattern, making it most suitable for stippling. One advantage it has over the double-action is its ability to spray thicker consistencies of acrylic paint, which in the double-action must be thinned to the point of weakening the color.

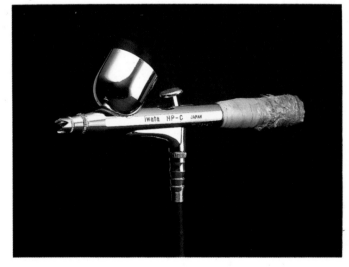

Double-action, Iwata HP-C

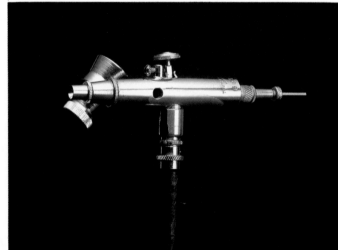

Double-action, Thayer & Chandler, Model A

The *double-action* airbrush pictured here is used by Jim Effler without its handle. This allows him access to the needle so he can move it in and out when flushing the brush with water to prevent buildup of pigment which would interrupt the paint flow.

ADVANTAGES

- Less expensive than all other brushes
- Sprays large areas faster due to larger aperture
- Durable
- Accepts thicker consistency paints due to larger aperture
- Good for rendering large stipple patterns and textures

DISADVANTAGES

- Paint flow can't be adjusted while you're spraying
- Manual adjustment of spray widths requires more time to do a job
- Delivers a coarse spray
- Unsuitable for detailed work

TURBO AIRBRUSH

The turbo is the most highly sophisticated and precise of the three types of airbrushes. It sprays a fine, even line that is ideal for rendering super-fine details. However, the turbo's fine spray makes it unsuitable for anything but detail work. Unless you do extensive amounts of fine detailing, it isn't essential that you buy a turbo. (We have only one that sees action in our studio.) The double-action can satisfy your needs.

Some effects rendered well with the turbo are subtle fabric textures, tiny shadows, soft highlights, such as spot highlights on metallic surfaces, and distant, glowing stars. You can also spray stippled texture by adjusting the speed of the turbine, in much the same way as you would reduce the air pressure on your air regulator to create this effect with the double- or single-action.

ADVANTAGES

- Ideally suited for detail work
- Delivers a consistent, fine line without breaks

DISADVANTAGES

- Expensive
- Difficult to repair
- Limited spray width
- Noisy
- Holds very small amount of paint
- Requires thinned mediums

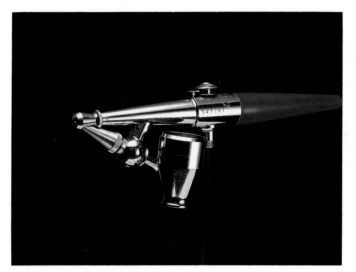

Single-action, Paasche H

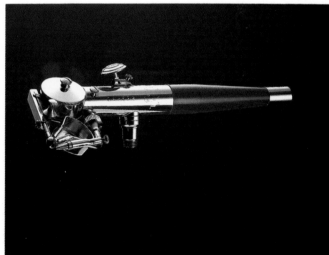

Turbo, Paasche AB

TEXTURES

Many artists view the airbrush as a tool for achieving only smooth, slick or metallic surfaces; as a result their airbrushing doesn't really achieve its full potential. However, it's possible to create a variety of textures using just an airbrush, a combination of airbrush and hand brush, or these same tools in combination with masking materials such as liquid frisket, cloth, or sponge.

By adding the ability to render a range of textures to your skills, you'll automatically expand the range of objects you can illustrate and increase the types of jobs you'll be able to take on.

On these two pages you'll see fifteen different textures you can create—and these are only a few of the possible effects. Don't limit yourself to just these—experiment!

STIPPLING

Stippling is particularly useful in rendering concrete, asphalt, gravel, sand, or stars, as shown in The Planets, page 156.

To achieve a stippling effect, lower the air pressure in your airbrush. An air pressure of 10 pounds per square inch or less creates an effective stipple pattern for many uses.

The type of airbrush you're using and the thickness of the paint can also affect the coarseness of the stipple pattern. A single-action airbrush generally creates a coarser, more irregular pattern than a double-action. Increasing the thickness of the paint will also make stippling larger and more textured.

Above you see stippling with a double-action airbrush and seven pounds of air pressure.

With the air pressure in the double-action lowered to three pounds, the stippling pattern becomes coarser.

The single-action airbrush creates large, uneven stippling. This sample was done with an air pressure of four pounds and the paint valve three-quarters open.

A toothbrush creates an even more irregular stippled texture.

DRY-BRUSHING

When used in conjunction with the airbrush to lay the overall tone, the dry-brush technique is a common and relatively quick way to produce fine texture such as hair, fur, wood grain, and grass—textures that would take much more time to render if you hand painted each hair or blade of grass individually. You can vary this texture by using different amounts of paint, stroke lengths, and colors. For example, in the Ryland Homes project, page 150, illustrator Jim Effler used very short brushstrokes of dark green and a second layer of light green strokes to create a plush lawn. For a step-by-step demonstration of the dry-brush technique, see A Day in Eden, page 18.

In this example you can see wood grain created with dry-brush.

A simple base color and dry-brushing result in grass.

A base color, dry-brushing, and gradated color create aluminum.

ERASING

Erasing the paint from an area is sometimes the best way to create texture, highlights, contours, or modeling. Erasing produces a cleaner color than you get by spraying a light color over darker paint, and spraying white to lighten an area may muddy or dull the colors. Working freehand with an eraser produces a softer-edged shape with a matte finish, while erasing through an acetate mask as a shield produces a shape with harder edges and more definition, one that will appear shiny, such as smooth plastic or metal.

The Vortex Logo, page 28, required extensive erasure to render the metallic fist, as did the Statue of Liberty, page 86, to build up the tarnished copper.

In Dynamic Airbrush, page 104, you can see very subtle freehand and cross-hatched erasure in the forearm area, where it models the fleshtone and keeps it from looking plastic.

DRY TRANSFER

By using dry transfers to mask specific parts of your illustration, you can create any number of effects—such as realistic fabric, wood grain, or leather (see Moeller's Football, page 132), or even incorporate a client's logo (see GPA Brochure, page 96). Transfers are available in art supply stores in sheets of numbers, letters, and textures. Custom transfers can be made from any *line* (not tone) art that's the right shape and perspective.

You can use many types of erasers. Hard rubber or ink erasers remove a lot of paint quickly and produce sharp lines.

Kneaded or soft gum erasers work slowly and can produce very soft, tonally gradated or feather-like edges.

To use dry transfer to create texture like this, burnish it onto your board; after spraying the color, remove the transfer with low-tack tape and clean off any residual adhesive.

CLOTH AND SCREEN

When you need to add highly "structured" texture to an illustration, experiment with different masking materials—loose-weave cloth, mesh, window screening, or any open or porous material. One example is the Statue of Liberty project, page 86, where the artist used window screening to create the microphone webbing.

To create this type of texture, first spray the exposed area with a base color. Secure the mask over the base color with a light coat of spray adhesive to prevent underspray. Spray a darker color over the mask, then carefully remove the mask, wiping off any residue from the spray adhesive with Bestine solvent.

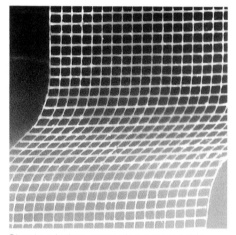

Compare the textural differences between the gauze used in the example above and the cloth used at right.

Simple window screening created this unusual effect. To render this texture with all lines parallel, lay the screen on the board. To create this curved effect, actually curve a portion of the screen before you spray through it.

LIQUID FRISKET

You can use liquid frisket to create such unusual effects as fabric textures, small distant objects (such as crowds of people or distant stars), or minute or unique highlight shapes. As shown in these two examples, the texture you achieve depends solely on how you apply the frisket.

There are many advantages to using this type of masking to render texture or any special area of an illustration. It's very easily controlled and is easily applied with a small nylon brush. Once dry, it becomes rubber-like and waterproof. Colors can be sprayed over the frisket after it dries. The frisket can then be removed with low-tack tape, such as 3M's no. 256, leaving the board beneath white. The edges created by this type of masking will be hard, but you can soften these edges by slightly overspraying the color sprayed on the masked areas.

A large brush can create a contrasting texture with liquid frisket, above left, but our general use for this masking material is with the technique, above right, to render objects such as trees, stars, highlights, or detailing. Liquid frisket was used in many projects in this book. Soccer World, page 72, includes a step-by-step demonstration of this technique. See also The Planets, page 156, and Bike Tour, page 44.

EDGES

Edges are as fundamental to airbrush illustration as is the airbrush itself. And a thorough understanding of the different ways you can create edges is essential.

Frisket film, acetate, and freehand spraying are the three primary means of rendering edges. It's important that you understand the strengths and weaknesses of each. They can give you the full selection of edge types you'll need, ranging from razor-sharp to soft, out-of-focus.

SUPER-HARD EDGES
If an illustration requires really crisp edges, you'll want to use frisket film for your masks. Because frisket film adheres to the board and is very thin, it creates an extremely clean line with no underspray. It will generally adhere to most surfaces, as it's quite flexible, but you shouldn't use it when you're working on heavy layers of paint or highly textured board surfaces, because the adhesive may remove some of the paint.

When you're using frisket on large areas, you can save yourself time and money (frisket film is the most expensive of the masking materials) by saving the various frisket masks you remove from your illustration and repositioning them as needed rather than cutting new masks to fit the shapes.

RELATIVELY HARD EDGES
Acetate can produce hard edges, but never to the point of crispness that frisket film can. For the hardest possible edge use acetate that's .003mm thick and secure it in place with a light coat of spray adhesive, by taping it at the corners, or by holding it by hand. Hand holding acetate works best for small masks. Whichever means you use, always spray *away* from the edge of the mask opening to prevent color bleeding under the mask.

SOFTER EDGES
Acetate, particularly clear acetate, is also the best material to use for softer edges, and there are two means to do so. One is to rest the mask on the board surface and *move* it slightly as you spray. The second way is to raise the mask *off* the surface. The underspray that results from both methods softens the sprayed edges. Acetate that is .075mm or .01mm thick is best suited for both methods. You could also utilize stiff paper or cardboard for the same effect, but you can't see through these materials to see what you're doing.

VERY SOFT EDGES
For the softest of edges freehand spray without any masking. This technique requires that you have peak control of your brush.

Frisket film masking results in the hardest possible edge.

Acetate mask, .003mm thick, held on the painting surface by hand creates a slightly softened edge.

Acetate mask, .003mm thick, moved slightly on the painting surface while spraying creates an even softer edge.

Acetate mask, .01mm thick, with quarters placed between the board and the mask, further softens the edge and allows for increased underspray.

Freehand spraying requires skill and concentration.

BRUSHES AND THEIR USES

The airbrush can't completely replace the hand brush; some things are simply better rendered by hand, such as thin highlights or tiny detailing. Mastering a range of hand brushes will enable you to save time by, for instance, putting in a thin highlight with a sable brush rather than cutting a frisket or acetate mask. It's sometimes tempting to do a piece only in airbrush, fearing that hand brush work would clash in style with the airbrush. It could, but when done well, hand brush work blends with airbrushed paint and enhances your illustration. Here are some of our brushes and their uses.

SABLE HAIR
It's essential to have a quality sable-hair brush especially for touch-up work, small detailing, and dry-brush work. Most touch-up and detailing can be accomplished with a no. 0, while washes and dry-brush need a large size—nos. 3, 5, and 8 should cover all your needs.

NYLON
We use nylon brushes, such as no. 0 or 000, mainly for applying liquid frisket. They're stiffer than sable brushes, which gives you more control when applying the frisket. They also cost less and are easier to clean.

CAMEL HAIR
Camel hair brushes in nos. 4, 5, and 6 are good to use for mixing paint and filling the airbrush color reservoir. Again, these brushes can tolerate more "abuse" than the sables and are less expensive. It's most efficient to have at least six of these on hand so you don't have to clean a brush every time you mix a new color.

DUST BRUSH
You can buy brushes strictly for removing dust from your illustrations. They're made of pony and goat hair, which ranks them between the sable and nylon brushes. The hairs are firm enough to clean the board surface, yet soft enough not to damage the delicate paint.

Hand brushes are helpful for everything from touch-up work to mixing paint. Here are a few we find handy to have around.

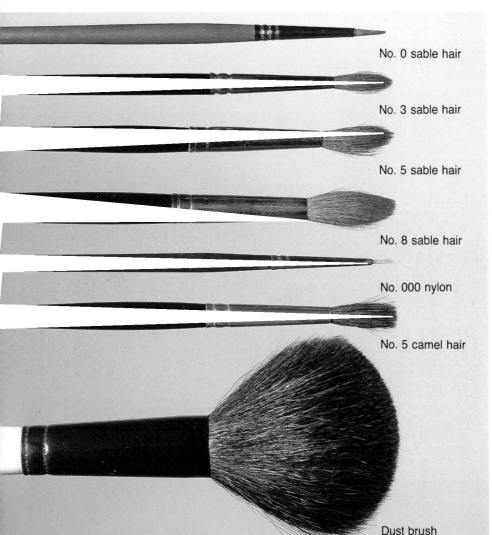

No. 0 sable hair

No. 3 sable hair

No. 5 sable hair

No. 8 sable hair

No. 000 nylon

No. 5 camel hair

Dust brush

BOARD SURFACES

There is a variety of illustration boards on the market and, like paints, they each have strong and weak points. Here are the boards we have used and what situations they are best suited for.

SMOOTH SURFACE
In general, smooth, plate-finish (hot-press) boards work best for airbrushing. The smooth boards we've used are Crescent 205, Letramax 2000 and 4000, Frisk CS10, and Bainbridge 172.

For most illustrations, we use Crescent 205 because it's not only smooth to the touch but also less modeled than other boards, which means that the natural hills and valleys in the board's surface are less visible (you can see these if you hold a light at the edge of the board and shine it across the surface at a low angle). You shouldn't

leave frisket on this board for a long time (such as a few days) because fibers on the surface can be pulled up when you remove the frisket. You can erase color from this board but don't use anything wet to wipe color off, or it might damage the surface. The characteristics of Bainbridge 172 are generally similar to Crescent 205.

The Letramax boards 2000 and 4000 are very smooth. You can erase easily and even use a damp cotton swab to remove paint without damaging the surface. Frisket won't pull up any fibers either, but overall surface modeling is slightly more prevalent than in the Crescent 205. All of the smooth-surface boards hold the color well when you pull up frisket from a painted area.

TEXTURED SURFACE
The modeling in textured (cold-press) boards is a design and rendering factor. Before you spray on textured board, consider whether you want to minimize the board's texture for a subtle effect, in which

case you'd spray directionally from all four sides in towards the center. To maximize the texture, spray from only one low angle, as illustrated below.

If you plan to use colored pencil in your piece, it's better to use a textured board so the pigment has something to adhere to. Crescent board no. 1 or no. 110 is good for this, but we recommend no. 110 due to its greater whiteness. Washes also work well on textured boards.

The overall effect of an illustration rendered on this type surface will be softer than on smooth board, since the texture breaks up the smoothness of the spray, preventing really hard edges. Imagine how much more effective an illustration of a fuzzy-haired teddy bear would look on textured board than on smooth.

The degree of texture on this board will affect the ability of frisket film to adhere, so watch for underspray.

Gouache sprayed on Crescent 205 from all four sides results in smooth, even surface coverage.

Gouache sprayed on Crescent 110 in one direction—from the bottom edge up—maximizes the surface texture.

Gouache sprayed on Crescent 110, from all four sides inward, creates the same look as on Crescent 205.

MEDIUMS

The four paints used in airbrushing—gouache, watercolor, dye, and acrylic—have unique and individual characteristics, both good and bad. When choosing a medium for a particular use, you should know exactly how it will act in your airbrush, on the board surface, and in relation to other mediums, in addition to the types of effects it can create and what its limitations are.

While we use gouache maybe 90 percent of the time, it's important that we have the option to use other mediums for the remaining 10 percent, because while gouache is very flexible, there are effects you can't achieve with gouache alone. That's why it's beneficial to understand the full capacity of every available medium.

In this section we'll discuss these four primary mediums, plus the use of dye over gouache and colored pencil. We'll give their characteristics, plus advantages and disadvantages for each, so you'll have the information you need to make the best choice of medium for your own illustration work.

GOUACHE

One of the key characteristics of gouache is its opacity when applied heavily. This results in a flat, "silkscreen" quality. You can vary the opacity by changing your paint consistency and application. Opaque gouache is the medium to use when you need to cover and rework a sprayed area. (Caution: Heavy buildup of gouache can break or peel when an illustration is bent for scanning during reproduction.)

On the other hand, you can thin gouache for translucent coverage. The look will be more luminous and add depth to your illustration because more light will go through the pigment and reflect off the white board surface.

The fine pigment grind in gouache creates few clogging problems in your brush, resulting in a steadier, more consistent spray. Gouache colors are nicely saturated and very compatible with each other.

ADVANTAGES
- Good coverage over large areas
- Reproduces well
- Dries fast
- Moderately priced

DISADVANTAGES
- Can get muddy when mixed
- Easily damaged since it's water-based
- Some gouache colors contain dye, which can stain

WATERCOLOR

Watercolor has the finest pigment grind of all four mediums, and as a result its best use is for transparent layering of color directly over the white board. The board acts as a "tinting" agent to lighten the watercolor without muddying the color or adding density. The step-by-step demonstration of the balloon in A Day in Eden, page 26, exemplifies this. Use watercolor over thin consistency gouache for finer detail work.

ADVANTAGES
- Most colors are bright
- Produces a smooth, even tone
- Flows smoothly without clogging

DISADVANTAGES
- Expensive
- Hard to cover other colors
- Easily damaged due to water base

DYE

ACRYLIC

DYE ON GOUACHE

Dyes are the best transparent colors to use, better than even watercolor. They work better over gouache than watercolor because they are a purer color mix with less grain or opacity. The drawback is that errors in dye are hard to correct because dye stains and will bleed through paint sprayed over it.

ADVANTAGES
- Mostly brilliant colors
- Easy to mix and use
- Non-clogging

DISADVANTAGES
- It stains and can't be covered easily due to its bleed-through quality
- Many colors are not permanent
- Tends to bleed under frisket
- May not reproduce faithfully
- Easily damaged due to water base

We don't use this water-based paint because it clogs airbrushes unless it is thinned severely, and this weakens the colors. For the most part, acrylic pigment is best suited for the basic level artist who tends to build up heavier layers of paint since acrylic can tolerate this without peeling or flaking. While the acrylic clogging problem is serious, consider this pigment if your piece is to be displayed since acrylic is the most durable of the four mediums.

ADVANTAGES
- Bright colors
- No bleed-through
- Waterproof and permanent when dry

DISADVANTAGES
- Clogs airbrush
- Transparent quality requires more time to build up color density

You'll sometimes find that gouache will dry to a color that's duller than you intended. You can brighten the dull color by spraying a dye, which adds color and some density. The darker, more color-saturated the dye you use, the more it will intensify the base color. The above example shows crimson dye over ultramarine gouache.

COLORED PENCIL

You can use colored pencils to render textures that neither the airbrush or a sable brush is well suited to, such as concrete or asphalt, rough wood grain, skin, or hair.

If you want the colored pencil to blend in with the illustration, use a cotton swab to lightly rub over the pencil work. This will soften the pencil work, making it appear more airbrush-like. Depending on what you are illustrating, however, you might prefer to leave the colored pencil unblended for a harder look. (A word of caution: Experience has taught us that hard-lined colored pencil over airbrush tends to look foreign to the illustration when the art is either separated or photographed.)

Do pencil work as the last step of your artwork—otherwise frisket film will pick the color up and Bestine solvent will dissolve it if you have to clean spray adhesive off your illustration.

ADVANTAGES
- Can produce a range of textures, including many that can't be obtained in any other way
- Can render hard or soft lines

DISADVANTAGES
- Must be done as the final step in a piece
- Colors less intense than paint
- Time-consuming if used over large area

Note in this simple impression of hair how the pencil line fades out the farther it gets from the skin surface.

Asphalt is rendered easily using the side of the pencil.

Rough wood grain is obtained using three different pencil colors.

Multiple pencil colors also give depth to grass.

WHITE PAINTS

The truth about white paints is that they aren't all created equal. And it's a good idea to know going into an illustration which white paint is best suited to what use.

There are two white gouache paints in general use: permanent white and zinc white. Permanent white is the more opaque of the two and covers other paint colors better. Although permanent white also does well for tinting, zinc is better—it mixes better and doesn't degrade the original color, which permanent white may do.

Bleed-proof white is the right white to use when you need to cover dyes (and some gouache and watercolor that contain dyes) that would normally bleed through other whites. Bleed-proof white is very opaque and covers well; it is, however, also grainier than permanent or zinc white and doesn't cover as smoothly.

Two other all-purpose whites are Instant Aero White and Gamma, both by Grumbacher. Both are opaque and smooth, great for spraying fine white lines. Gamma White is the best pigment for fine hand brush work.

USING REFERENCE MATERIALS

To help us conceive, design, and visualize our illustrations, we rely heavily on reference materials such as books, magazines, photographs, maps, and advertisements. Some of these materials—good 35mm photographs you shoot for yourself, for instance—can provide exact information on an object's detailing, size, shape, color, and perspective. Books and magazines are also good sources for this type of information.

Other resources offer different advantages. Instant prints are excellent sources for immediate information in working up preliminary drawings, even though they're generally useful only for insight into an object's shape.

There will be occasions when you won't be able to find or create a reference that pictures an object in the exact form you need. In these instances, you may have to alter the perspective or size from what's shown, but can still use references for help in depicting details such as color or general shape. These references will serve mostly to help you imagine what an object *could* look like in your illustration.

On the following three pages we'll describe the references we use, and how we use them.

35MM COLOR PRINTS

If you own a decent 35mm camera you can shoot your own reference photos. This allows you to set situations up just how you need them for a particular job. In general 35mm prints are better for color, tone, and detail than instant prints. Photos from 35mm negatives make better direct reference for finished art, especially for involved subject matter, because you can enlarge them to the size you're working. Instant print images must be enlarged on a Lucidagraph (which projects an enlarged image onto glass so that you can trace it at the desired size).

The drawbacks to using 35mm photos are: 1) you must use a whole roll of film even if you don't

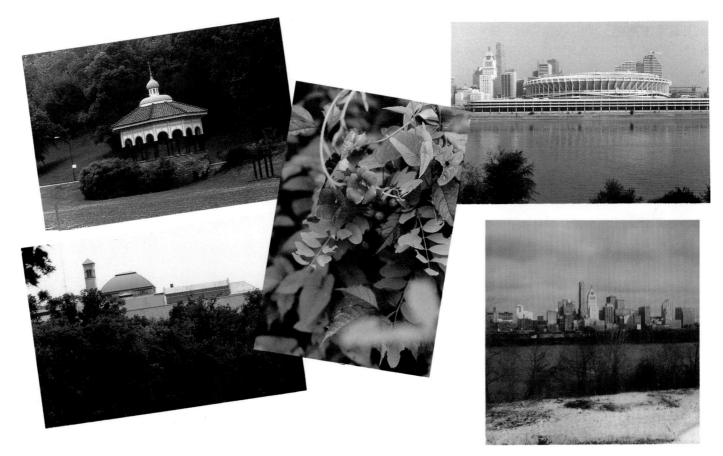

Three photographs were used as reference in the A Day in Eden poster, page 18. Note the detailing they provide in addition to the color representation.

By comparing the 35mm print with the instant print, you can see that the 35mm print works better in some situations than the instant photo.

need it, and 2) it takes longer to get your pictures back, although one-hour photo developers are becoming more and more popular in many cities.

While neither 35mm prints or instant photos are cheap, the information they provide is often valuable in saving time and getting your subject matter to look just right.

INSTANT PRINTS

You can't beat an instant print for quick reference. You can set the props up just the way you want them and shoot from the exact angle you need. These photos are helpful for pencil sketches or even reference for a finished piece if it's not complicated, detailed subject matter. While they're good for get-

ting the shapes of objects, you must be aware of possible distortion when you are *very* close to the subject matter because of the wide angle lenses these cameras have. Instant photos are not good for color reference, either.

CLIP FILE

Sage advice: Start a clip file, maintain your existing clip file, or update your old clip file. It's invaluable and will serve you well in your search for that just-right image.

Our studio file is divided into two parts: the first part holds images (from any type of printed matter) of objects; the second part harbors examples of other artists' illustration styles and techniques.

Our objects file gives us quick

access to visual reference for a range of subjects. This is especially helpful if the subject is one we can't photograph ourselves, such as the Taj Mahal, Bambi, or the planet Saturn. Keep your clips filed and indexed according to subject matter; add to the file regularly. And even though it may seem that for some jobs you couldn't possibly have the reference you need, if the file is maintained well, oftentimes there is something in it that can serve as a springboard.

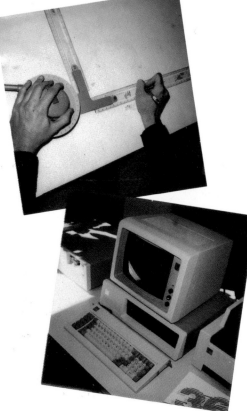

These two instant prints show the ideal use for this type of reference material—images where you can get in tight and color isn't critical. The print of the two hands was used for the GPA Brochure illustration on page 96 and the computer photo was used in Tropical Computer, page 160.

Clippings of advertisements can give you access to a range of fruits, such as these, many of which may be out of season if you tried to buy them. You'll have more time to study what ice looks like with a clipping than with the genuine article.

In the second half of the file, keep illustrations by other artists. From these samples you'll not only expose yourself to a range of different illustration styles, but often you can pick up on a new approach to a common (or tricky) subject matter.

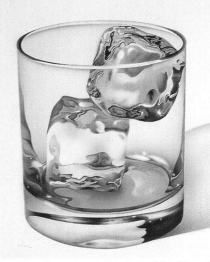

Certain effects, such as that of liquid and ice cubes, result from careful consideration of masking and contrast. You can learn a lot about these elements through other illustrators' work, so your reference file should contain samples like this one.

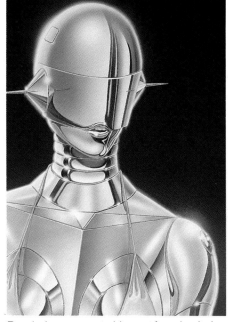

Rendering a super shiny surface is challenging. Studying examples of work by other artists, such as this piece, will help you understand how to render reflections, edges, and hot spots that result in the metallic effect.

The unique style of this illustration could give you an idea for handling a job of your own.

LEAD PICKUP TECHNIQUE

The lead pickup technique is a real time-saver for transferring a drawing to board, something which is always welcome in this business. This method works best when there aren't too many shapes to be cut out and re-positioned, with shapes that aren't so complicated that you can't re-cover them with the pieces you removed, and with shapes requiring hard edges. Your pencil drawing should consist of precise lines, so you know exactly where to cut, and be drawn with a lead such as an H that is not too hard or too soft.

First tape your pencil sketch (which is on tracing paper and should be rendered as accurately as possible, without tone or shading) to a board to keep it flat. Lay a piece of frisket large enough to cover the entire drawing on top of it. Go over all the lines with a burnisher so that some of the graphite from the pencil drawing transfers to the adhesive side of the frisket. Then remove the frisket from the drawing and *carefully* place it down *smoothly* on your final illustration board. (It's vital that there be no air pockets in the film.) You now can start lightly cutting along the illustration lines, but save the pieces so you can replace them as masks later. Remember that you'll have to spray all the shapes in the piece before you remove this frisket; otherwise you'll lose the drawing.

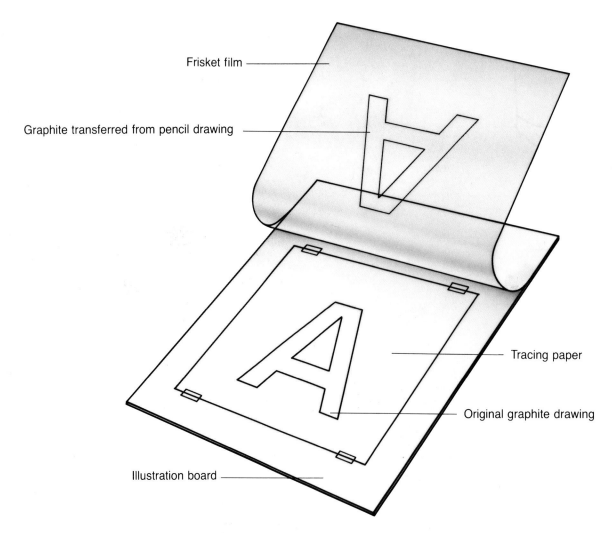

Frisket film

Graphite transferred from pencil drawing

Tracing paper

Original graphite drawing

Illustration board

Here's a trick you can use to make transferring a large drawing with the lead pickup method easier. First, tape the drawing down to the illustration board you're going to use for the finished art, making sure the board is larger than the drawing on all sides. Cover the drawing and board with frisket and burnish. Be sure the frisket overlaps the drawing and adheres to a good portion of the board, as shown in the diagram. When you remove the frisket, pull it up only far enough to remove the drawing beneath it, leaving it tacked at one side of the board. Then smooth the frisket back down on the board to complete the transfer.

PART II: THE PROJECTS

A professional airbrush illustration develops through a series of stages including the briefing with the client, conceptualization and design, drawing up pencil sketches and, finally, rendering the finished piece of art. During each of these stages the illustrator, either alone or with the client, makes dozens of important, thoughtful decisions about mediums, edges, masks, and more.

In Part 2 of this book you'll see seventeen actual client projects and two experimental pieces with step-by-step demonstrations, enlarged details, and extensive instructional captions so you can learn exactly how we drew upon our knowledge of airbrush essentials to make decisions throughout the entire process. We'll specifically discuss what went into our decisions, and how they directly affected whether the finished illustration met the client's needs.

As with Part 1, use this second half of *Dynamic Airbrush* as a well of ideas, a guide in making decisions on your own illustrations, and we hope, to some extent, a source of inspiration as you work to satisfy the needs of your own clients.

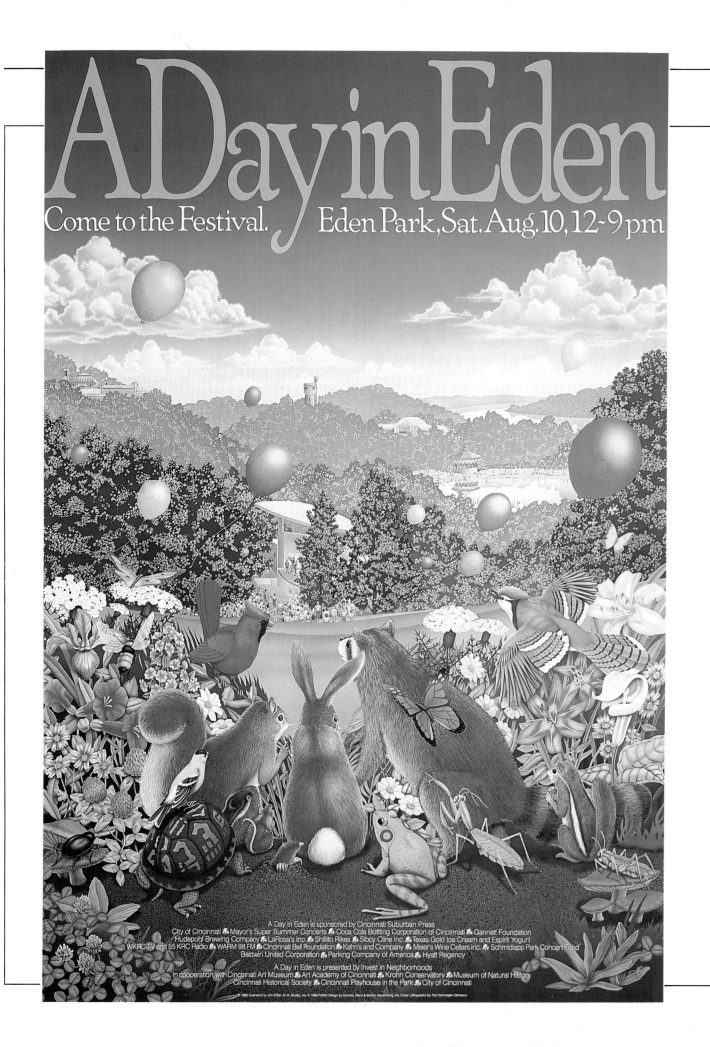

A DAY IN EDEN

PROJECT 1

ASSIGNMENT

A poster promoting a summer festival in Cincinnati's Eden Park

ARTIST

Jim Effler

CLIENT

Horwitz, Mann & Bukvic Advertising, Inc.; Dave Bukvic, art director

The A Day in Eden illustration shows how much planning can go into a complicated design. The illustration was used as a poster to promote a summer festival in Eden Park in Cincinnati, Ohio. The advertising agency's art director wanted to incorporate lots of animals, trees, and balloons to create a colorful, storybook-like setting, and he provided a rough pencil layout showing the basic composition. Another important consideration was that the poster accurately portray some of the park's landmarks so that people seeing the poster would immediately identify the location.

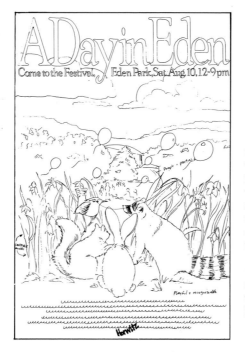

1 **Refining the Concept:** In all, I spent fifty hours in the preliminary stages of this illustration, just getting to the point where I could transfer the drawing to the illustration board. That included talking to the art director about his rough layout (shown here), taking pictures in the park, researching the animals at the library, and completing the first pencil draft and the finished pencil drawing.

From that point on, I spent another 100 hours doing the illustration. When I started it, I felt like I'd never finish it, but when I did, it brought a real sense of satisfaction. It takes patience.

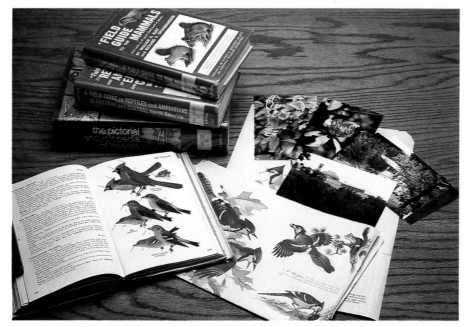

2 The first step in researching the illustration was to snap photos of the area's general landscape, foliage, and landmarks. Then I carefully researched the animals in the foreground to make sure they were all native to the area and to find visual references for drawing them. You can see some of the references I used here. In some cases—the blue jay for instance—I was able to find a reference with the animal in a position very close to what I wanted. The only changes I made to the blue jay were to move its head so it was looking toward the crowd and to use brighter colors because I wanted the poster to have a colorful fantasy feeling. The sample I had for the turtle, though, wasn't close to what I wanted, so I used it as a guide as I drew the turtle and imagined what it would look like from the actual point of view I wanted.

Gouache and watercolor; 25" × 35½"

Courtesy of Horwitz, Mann & Bukvic Advertising, Inc.

3 Once I'd finished the research, the next step was to produce two drafts of the illustration on tracing paper. The first draft generally mapped out the illustration. The second draft had cleaner lines and a few minor changes. I gave the jack-in-the-pulpit, the flower in the right foreground, a longer stem to enhance the realism and added a small mole for interest in the center foreground. After completing the second and final drawing, I sent it to the art director for approval.

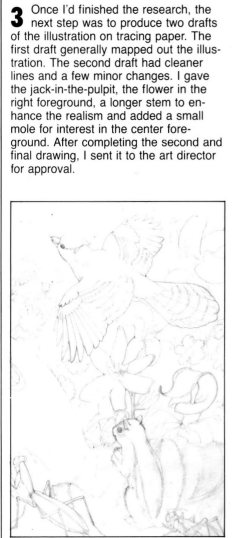

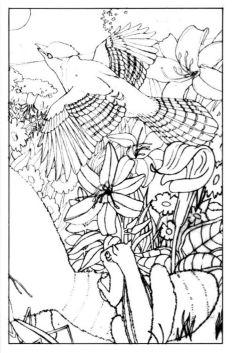

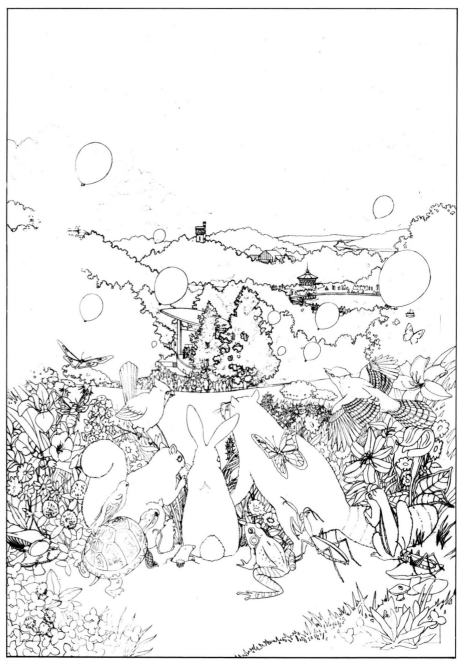

4 **Inexpensive Masking:** Following the art director's approval, the drawing was transferred to the illustration surface with graphite-coated tracing paper. Then I began the painting. This particular illustration was done to full size: 23″ × 33½″ with a one-inch bleed. To protect the illustration and save frisket, I put a cheap paper mask down first, as described in the sidebar below.

5 I illustrated the most important objects first, beginning with the foreground—animals, flowers, plants, and ground. The next stages included the tree-covered hillsides, the clouds, and the sky, with detail work like the pavilion, crowd, and other landmarks coming last.

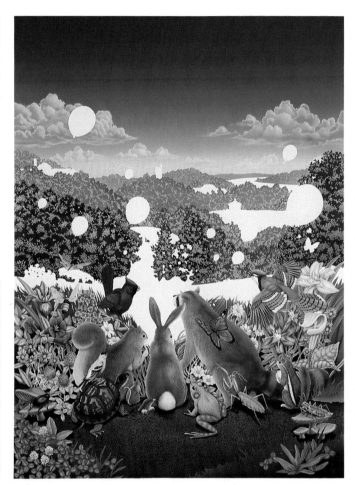

INEXPENSIVE MASKING TECHNIQUE

To conserve frisket, cover your entire illustration with inexpensive white wrapping paper; cut a hole in the general area in which you'll be working. After you've made this protective sheet, cover the open image area with frisket. Now cut the frisket exactly along the edge of the shape to be sprayed.

6 **Animal Fur:** The technique for illustrating most animal fur is similar to that I used for the chipmunk in the right foreground. First I masked the image so the background was covered, leaving the white stripe of the chipmunk's fur covered also. Next I sprayed a light (20 to 30 percent) tint of the fur color to give shape to the animal, as you see here.

7 Since I wanted the chipmunk's tail to be lighter than its back, I used acetate to cover the tail while I sprayed the back darker, moving the mask slightly to avoid creating a hard edge. (You can see the mask I used here better at the top of the previous illustration.)

8 At this point, I added the fur, using the dry-brush technique. For this technique, use watercolors from a tube or gouache and a good sable brush, any size from no. 5 to no. 8. You'll want to work with a relatively dry brush, so to achieve the correct consistency, put approximately one-eighth of an inch of the sable brush into the paint and stroke it lightly across a scrap piece of illustration board. When you get the "fur" effect that you're after, start applying paint on your illustration. Keep your strokes fast, light, and going only in the direction the fur grows. Every time you dip the brush for more paint, you must first get it started on the scrap board. To get the brush hairs to separate nicely, sometimes it's necessary to press the brush down on the scrap board almost to the ferrule and twirl it slightly.

9 After this step, I airbrushed some more tone to make the shadow areas darker.

10 Next I used the dry brush again to apply a second layer of fur to make it look thicker. When applying the second layer, remember to point the hair in the same direction as the first coat.

11 You may choose to spray more tone over the second layer if you think it's necessary.

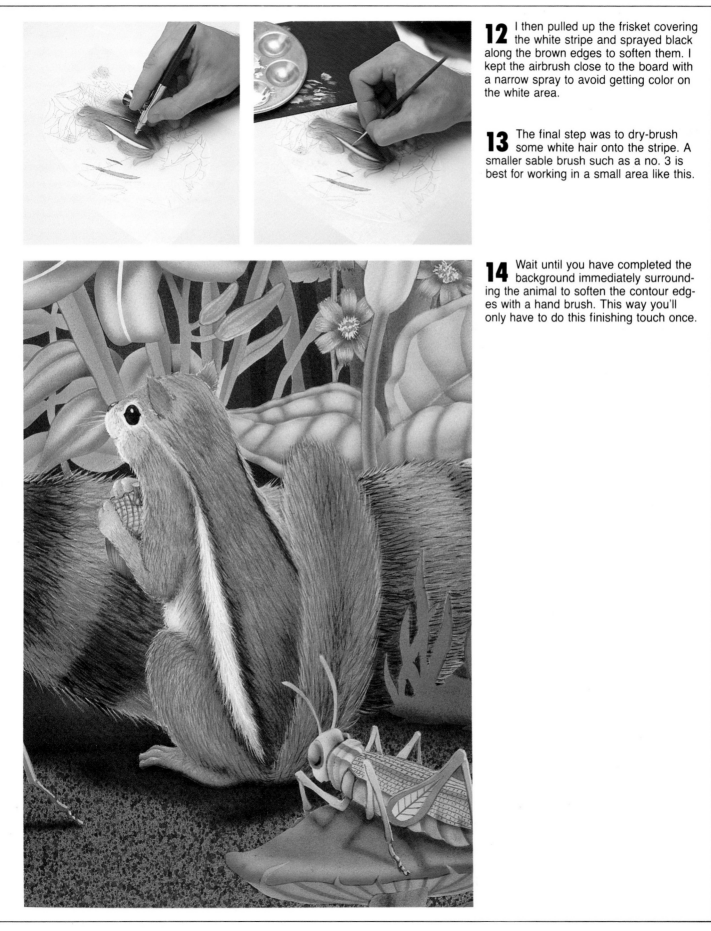

12 I then pulled up the frisket covering the white stripe and sprayed black along the brown edges to soften them. I kept the airbrush close to the board with a narrow spray to avoid getting color on the white area.

13 The final step was to dry-brush some white hair onto the stripe. A smaller sable brush such as a no. 3 is best for working in a small area like this.

14 Wait until you have completed the background immediately surrounding the animal to soften the contour edges with a hand brush. This way you'll only have to do this finishing touch once.

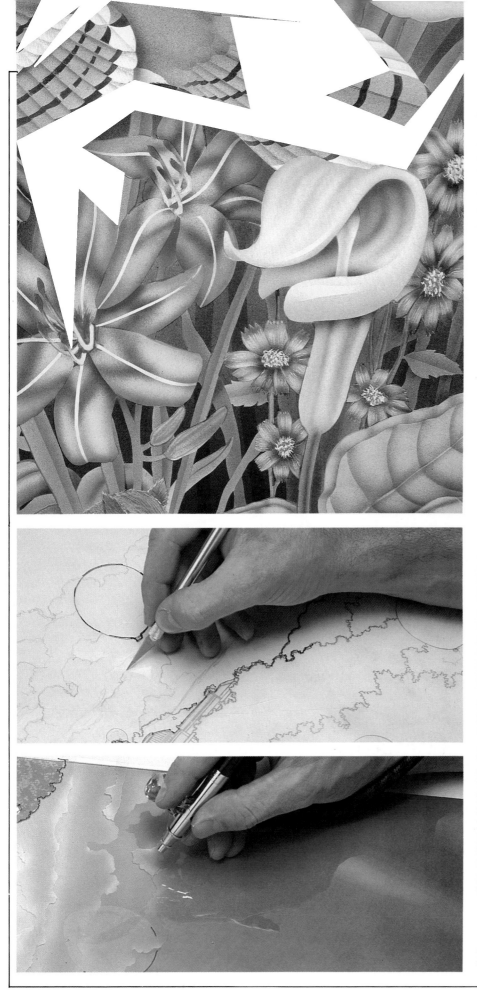

15 **Plants:** To achieve the depth in the foreground plants I first sprayed the flowers, since they are the most important. I decided to start in the foreground and work my way to the background because the flowers in the foreground were the important objects here, and I knew how I wanted them to look. I then rendered the plants in the background to support and contrast the flowers. The next things to render were the stems and leaves of the flowers; then I masked off the flowers and plants I'd finished and exposed the background. To heighten the feeling of depth in areas of foliage, spray a green in the background areas dark enough to separate them from the previously painted plants. Check to see how they contrast as you go by carefully lifting up, and replacing, some of the frisket over the already painted plants. While doing these areas you can use some "stem" and "leaf" shapes cut out of acetate to lay on the background areas as you spray. This will create more plant forms in the darker areas.

16 **Clouds:** The clouds were put in after the sky gradation had been sprayed but while the masks covering the land, balloons, and other objects in the sky were still down. Colors used in the sky should be gouache or watercolor; dye will stain the white you spray on top for the clouds. Some of the gouaches and watercolors also contain dye that might come up through the white. If this happens, use bleed-proof white to spray your clouds.

When transferring the overall drawing to the board, it's better not to trace down the cloud shapes. Then when you're ready to render them, tape a piece of .003mm acetate over the pencil drawing, which should also be taped down to a piece of board. Cut the cloud shapes out—you can use more cutting pressure than usual since the finished art isn't underneath the blade. After you do this, mark the acetate with a grease pencil, registering it to some of the objects in the illustration such as the horizon and landmarks. Then pick up the acetate and put it over the final art, registering it with the traced landmarks.

17 Spray just enough white through the cloud shapes in this mask so you can easily differentiate the clouds from the sky when the mask is lifted.

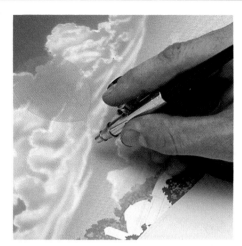

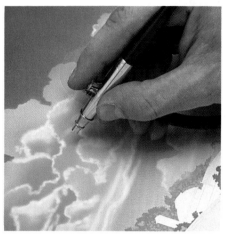

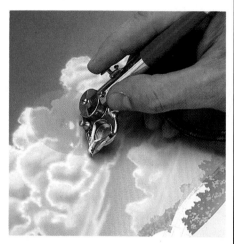

18 Remove the cloud mask and spray white paint freehand along the edges of the clouds to soften them. Also use white to model the clouds' interior shapes by spraying the sides facing the sun.

19 The shadow sides should be sprayed with a color similar, but not identical, to the sky. Clouds reflect the sky color somewhat, but by using a different shade of blue, in this case a gray-blue, you give the cloud substance.

20 The bright white edges take several layers of sprayed paint to build up opacity. You'll have to spray them again after putting the shadows in. Use a turbo for this final and more detailed application of the soft white edges.

21 Pull up the frisket only after you are completely finished with the clouds.

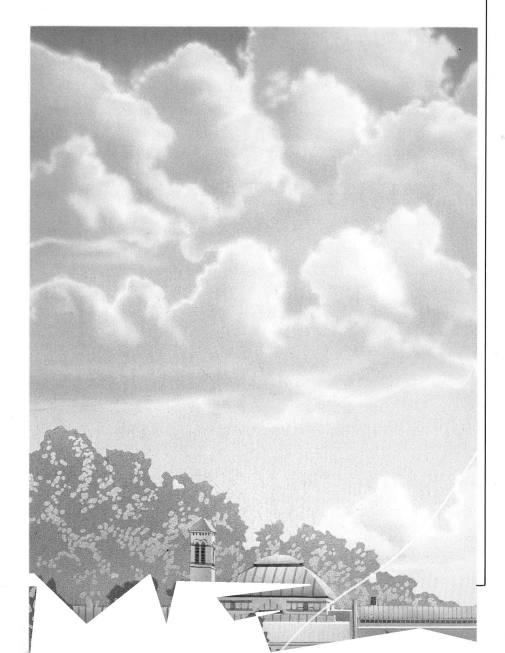

22 **Translucent Objects:** To achieve the translucent effect of balloons, paint them in after the background, so you know what shapes and colors must show through each balloon. To get clean, bright colors you should mask off the balloons while doing the background, giving you pure white board to start spraying your balloon colors onto. (If you painted the entire background first and then put the balloons in on top of it your colors would never be as bright even if you put down a layer of white.) After I sprayed this particular balloon red, shaping it by avoiding the highlight area, I cut an acetate mask in the shape of the tree behind the balloon. A couple of small areas were masked off with frisket to create holes in the branches. Then I lightly sprayed a dark green color to give the effect of the tree showing through.

25 **Final Tint:** The last step in doing this piece was to spray a tint of yellow over the bottom third of the illustration to unify the colors. Other colors can be used but I chose a golden yellow so it related to the yellow in the sky at the horizon, and also to warm the illustration up just a little. This tint was very faint and transparent, maybe 5 or 10 percent of the full color strength. I did not spray the upper portion because I wanted the color in the balloons to be as bright and clean as possible, and I didn't want the clouds to turn yellow and the sky green. Spraying a final tint can cause problems, as it did in this case, but it can also pull the colors together. You have to keep the spray away from areas that you still want white, such as the Queen Anne's lace here. I was unable to avoid the rabbit's tail so I had to spray white over it after spraying the yellow tint. Another problem you might run into by spraying a tint is it might ruin some of the colors in your artwork, especially opposites of the color spectrum. I kept the spray away from the blue jay after noticing that the small purple flowers were turning an undesirable color. I had to mask around these flowers and go back over them with white and then blue to get rid of the yellowish tint on them. Had I realized this before I sprayed the yellow I would have covered them up with frisket first.

23 The strings were added last. I made the mask for the strings with one curve cut in a piece of .003mm acetate. It was cut from end to end then cracked, and separated. I then taped the two pieces back together, leaving a space (the width the string would be) in between them. I also put a piece of tape on the ends where I wanted the string to stop.

24 Masks such as these acetate "string" masks should be taped down (not directly to the art but to a protective mask). This allows you to lift them up and see if the strings are white enough and get the masks back down in the same position if they are not.

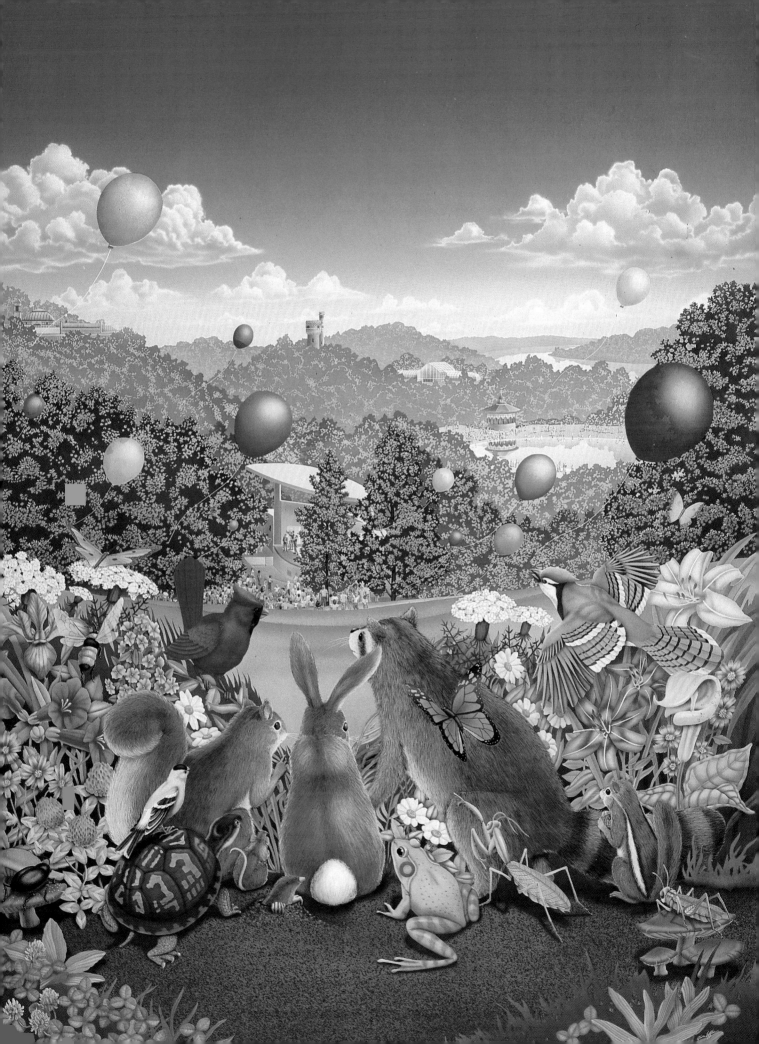

PROJECT 2

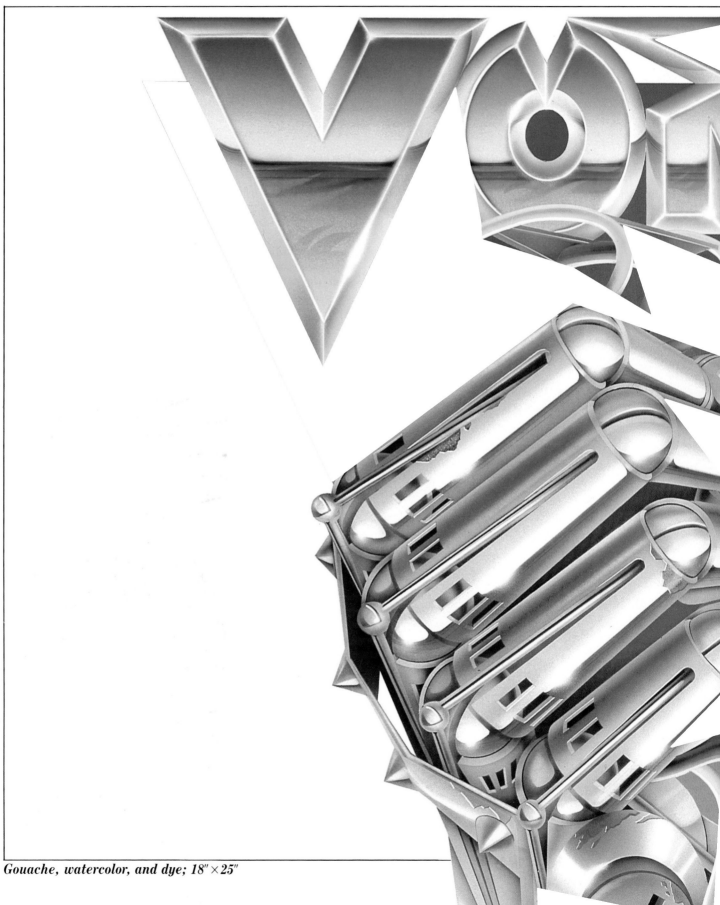

Gouache, watercolor, and dye; 18" × 25"

ASSIGNMENT
Logo for the Vortex, a roller coaster at Kings Island amusement park

ARTIST
Dave Miller

CLIENT
Sive Associates; Kim White, art director

Vortex is a $4-million roller coaster at Ohio's Kings Island amusement park. The ride features two and a half minutes of hills, drops, and vertical loops, plus corkscrew, boomerang, and 360-degree helix turns—at speeds of more than 50 miles per hour. The ride is designed to make riders feel like they are totally under the control of outside forces.

My assignment was to create a logo that reflected this mood but didn't frighten or intimidate people. The logo would serve as the ride's trademark in all kinds of advertisements and promotions. To be successful, the illustration also had to please the client and incorporate ideas and goals.

Courtesy of Kings Island

1 **Working with Your Client:** The art director did several thumbnail sketches to establish the basic concept, then gave me a rough sketch to follow. As the work proceeded, I worked closely with the art director to make sure he approved of my execution and design decisions. We met to discuss the drawing four different times. Our first meeting was to discuss the concept and price. During the second, I showed him the preliminary drawing of the fist and shot reference photos of various ride tracks from the agency's videotape library. The third and fourth meetings involved reviewing the preliminary drawings, discussing the lettering, approving the final sketch, and making color choices.

One of the first steps in doing this illustration was studying my photo and illustration file of fists and chrome lettering. Establishing good, strong tonal contrast and separation was of primary concern in rendering a shiny steel surface.

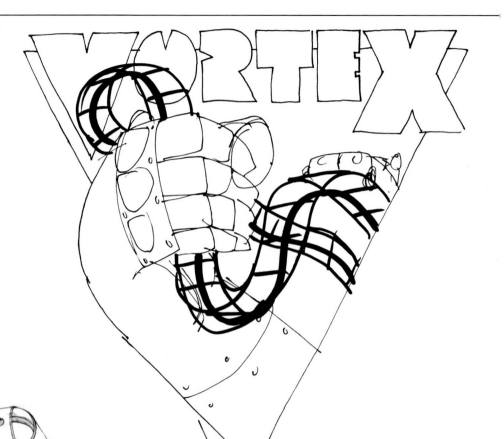

2 I prefer to concentrate on drawing one area of an illustration at a time because this lets me rework and refine each area as needed. I began with the robot fist, then worked up the track and the lettering separately. A primary consideration in sketching the fist was to keep it from looking too menacing, and while it was very important that it look functional, composition was my primary consideration. We decided at the briefing session that the knuckle spikes, which you see indicated on the art director's rough above, would be left off the pencil drawing. However, after I rendered the fist without the spikes, it seemed too delicate.

3 This rough sketch shows the revised fist. To change the delicate look of the fist I added the knuckle shield and the spikes to both it and the wrist. Note that I lessened the overly aggressive impact of the spikes by making them short and wide rather than long and vicious-looking.

I drew up this basic concept several times as half-size roughs to refine the details in the fist and letter design before completing the finished, full-scale drawing on page 33.

4 To plan the track's design and under-
stand the shape of the support struts,
I shot 35mm stills from several commer-
cials for rides similar to Vortex.

5 The final drawing of the track shows
triangle-shaped struts rather than the
less visual L-shaped supports of the ac-
tual ride, since the triangle shapes were
deemed more exciting visually.

6 After completing the individual sketches of the hand, track, and lettering, I traced them onto a single sheet of heavyweight tracing paper. (If you work up your preliminary sketches either larger or smaller than your final illustration size, photocopy the sketches to the finished size and paste them down onto a board. Then trace the drawing onto the tracing paper.)

I then used the lead pickup method described in Part 1 to transfer this finished drawing onto smooth illustration board.

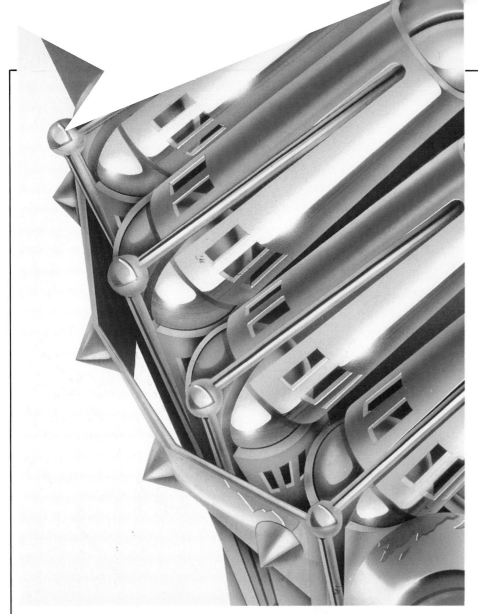

8 In the final drawing, detailing is more important than at the rough sketch stage. Proportions and shapes must be accurate, shadows must be indicated and lines should be clean.

7 **Shiny Steel:** In this step-by-step demonstration you'll learn exactly how I created the metallic effect in the fist and wrist.

12 Leaving the sprayed areas exposed, I pulled up the next value areas.

13 At this point I re-covered all the areas whose density I didn't want to increase. To create the hairline shadows between the fingers and the knuckles I readjusted the frisket masks covering the knuckle just slightly. I sprayed these areas a mid-value.

14 With most edges now defined by some tone or shadow, I exposed the entire finger and added tone. Each finger was sprayed and re-covered before I moved to the adjacent one.

9 With the outline drawing transferred onto illustration board I began cutting the frisket using a sharp blade and a straightedge.

10 I removed the frisket first from the areas to be sprayed darkest. I worked from dark to light because the density of the darkest areas would serve as a guideline for establishing the values of lighter areas.

11 Using ivory black watercolor, I sprayed the dark tones, making them slightly less dense than I wanted in the finished illustration since they would pick up tone when I sprayed subsequent areas. My objective was to define the fist's overall form since many of the shapes were similar, such as the fingers. In addition, the project moved more rapidly when I worked these areas up in mass.

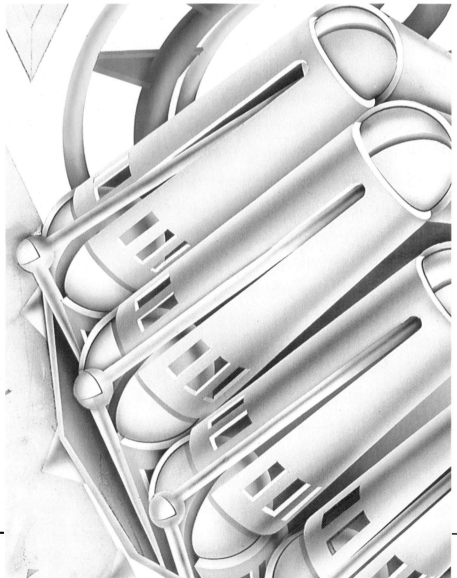

15 After applying light gray tone to the fist, I used a plastic straightedge as a guide for spraying the dark, soft-edged lines running the length of each finger.

16 Tone now defines the fist's basic form and construction, but not its color or reflectivity.

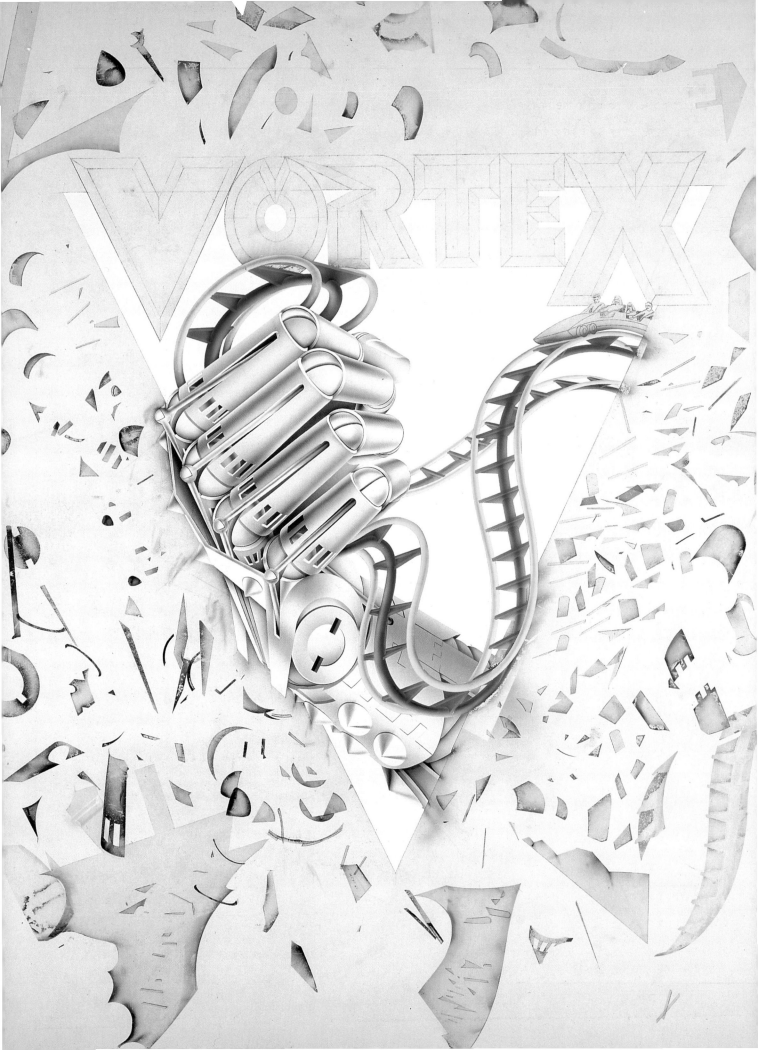

17 **Track and Background:** At this stage, I added color to the track. I can often save time by reusing original frisket pieces, such as you see scattered around this image, rather than cutting new masks.

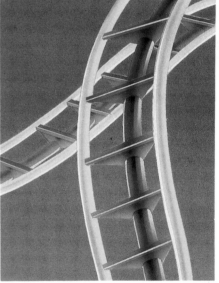

18 I put the background in next because at this point I wanted to establish the right contrast between the background and the fist. The gradated background helped emphasize the top portion of the illustration, especially the lettering and fist, while giving a lighted appearance to the lower portion. The contrast of the hot background colors against the cold metal warmed up the illustration and intensified the fist's impact.

19 I made the rails yellow with blue supports, rather than orange with blue supports as on the actual ride. True color representation wasn't critical to the piece, and as you can see here, the yellow complements the hot red background. This type of decision was crucial to the overall look of the illustration and was made with the art director in one of our preliminary meetings. Discuss considerations such as this with your client before you begin working to prevent problems later on that could mean changes to the finished piece.

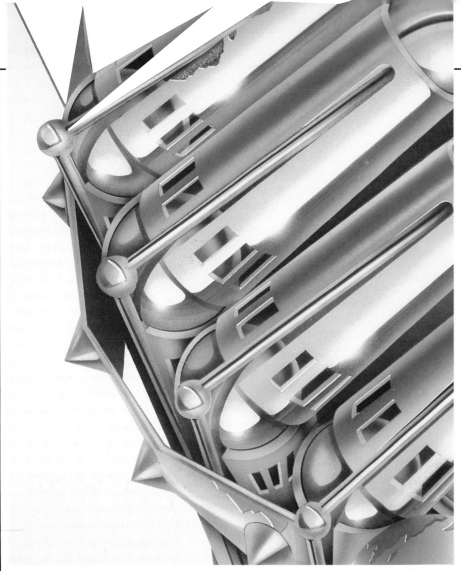

21 Since all the top surfaces of the fist reflected the sky, I sprayed them with blue gouache, fading it to pure white or gray, and being careful to match the base tones of the metal.

20 **Reflections on Shiny Steel:** The next sequence of illustrations shows how by adding sky and ground reflections you can transform a dull metallic surface into one that is slick, polished, and highly reflective.

25 Freehand spraying of permanent white along the horizon line reflection intensified the contrast; the occasional hot spot accentuated the light source.

26 The final step in detailing these edges was to hand brush thin white lines for hard reflections. When rendering shiny metals, keep hard-edged white highlights to a minimum, ideally in equal proportion to the shadow areas.

22 Here I used an acetate mask to lay in the horizon, keeping the edges semi-hard and fading the brown ground reflection out at the bottom.

23 I increased the reflections' contrast by erasing some tone along the top of the horizon's reflections. To protect the brown ground area, I used a piece of acetate as an erasing shield.

24 To further delineate the ground reflections through added texture and depth, I penciled in fine, dark lines near the horizon line.

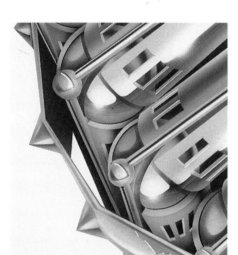

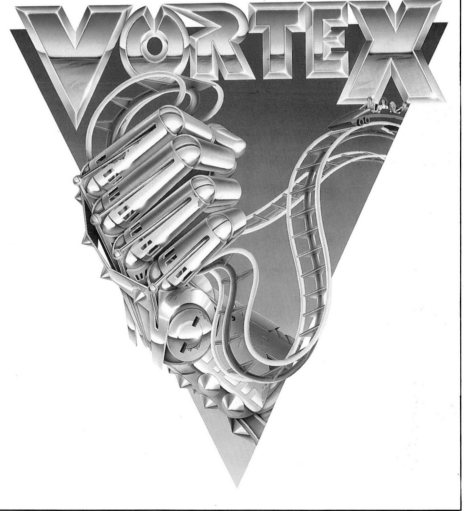

27 To see just how important these latter stages are to the overall finished rendering, imagine the fist without the glowing white highlights, the penciled-in horizon lines, or the hard-edged white highlights. Would this surface look like shiny steel?

28 Here you can see how the finished fist became a powerful element in the complete illustration.

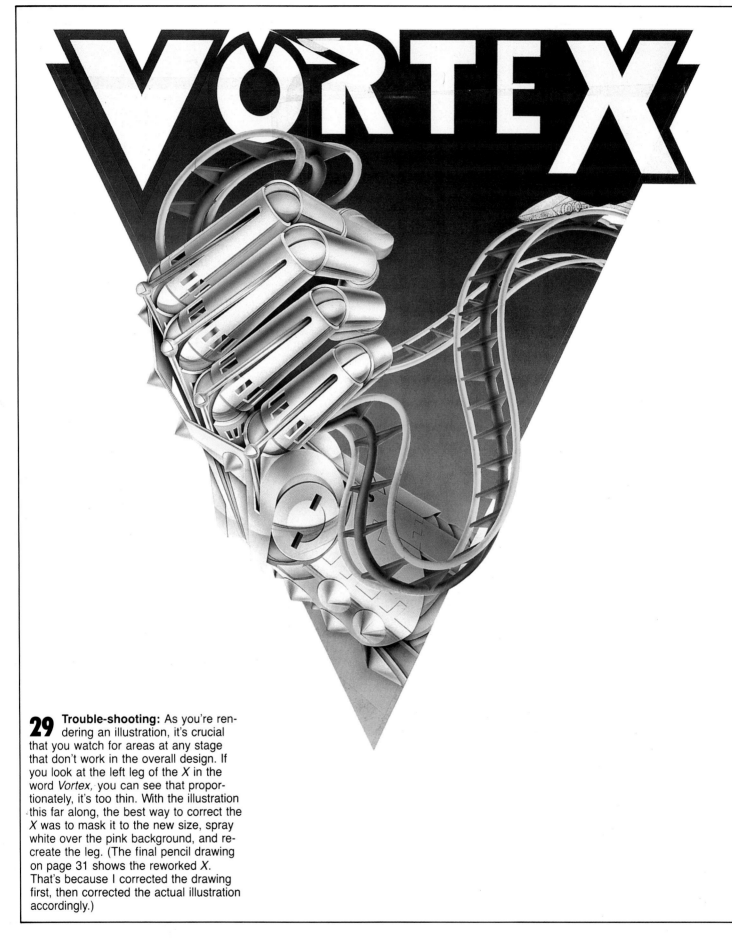

29 **Trouble-shooting:** As you're rendering an illustration, it's crucial that you watch for areas at any stage that don't work in the overall design. If you look at the left leg of the *X* in the word *Vortex,* you can see that proportionately, it's too thin. With the illustration this far along, the best way to correct the *X* was to mask it to the new size, spray white over the pink background, and re-create the leg. (The final pencil drawing on page 31 shows the reworked *X*. That's because I corrected the drawing first, then corrected the actual illustration accordingly.)

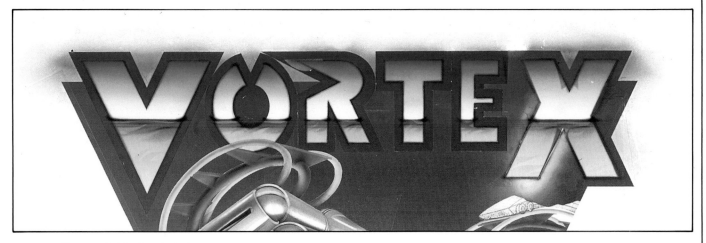

30 **Reflective Lettering:** The Vortex lettering was designed to be heavy and thick, with sharp edges and a mirror-like steel finish. Readability was critical, which is often difficult with reflective surfaces. A way to keep metallic lettering readable is to render the reflected sky and landscape very simply and cleanly. While the reflections you see here weren't included on the final pencil drawing, they were discussed at that stage with the art director.

After spraying the front surface reflections of each letter I re-covered these with the original frisket masks and pulled the frisket up from the sides. The ground and sky reflections on the side surfaces are similar to the front area, but they include reflections from adjacent letters, curved horizon lines, and background color.

In the top illustration you can see the reproportioning of the left leg of the X. In the bottom illustration, the background has been completely resprayed, and the leg is now more effective at its new size.

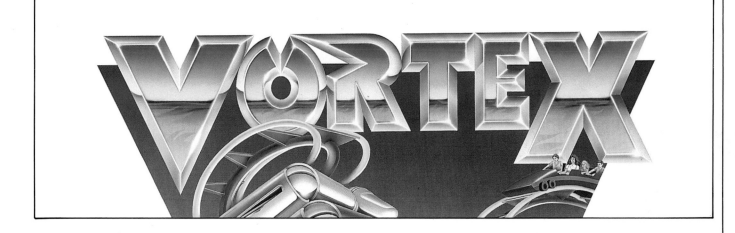

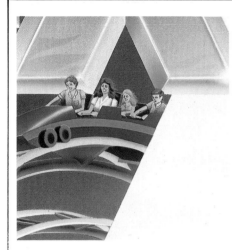

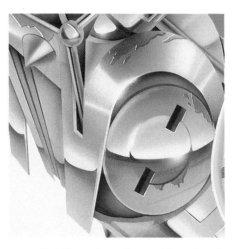

31 **Refining with Details:** Small details such as those shown in the next three illustrations are crucial in helping define the scale and in lending realism to the illustration. I painted the people last using primarily hand brush work, since they were a small element in the illustration. Their addition made the robot fist seem gigantic, giving it more force.

32 Details such as these chipped and peeling areas increase the realism and impact of the robot's fist.

33 The detail shows you how the gradation of tone in the reflections is important in defining the type's shape and weight. The thin white highlights and occasional hot spot along the leading edges add balance and shine.

34 Once the full-color illustration was completed, I generated additional Vortex artwork such as this tone art for newspaper and other print advertising. For this image I retouched a black-and-white print of the original rendering. Because a black-and-white conversion of full-color art makes the blue tones very light and the reds dark, I needed to increase the contrast and separation with airbrush and hand brush work.

35 A version of the logo was also needed that could be printed in flat colors for T-shirts, coffee mugs, and other gift items. Since the logo was to be used as small as two inches across, it needed a bold line weight.

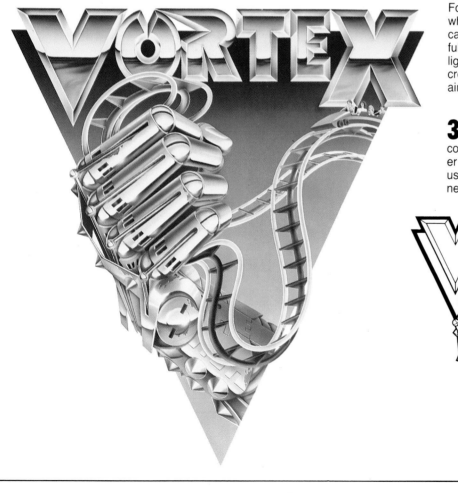

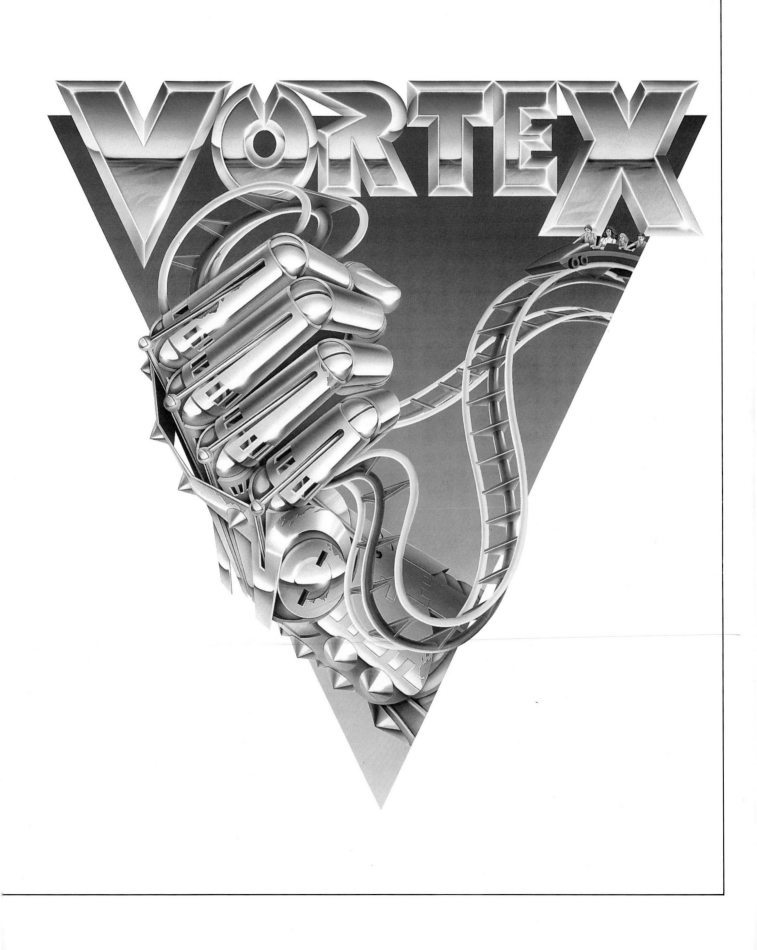

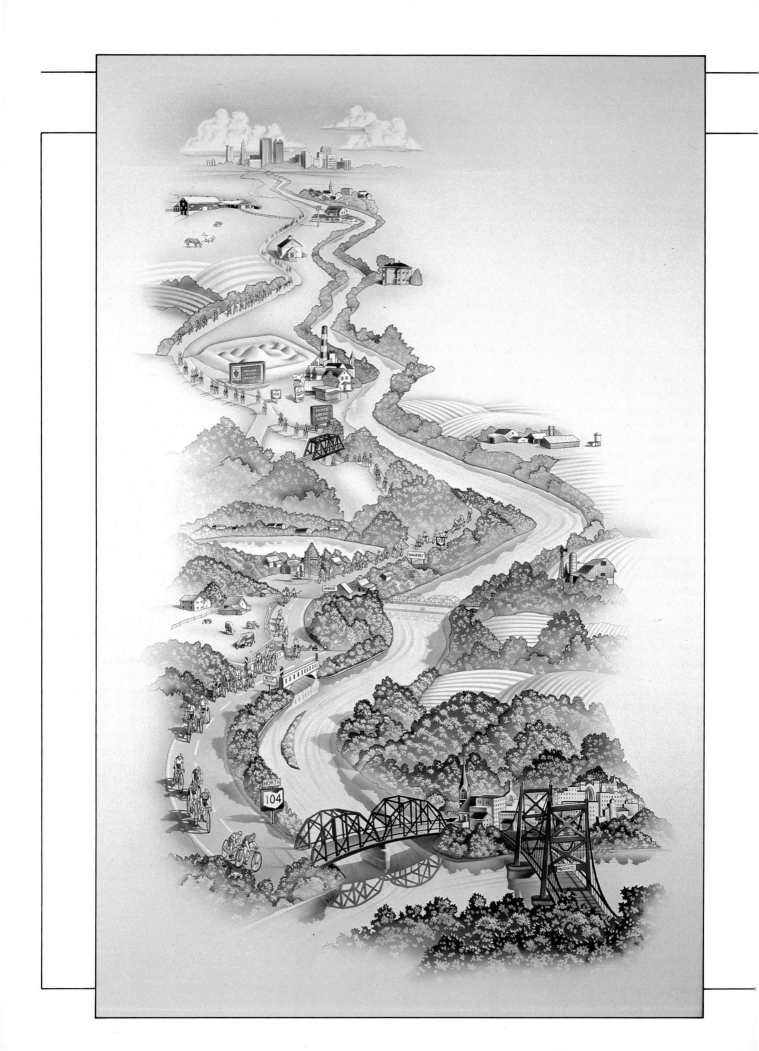

PROJECT 3

BIKE TOUR

ASSIGNMENT

Black-and-white newspaper ad for a cross-country bicycle tour

ARTIST

Jim Effler

CLIENT

Flynn Sabatino Advertising Agency; Stan Grimes, art director

This job offered a couple of challenges—both of them created by the combination of a realistic, detailed approach and an unusual point of view. The first was the problem of getting accurate reference materials; the second was the tricky perspective of the bridges and bikers along the route.

An art director with Flynn Sabatino advertising agency had seen the A Day in Eden poster (see page 19) and contacted me about doing an illustration combining cartoon and realism for a full-page black-and-white newspaper ad he was working on. It was to advertise a long-distance bike tour sponsored by the Huntington Bank from Columbus to Portsmouth, Ohio, along Route 104. This state route follows the Scioto River, a valley which has many beautiful farms and wooded areas, characteristics we wanted to emphasize in this illustration to attract bikers for the tour. His idea was to show an imaginary aerial view of the river valley with Portsmouth in the foreground at the bottom of the page and Columbus on the horizon at the top. We planned to include areas of interest in this "fantasy" portrayal of the Scioto River Valley. He provided a rough sketch of this idea. We also decided on an outline style because this would hold up better when screened to 65 lines per inch and printed in black in the newspaper.

1 **Originating Your Own References:** A map of the actual bike route was supplied by the client, along with a touring map of Route 23, which runs just on the other side of the river from Route 104. I also had a topographical map of Ohio with shaded relief as reference.

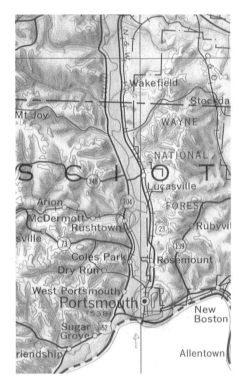

2 Since I always try to get the best reference possible, I decided to take my own aerial photographs of the river valley. Looking for references at the library would have been like looking for a needle in a haystack and would have taken a long time, especially since I was after a particular view, from the south looking north.

Unfortunately, the weather was not good the day I had scheduled the plane for these photos. I was able to fly, but since it was overcast and raining at some points I couldn't photograph clearly everything I was after. Despite that, the pictures we shot sufficed for drawing reference. For extra visual references, I also drove the route in a car to take photos I couldn't take from the plane. This might seem like a lot of unnecessary work, but in my experience starting with better references always leads to a better finished illustration.

When shooting reference photos, remember to take them from the same viewpoint as they will appear in the illustration. In this particular job, my efforts to do this made drawing the construction of the steel bridge much easier since the perspective in the photos was accurate.

Even though this particular piece was not done in a realistic style, it was still important for landmarks to be recognizable to keep the illustration from looking "wrong."

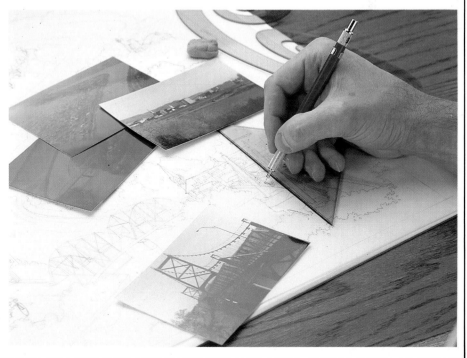

Watercolor and gouache; 14" × 23"

Courtesy of Huntington Bank

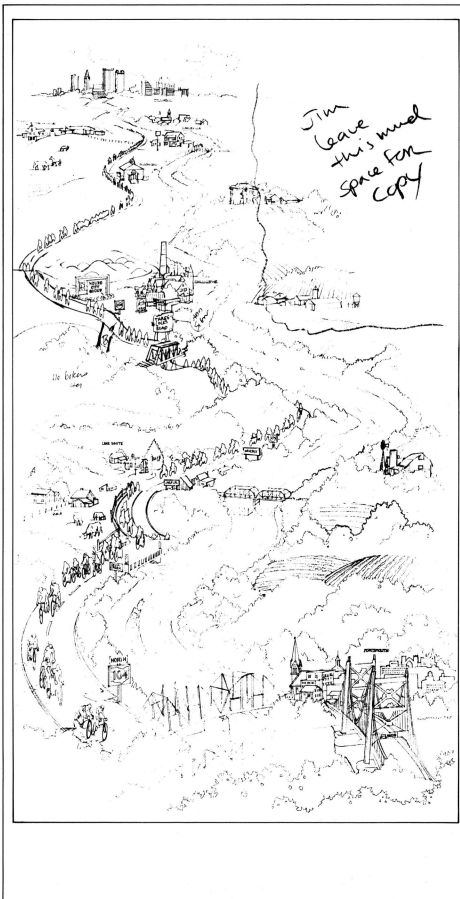

3 **The Pencil Drawing Stage:** The purpose of this pencil sketch was to establish the design, perspective, composition, and basic location of all the elements. In this case I simplified the curves in the road and the river, drew them in, and created a basic perspective. I added in the towns and other key points, drawing in only the most striking visual landmarks. Too many details would have produced an overworked drawing and made it difficult to pick out the trail of bikers. The bridges took some careful drawing to obtain the correct perspective. Notice the bridge reflection in the river—it was especially tricky because I couldn't simply flop and reverse the bridge image.

4 The second sketch, done on tracing paper on top of the first, needed to have clean, precise lines. To do this, use templates, straightedges, and French curves to achieve the perfect line. I prefer a 0.3mm mechanical pencil to get an accurate thin line. This sketch was shown to the client for final approval before I transferred it to illustration board.

The client requested a couple of changes at this point. I had to move two of the farms on the upper right to make more room for the copy and added a small portion of road and a sign that said "Three Locks Road." I sent the art director a copy of the revised sketch, then transferred the approved drawing to illustration board using graphite coated paper.

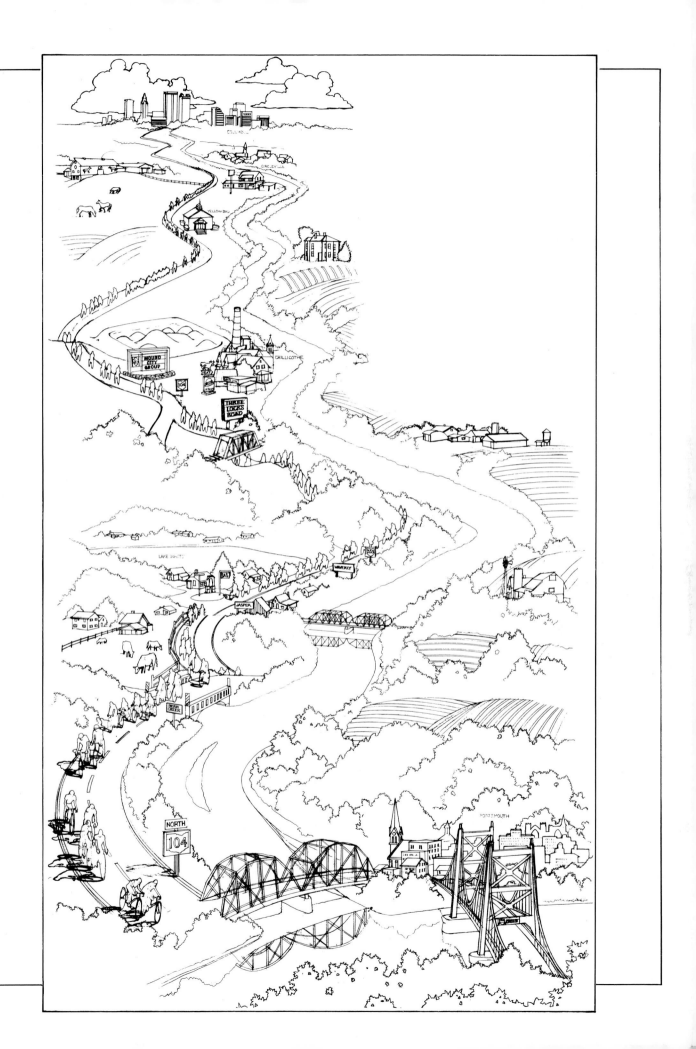

5 The next step was to put a piece of frisket film down over the entire board. A board this big (23″ × 34″) can be difficult to cover with frisket film, but this method works well.

First cut a piece of frisket film that is a couple of inches longer than your board in each direction. Peel back the protective backing paper about five or six inches and line the frisket up with one end of the board; burnish it down evenly.

Use a large plastic triangle in one hand to push down the rest of the frisket as you pull back the protective paper with your other hand at the same time. If wrinkles start to appear, stop, pull the frisket up to the point where there are no wrinkles, smooth it with the triangle edge, and then proceed again. Once it is down flat, trim the excess frisket away from the edges. It is important to get the frisket flat, otherwise it is hard to cut, and paint spray may bleed underneath the wrinkled edges.

6 **Creating Trees with Liquid Frisket:** One way to create dense foliage without cutting a lot of complicated masks is to use liquid frisket. To do that, I cut around the first couple of sections of trees that were the closest to the foreground, but peeled up the first group only. I worked the closest section first so it would be the darkest and appear closest to the viewer. When this area was exposed, I used a small nylon brush to paint down dots of liquid frisket that would be the light areas of leaves on the trees. To use this process yourself, you will need a small amount of Bestine solvent to clean your brush as the liquid frisket starts to dry.

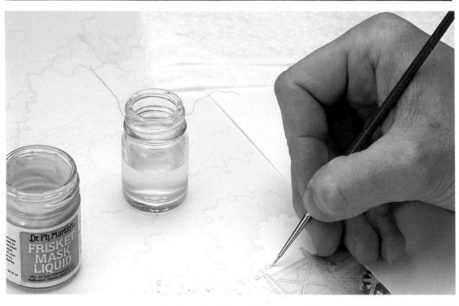

7 When all the dots are dry, you can spray the first tone on the trees. You will go back over the whole area later, so don't spray too dark now.

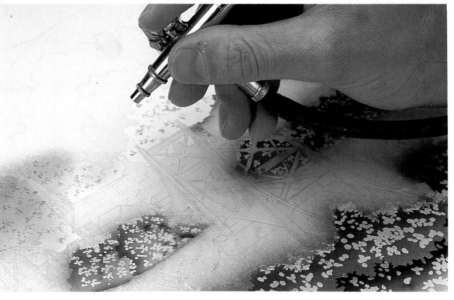

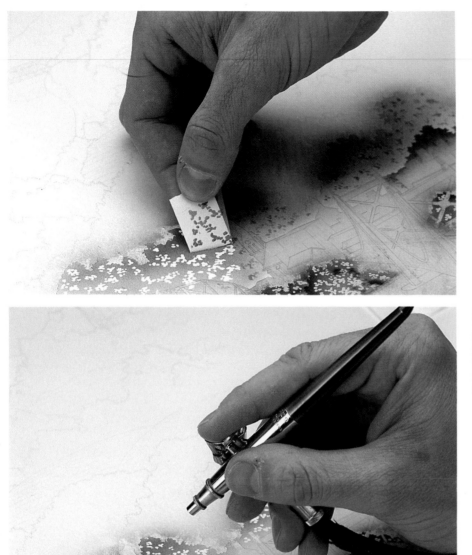

8 After the paint is dry, pick up the liquid frisket dots by burnishing white artist's tape over them, then peeling it up.

9 Now spray a second, lighter tone over the dots and the trees so the white dots will have some tone on them; this will also darken the first tone on the trees. Now do the next row of trees in the same manner and keep working your way back.

10 You can add more tree shapes by using several tree templates cut out of acetate or frisket. Place one down where you want a tree and spray dark tone around it. Move the templates around or overlap them to achieve different tree shapes.

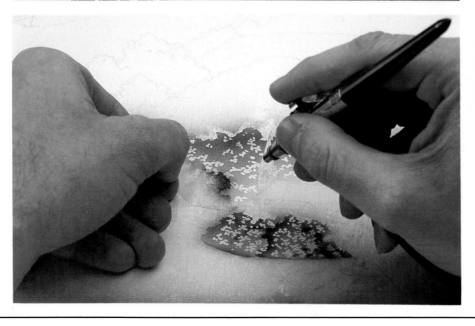

11 The next step on the trees can be done now or you might choose as I did to get some other areas of the illustration going—such as the land, road, and river, in this case. (As a general rule, I prefer to get as many areas of the piece started as possible before getting one area completely finished, unless this means you will have to cut duplicate masks.) To complete the trees, develop different leaf shapes with a hand brush, matching the lighter tones already painted. This will provide an interesting variety of dot shapes and relieve the monotony of the regular round blobs caused by the characteristic viscosity of liquid frisket.

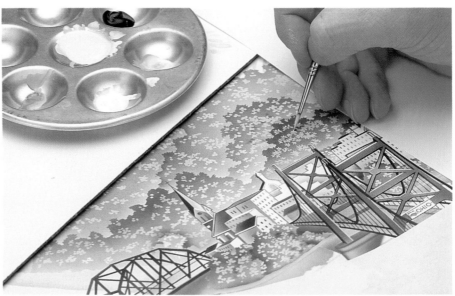

12 You should also spray a little white on the lighter areas of the trees so the value contrast will not be too sharp and prominent, detracting from other more important elements in your illustration.

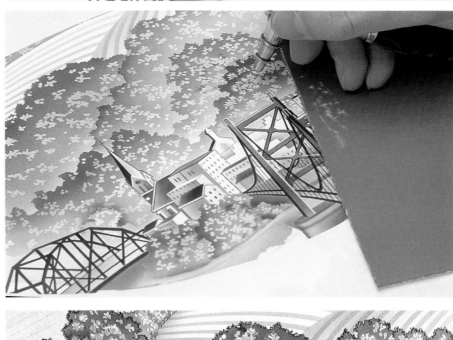

13 Because this illustration was for reproduction in a newspaper, and I needed to create distance between the clumps of trees, I went around the edges of the trees with a black colored pencil for definition. Colored pencil work should be done when the rest of the illustration is complete because any further use of frisket will pull up the colored pencil lead.

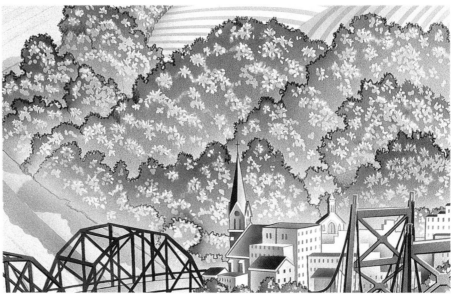

14 **Rendering Landscape:** I cut the land, road, and river out of one piece of frisket, exposing the land first. I sprayed the areas of land close to the road and faded the tone out. For the farm fields, I cut one curved strip out of acetate, placed that over the field (which was masked at the edges with the frisket film), sprayed through this, and then moved it to spray the next row. Next, I pulled up the frisket covering the road and sprayed it, so that the land (which was still exposed) got darker with the road.

15 Now I uncovered the river and sprayed a light tone over it. Also, I cut some lines out of acetate that followed the flow of the river, and used this to spray some darker ripple-like lines in the water. You can use an eraser such as a pink pearl to make some light ripples in water.

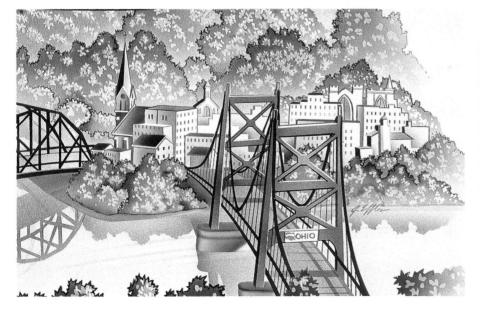

16 Next, I moved on to the buildings, bridges, and other objects on the landscape. When you're developing buildings or bridges, spray the shadowed side first to define the shape, then unless the object is white, spray a light tone over its lighter side. To define more clearly the shapes of each building, I chose to outline each one in dark gray with a hand brush rather than black colored pencil, because the pencil effect was too soft. The brush line yielded a harder edge that was more appropriate for buildings.

WINDOW MASKING TECHNIQUE

The technique I used for the building windows in this illustration can come in handy. First, cut parallel bars out of two pieces of acetate. Then mask off the face of the building and lay one mask down so that the cut-out bars run parallel to the side of the building. Lay the second mask down parallel to the roof and ground line of the building. Spray through this and your windows are finished. You can use the same masks on buildings of different angles because you can change the angle of the two acetate masks to fit the building's specific planes.

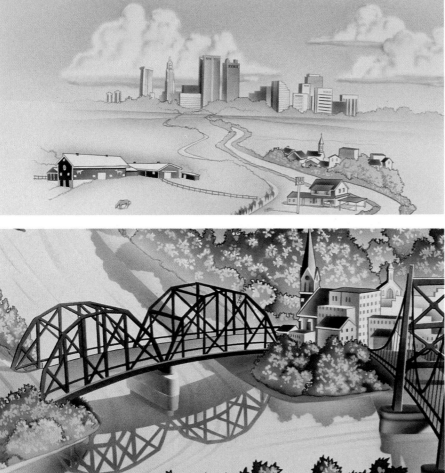

17 **Finishing Touches:** To do the sky, I first masked out the buildings, lands, and clouds. Then I sprayed about a 20 percent gray for the sky tone. I exposed the clouds, then shaped them with gray and softened the edges with white.

In designing this project, I made sure that the Huntington Center was the tallest building on the Columbus skyline so it would show up well since Huntington Bank was sponsoring the bike tour.

18 I painted the bridge using both airbrush and hand brush and then added the reflection in the river. The reflection is very important because it creates the feeling of water.

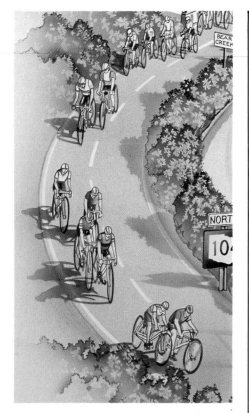

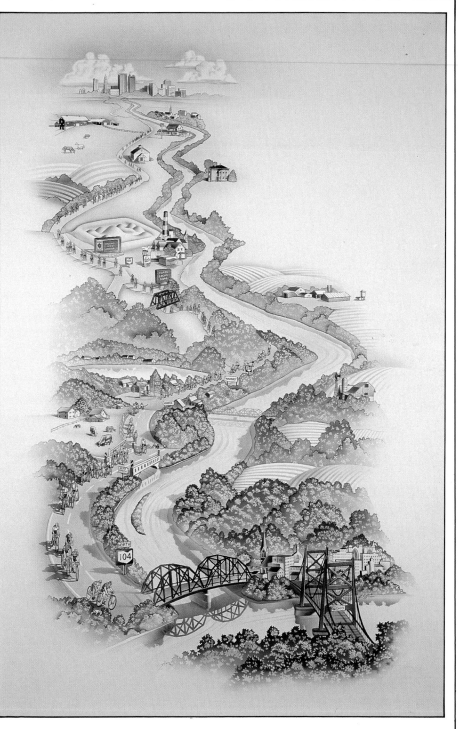

19 I handled the bike riders in the lower portion of the illustration by first painting a gray outline defining the outside edges and internal shapes within the figure. Then I filled them in with a hand brush using different tones of gray. For the bikers in the upper half of the illustration I cut several different size silhouettes and just re-used the shapes to create a group of bike riders. You can add some simple definition to distant figures like these with hand brush work. I used acetate masks for the shadows of the bikers, buildings, signs, and trees.

20 All that's left to do is sign it and it's ready to deliver! About 4,600 cyclists from forty-four states and several foreign countries turned out for this twenty-fifth annual bike tour of the Scioto River Valley. It was a two-day, 210-mile trip from Columbus to Portsmouth and back again.

PROJECT 4

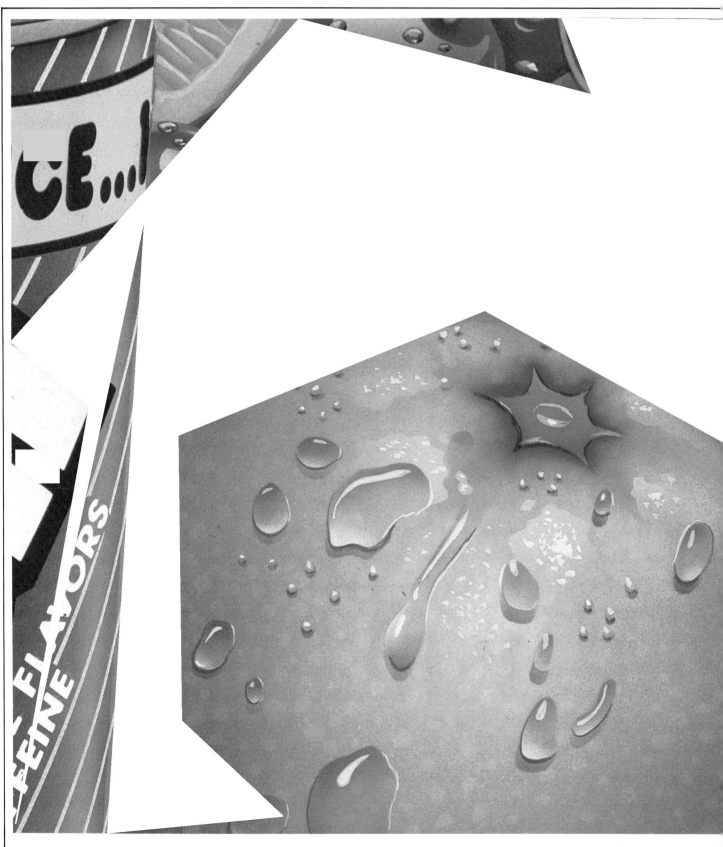

Gouache and dye; 22″×27″

CRUSH SODA DISPLAY

Courtesy of the Procter & Gamble Company

ASSIGNMENT
In-store display promoting the addition of fruit juice to the Crush soft drink line

ARTIST
Dave Miller

CLIENT
Campbell Art Studio & Associates, Inc.; Tom Hutchinson, art director

A SYSTEMATIC APPROACH TO A COMPLEX JOB

This in-store display for Procter & Gamble's Crush soft drinks required a lot of planning and an organized, systematic approach. Not only was it a complex job, given the dozens of small elements like grapes and cherries, but I also had only one week to complete the piece. By knowing the exact order in which I planned to do the elements, I saved time that later could be spent embellishing certain parts of the illustration, such as the fruit, which I wanted to exaggerate and idealize by playing up the pulp of the orange slices and the strawberry seeds.

By the time a drawing is approved I usually have a mental plan of how I will approach the actual painting of the illustration—whether I'll lay a base tone down first or perhaps do the background first. By "walking" through your painting process in advance you can usually anticipate problems, such as areas that may demand stronger contrast or color separation.

This illustration was to be used in stores nationwide to promote the addition of 10 percent real fruit juice to the Crush line of sodas. Earlier, I'd done a nearly identical illustration for P & G when the company first test-marketed four of these juice flavors. With the success of the four, they added two additional flavors, and needed the illustration redone with all six flavors.

Campbell's art director wanted

the six products to be featured in a setting of fruit that represented the actual juice flavors of the soda. The fruit was a challenge to render. It had to be very vibrant and attention-getting, since it would be the main focus of the illustration. The fruit colors were to be bold and bright—Pantone colors that matched the colors on the soda cans—with water droplets added to indicate freshness. The background of the piece had to be minimized so as not to compete with the foreground, even though there would be type printed on the background.

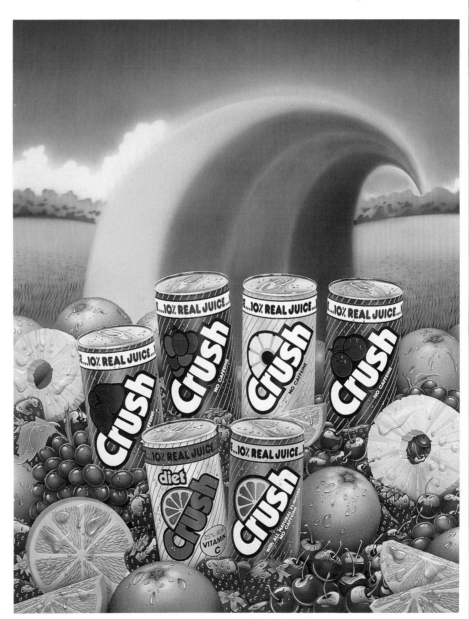

1 **The Sketch:** The first step in this illustration was to draw up a pencil sketch to working size, 22″ × 27″. The actual art would be used a bit larger in some cases but I felt working larger than this would be awkward. The finished sketch was arrived at after several revisions requested by the client. It's best if you finalize all changes on a drawing before you start on the final art, as it is often difficult, if not impossible, to change an area that has been rendered. (This was especially true for this job, where in order to make the colors brilliant I built them up through transparent layers of tints. To make a change to this type color development, you have to completely cover the paint with white and start over.)

I decided to transfer the drawing by the lead pickup method, going with this method instead of carbon tracing to save time. Also, most of the illustration would be defined with fairly hard edges, which can be best obtained with frisket film. Only the background required soft edges—to increase the depth—so I used acetate masks there. I used an ellipse template to cut out the grapes. (Note: In a complex illustration such as this it's helpful to place the frisket pieces you remove onto the original tracing in their proper position so they can be found and replaced easily.)

VIBRANT FRUIT

I've re-created a cherry, strawberry, grape, and orange slice in the following sequence so you can see exactly how they were rendered for the Crush illustration. The first step for each fruit, as I mentioned earlier, was to transfer the designs by the lead pickup method to the board, cut out the shapes, and remove and save the masks from the first areas to be sprayed. In the actual illustration I rendered the strawberries first, then the cherries and orange slices. At that point I hadn't decided how to handle the orange peel, so I did the grapes and pineapple slices next. With this much fruit, I found it easier to concentrate on one kind at a time. In the demonstration, however, I've done four kinds of fruit at once so that you can see how each was developed.

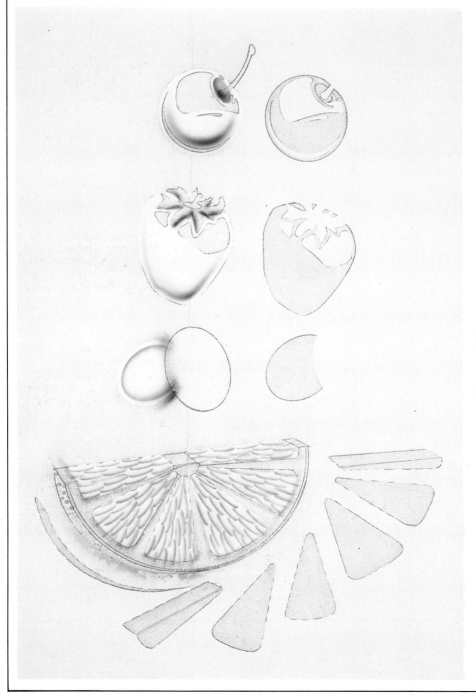

CHERRY

2A The shadow areas of the cherry were sprayed first with Marabu's gloss reddish. (I selected this color, which is sold in cakes, because it's very finely ground, resulting in a smoother spray. The color is transparent yet capable of very dark density build-up.)

STRAWBERRY

2B The shadow areas on the strawberry were sprayed with the same reddish color. (A way to save time on an involved project such as this Crush illustration is to uncover and spray all the same color areas at one time.)

GRAPES

2C I sprayed the reddish color for the grape's darkest inner tone through a small diameter ellipse template, moving the template to create a soft edge.

ORANGE SLICE

2D To create the shadowed portion of the orange pulp, I repeatedly sprayed Winsor & Newton's carthamus pink gouache along one edge of an ellipse-shaped template. (I used a 9mm ellipse with a curve of 10 degrees, and covered the other ellipses on the template with tape to make sure no overspray hit the board through those openings.) To create the difficult texture of the orange peel, I applied small drops of liquid frisket, over which I sprayed a light tint of the same pink.

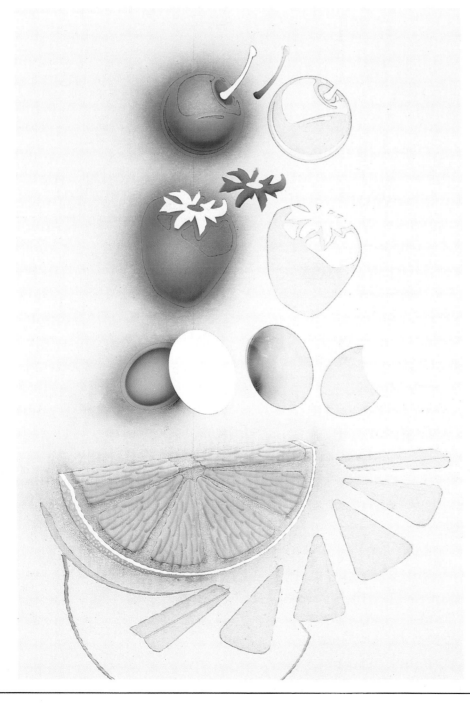

CHERRY

3A With the highlights still covered, I sprayed carthamus pink, concentrating on the shadow areas. The next step was to remove the stem frisket in preparation for spraying.

STRAWBERRY

3B Again, this stage was identical to that of the cherry with the exception that the paint was applied thinner in the center area to emphasize the strawberry's form. The leaf mask was then removed.

GRAPES

3C First a light tint of pink was sprayed around the larger ellipse, then ultramarine blue was sprayed within the smaller one; both colors were faded into the center.

ORANGE SLICE

3D Yellow dye was sprayed over the same areas that were uncovered in the first step; note that the liquid frisket was removed before I sprayed the yellow. In preparation for the next step I also uncovered the peel thickness.

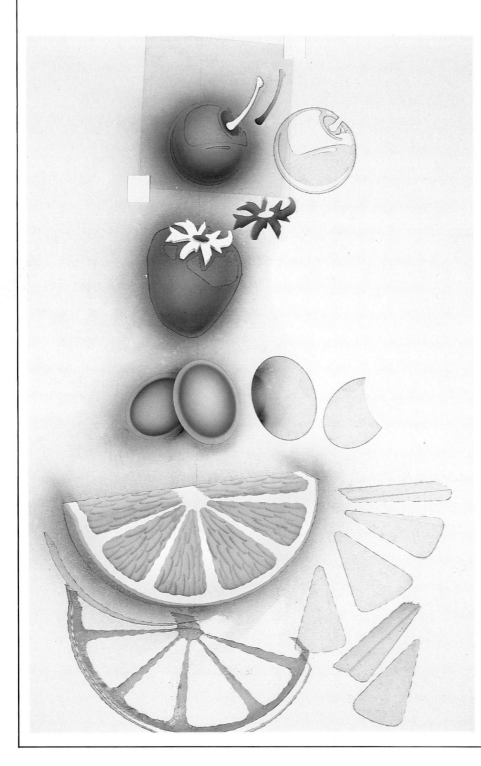

CHERRY

4A Before spraying the stem, I cut an acetate mask to cover the cherry, rather than replacing the original frisket, because this was faster and easier to position. I then sprayed ultramarine blue just along the edges of the stem which would serve as the base for dark outlining to be added later.

STRAWBERRY

4B For this step of the strawberry I replaced the original frisket film slightly off register and sprayed some ultramarine blue to give the leaf dimension. I then removed this mask completely.

GRAPES

4C The first two steps were repeated on the foreground grape. The background grape was left uncovered so that the overspray would increase its density.

ORANGE SLICE

4D I sprayed a light pink tint over the entire slice, before removing the mask from the orange section dividers and spraying light yellow dye over the entire surface of the orange slice. The dye adds color but not opacity.

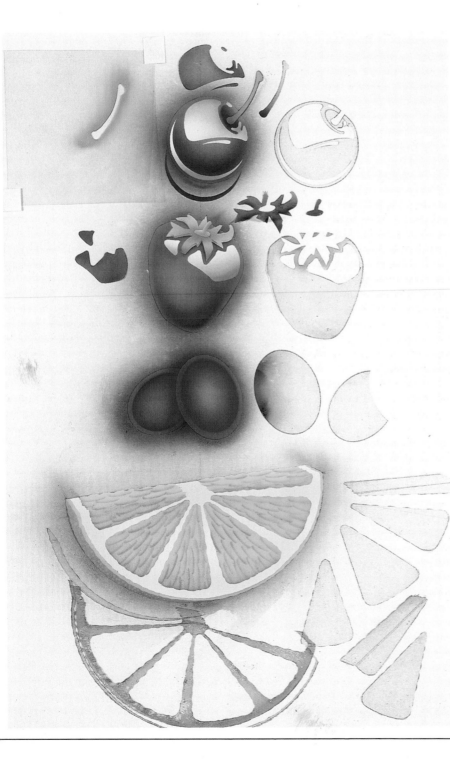

CHERRY

5A After the stem was sprayed permanent green light, friskets were removed from the highlighted areas. Pink was sprayed on the lower, crescent-shaped highlight and around the base of the stem to soften the edges and add form.

STRAWBERRY

5B Before removing the highlight mask I sprayed the same green over the leaf and stem. Note that the tone was gradated to give this area shadow and form. The highlights were sprayed in the same way as the cherry above.

GRAPES

5C Winsor & Newton's bengal rose gouache was sprayed over both grapes, still avoiding the centers where I wanted soft highlighting.

ORANGE SLICE

5D A final thin overall tint of spectrum yellow gouache added more color saturation, and resulted in the combination of bright orange and light yellow orange I wanted.

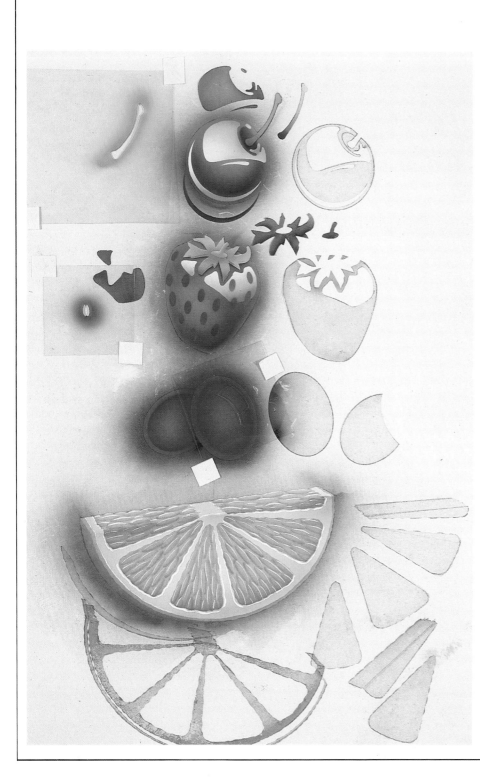

CHERRY

6A At this point in the development of the other fruit, the cherry remains unchanged.

STRAWBERRY

6B To make the indentations in the strawberry where the seeds would be rendered, I cut a single, small ellipse out of .003mm acetate. I sprayed rose carthamus gouache in a random pattern over the berry, making the spots darker when they fell in the shadow area.

GRAPES

6C Ultramarine blue was sprayed thinly over both grapes, giving them their final color. I cut a mask out of .003mm acetate and placed it over the foreground grape to prepare for spraying the hard-edged but gradated white highlight.

ORANGE SLICE

6D Permanent white was painted with a no. 00 sable brush onto the top highlighted edges of the pulp. (Remember that the highlights and shadows areas of texture detailing, such as this, should be consistent with the direction of light in the rest of the illustration.)

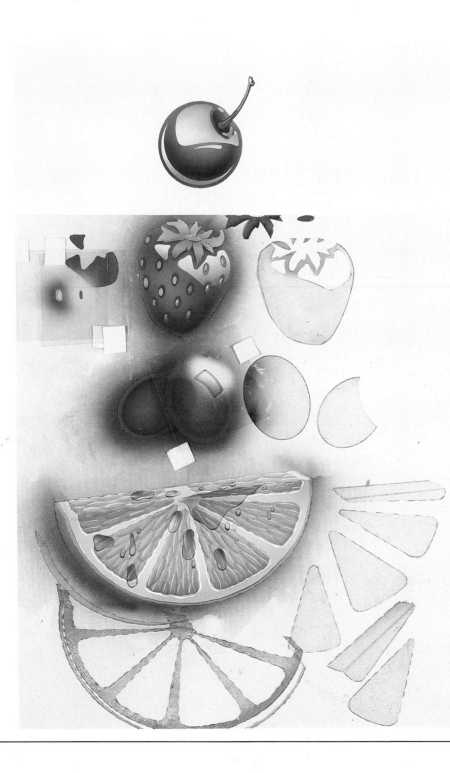

CHERRY

7A All the frisket has been removed; using a sable brush, I added dark outlining to the stem and two white spot highlights to the stem and cherry.

STRAWBERRY

7B I cut a smaller ellipse from acetate and sprayed cadmium primrose (yellow) through this mask, which was placed directly on top of the red indentations. I then began adding detailing to define the seeds. I first outlined the yellow portion with brown using a hand brush, then painted a lighter tan on top of the brown. The last step was to add the tiny white highlight to the top of each seed. Some brown detailing was also added to the leaf and stem.

GRAPES

7C I sprayed permanent white through the highlight mask, concentrating the pigment at the top of the opening and gradating it downward. I repeated this step on the second grape by simply flopping the mask. You can see this highlight in the next step.

ORANGE SLICE

7D I added the water droplets to the orange slice by first hand brushing their general outlines using rose carthamus. I then cut acetate masks to fit these shapes and sprayed the same color lightly, increasing the density around the tops of the mask openings to give shape and translucency to the droplets.

CHERRY

8A The small water droplets were painted entirely with a hand brush using the same colors as the surface they're on. Their outlines were painted first, then the shadows were added, and finally the white highlights.

STRAWBERRY

8B I completed the seeds, and applied the water droplets in the same way as the cherry. The mask surrounding the berry was then removed.

GRAPES

8C I again used an ellipse to cut two thin crescent shapes out of acetate for the base highlights. To emphasize the grapes' form, I concentrated the highlights' spray in the center of each mask and faded the pigment out to the ends.

ORANGE SLICE

8D The broad highlight on the largest water droplet was gradated. To create it, I sprayed permanent white through an acetate mask placed on the board surface.

CHERRY

9A Additional water droplets were added to establish a link between this cherry and the strawberry.

STRAWBERRY

9B To give credibility to the grapes' water droplets, I added a few more to the strawberry.

GRAPES

9C After removing all masks I outlined the water droplets on the grapes by hand with ultramarine blue before adding the white highlights.

ORANGE SLICE

9D The long, opaque white highlights were added to the smaller water droplets using a sable brush and opaque white. This simple step gives the droplets their reflectivity.

GRAPES

10A Not wanting to lose the continuity of the water dripping from fruit to fruit I added more droplets to the grapes.

ORANGE SLICE

10B After the masking was removed, I added the yellow-orange shadow beneath the orange slice, water droplets on the ground surface, and dark shadowing directly beneath the orange slice.

11 **Procedure:** In the actual illustration, the strawberries were rendered first, then the cherries and orange slices. Where there were berries or cherries next to each other I exposed and sprayed the fruit that was farthest from the foreground. By rendering the back piece of fruit first you can achieve depth; the fruits closest to the foreground have the brightest colors and highlights. Before I began the orange slices, I made sure that all the friskets were replaced over the cherries and strawberries to protect them from overspray. (New frisket can be cut to fit these finished areas if that is easier than finding all the original pieces and replacing them.)

The texture on the orange peel was the hardest to simulate and at this point I didn't have a satisfactory solution so I moved on to the grapes.

12 The approach to the grapes was similar to the berries in that I removed the grapes in succession, working from back to front, defining shape and separation as I went. (This is a good instance of when it is more convenient to replace the original frisket pieces than to cut new ones since there are so many pieces and their shapes so exact.)

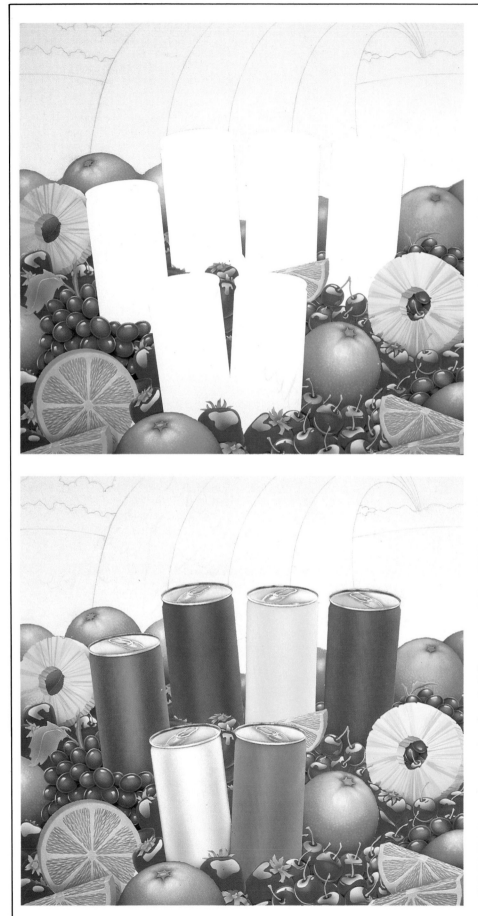

13 The pineapple slices were rendered in basically two colors. A light tint of orange sprayed through several wedge-shaped acetate masks created the look I needed to define the form. I moved the mask frequently, holding it down on the board by hand and varying the density of the tint. I repeated the procedure with spectrum yellow and the pineapple slices were finished.

Having thought about the orange peel a little more, I decided to create subtle texture by first covering the surface of the area with small drops of liquid frisket, as described in the demonstration on page 58.

14 **Soft Drink Cans:** With all the fruit rendered, I turned my attention to the cans. Each can color was matched to the actual product. The cylindrical shape was simply rendered by two solid color bands running vertically, fading out in the highlight area, and into solid color again. Where cans were placed side by side, a light spray of color from the opposite can into the highlight helped give the sense of color reflectivity, such as the magenta that appears to be reflected in the left side of the purple can. The tops of the cans, being shiny metal, also would reflect the colors that surrounded them and were rendered this way even though I hadn't illustrated the background yet.

The pull tab and rim of the tops were defined easily with a hand-held acetate mask that was cut to define the shadow areas mostly. Interestingly, the same mask worked on all the tops and was flopped to change direction of the pull tabs on some of the cans.

The completed foreground was then covered with acetate before I began working on the background.

15 **Rainbow:** The rainbow colors were also determined by the product colors and were used at full strength. The blending between the colors was the most difficult task in completing the rainbow. The rainbow had to be rendered freehand in order to create the soft, blended transition of color. Curved acetate masks were used initially to establish the base shape of each color. As you move masks like these back and forth on the board to avoid hard edges, you must spray each color very close to the board and *away* from the color next to it to avoid overspray that could alter the pureness of the adjacent color. I found it best to work from light to dark so any overspray would be a darker color than the surface where it landed. This enhanced the blending effect.

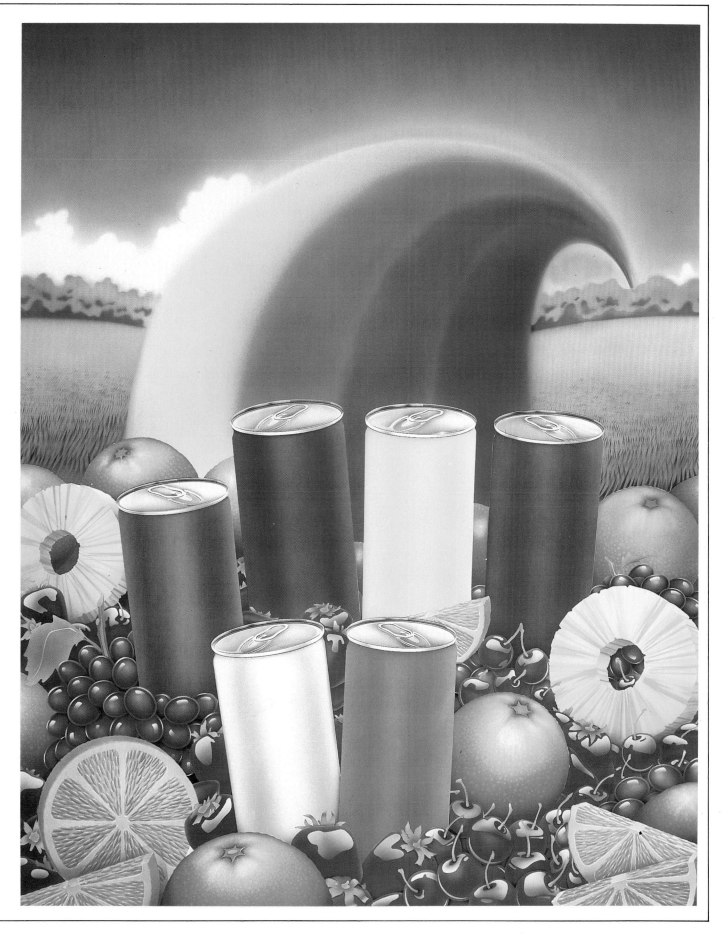

16 **Grass and Trees:** The grass and the tree line were rendered so that the large blades of grass are fairly hard-edged and the tree line is soft. By cutting acetate masks for each successively smaller size of grass blade, I created a lot of depth in the illustration's background. Using permanent green dark, I sprayed the tips of the grass blades and faded out towards the bottom of the blade. It's best to work from the biggest grass blades to the smallest with the smallest gradating to a soft yellow green at the tree line. The tree line was easily accomplished by using two acetate masks, one for the shadow areas and the other for the light areas. Again the soft edges came from moving the acetate slightly back and forth as I sprayed.

I cut an acetate mask that would create the clouds when the sky was sprayed, while covering the rainbow and horizon. Ultramarine blue was used for the sky gradating the color from dark at the top to light at the horizon. Again, I moved the mask as I sprayed to keep the edges of the clouds and rainbow soft.

17 All the type and graphics on the cans were accomplished with dry transfer lettering that was produced and applied to the art by another studio. (See page 82 for more on dry transfer.) Below you can see the black-and-white Kodalith perspective shots of the actual product from which the transfers were pulled. This method is especially useful in commercial illustration because of the crisp definition it gives the type. Since the transfers produce only flat color, a little tone sprayed over the type's shadow areas helped to give form to the cans.

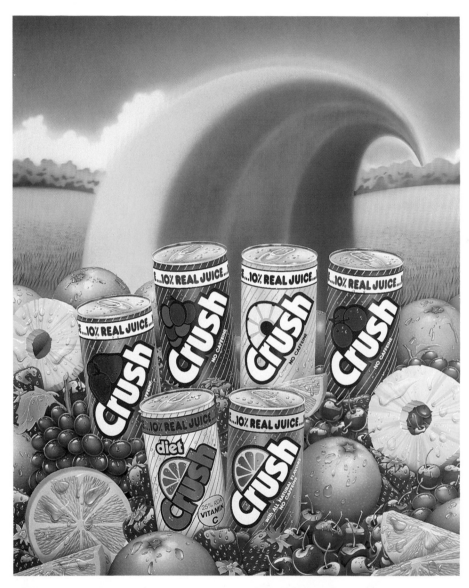

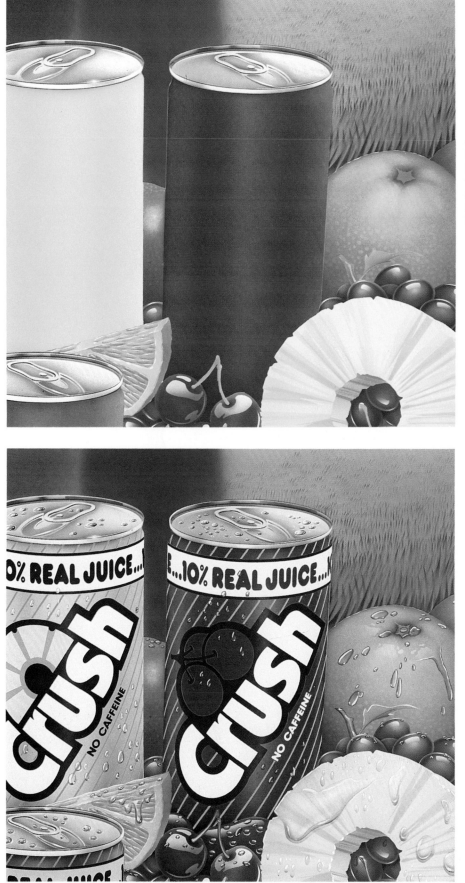

18 Removing all the masks from the fruit, I completed the detailing including the strawberry seeds, some hand brush work on the stems, small white highlights, and water droplets. Compare the finished illustration at bottom with the earlier stage shown at left to see how much life these details add to the illustration.

PROJECT 5

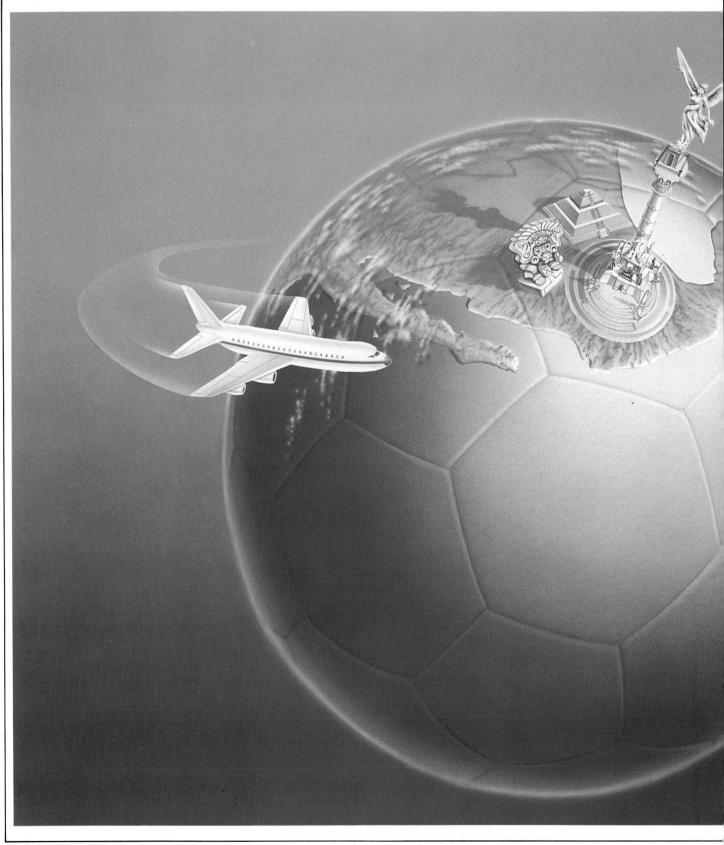

Gouache and watercolor; 20″ × 22″

SOCCER WORLD

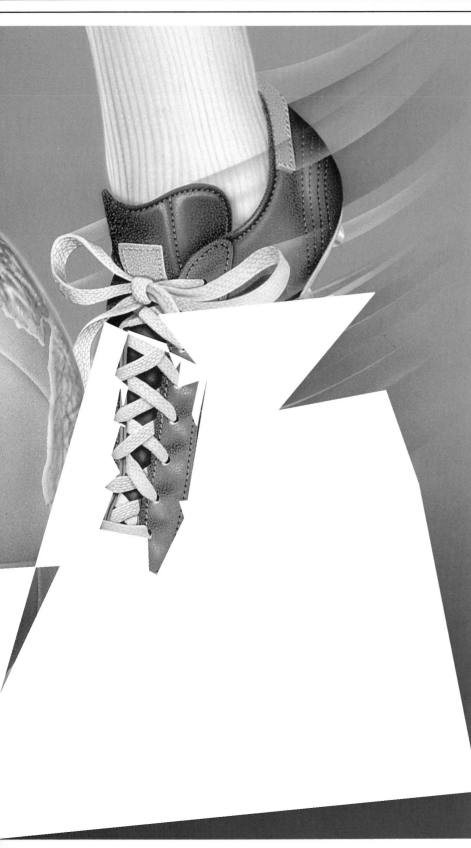

ASSIGNMENT
Poster promoting a sweepstakes in which the prize was a trip to the World Cup soccer tournament

ARTIST
Jim Effler

CLIENT
Campbell Art Studio & Associates, Inc.; Tom Hutchinson, art director

This illustration demonstrates how you can manipulate the elements in an illustration without a lot of redrawing. By sketching each item separately, I was able to move or alter one item without affecting all the others.

The illustration was used to promote a sweepstakes sponsored by Pepto-Bismol in Mexico. The sweepstakes prize was a trip to Mexico City for the World Cup soccer tournament. In doing this project, I used an interesting method to achieve the look of leather without having to render the texture by hand—by using dry transfer sheets instead.

1 **The Concept:** As with most commercial projects, this one began with a rough compositional layout from our client. Although this layout was very rough, it served its purpose in communicating to me what the art director had in mind and it also established the basic size and position of the objects. The art director specifically wanted a foot clad in a soccer shoe, kicking a soccer ball rendered to look like the world. Because of the nature of the advertisement, the country of Mexico and certain identifiable landmarks had to be incorporated.

2 The first step was to gather references for the pencil sketch. I used an ordinary exercise shoe for the photo reference shots of the foot and took a side view and a three-quarters front view. I knew I would need a soccer shoe for detail reference eventually, but it wasn't necessary at this stage because I was just concerned with composing the objects in the picture.

3 I decided that the three-quarters front view of the foot was better for this illustration than the side view because it fit the design better. I drew the shoestrings flying back to indicate the forward motion of the foot.

4 The client supplied me with soccer balls and books that contained photos of landmarks in Mexico that they wanted included in the poster. I used an actual globe to draw the country of Mexico and a photo of one of the soccer balls for the form of the world; the jet was drawn from my imagination.

Each object was drawn separately and to the size that it would be used in the final illustration. I laid the drawing of Mexico over the tracing of the soccer ball and rotated it to a position where the patches on the ball interfered as little as possible with the shape of the country. Then I combined these two drawings onto one tracing.

5 After I completed the individual sketches of the airplane and monument, I traced all the elements together and completed the first pencil drawing, which I then took to show the client.

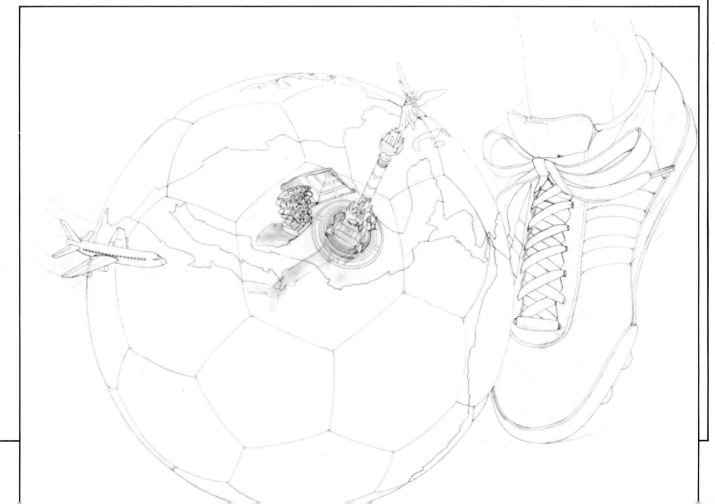

6 The client took my drawing and put together a layout to see how the illustration and type would work together. We made a few changes. In order to keep the type from overlapping the top of the monument and part of Mexico, I had to redraw the land mass so that it was sitting up higher on the soccer ball. I also changed the positions of the patches on the ball by rotating the same ball tracing underneath the new drawing of Mexico again until it was in a position where the patches interfered least with the shape of the land.

I shortened the monument about three-eighths of an inch so that it wouldn't get cropped off at the top of the poster. (On the final printed piece it ended up only an eighth of an inch away from the top edge.) I redrew the plane of the pyramid and the idol so that they appeared firmly seated on Mexico in its new position.

7 The client also wanted the jet to be larger so I redrew this. Finally we decided to add some clouds to give a little extra interest to the land and sea.

8 I bought some soccer shoes and photographed one of them in the exact position in which it would appear in the illustration. (You can see the drawing based on those photos at right.)

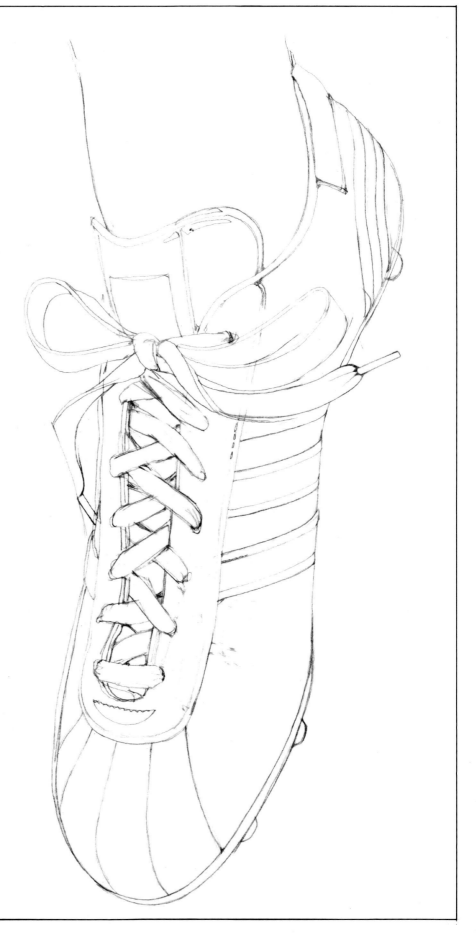

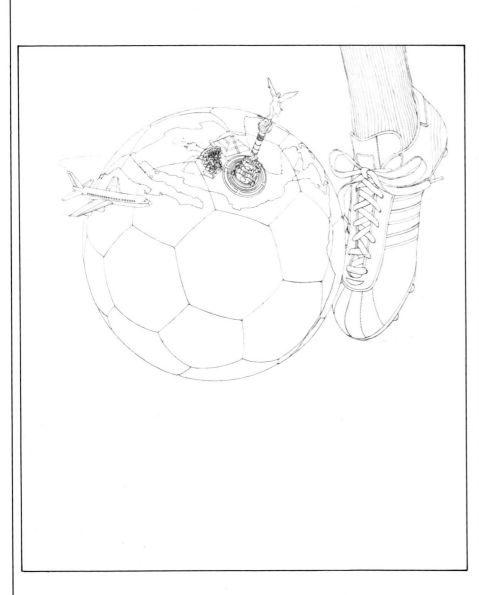

9 Finally I put together the complete pencil layout, which was approved, and set about starting the airbrush illustration.

10 After transferring my pencil sketch from the tracing paper to the illustration board, I masked out the foot, world, plane, and statue in order to spray the background first. With a background that is as dark as this one, it is better to spray it in before you start working on the objects. If you paint the objects first, you will paint them so that they look right against a white background. Then when you put in a dark background, the objects will look too light and it will take a lot of extra work to go back and darken all the objects.

The next area I worked on was the ocean. I made a non-adhesive, protective mask to protect the painted background, leaving only the world and a quarter of an inch gap around it exposed. This extra quarter of an inch provides enough space around the world for the frisket that will cover the land mass to stick to. You can use .003mm acetate for a protective mask such as the one used here, or, to cut expenses on large illustrations, use a combination of frisket for the area right next to the illustration and cheap wrapping paper for the remaining area.

After cutting the frisket mask to leave only the ocean exposed, I sprayed it, keeping in mind the direction of the light source on the sphere and creating shadows and a highlight to give it credible form.

11 **Soccer Ball Patches:** The next step was to achieve realistic soccer-ball patches on the globe. I left the frisket covering the land in place for this entire process. First, I taped a piece of acetate over the entire area and cut out as many patches as I could, without cutting patches that were directly next to one another. I needed four different acetate masks to incorporate all the patches without having any two adjacent patches on the same mask. With tape, I hinged one acetate mask to the top of the illustration board, one to the bottom, and one off to each side. With only one of these masks on the art at a time, I then sprayed the dark edge of each patch. After doing all the patches on one mask I moved on to the next mask until all the patches were complete. I used the same masks and an artist's kneaded eraser to lift out the highlights along the edges that faced the light source. I saved these four acetate masks and then pulled up the frisket mask.

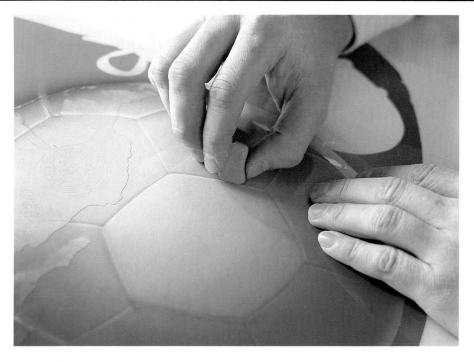

12 Now I laid a new piece of frisket over the globe, leaving in place the acetate that protected the background. I exposed the land masses and sprayed them in varying colors to indicate desert and greener areas. Next I sprayed the mountains. (It is sometimes a good idea to use watercolors rather than gouache when spraying small detail work because it flows more smoothly in the airbrush.)

After putting in the mountains, I used the same four acetate masks to shape the ball's patches on the land just as I had done on the ocean. Then I removed the acetate masks and the frisket. I sprayed the clouds and their shadows without using a mask, but kept the background protector in position. Next I removed this protector and sprayed in the light atmospheric layer around the globe.

To complete the plane, temple, idol, and statue, I simply sprayed in the basic tones and added in the detail work with a no. 0 sable brush.

Notice how the highlighted edges of the patches facing the light source give a realistic, three-dimensional quality to the surface of the soccer ball.

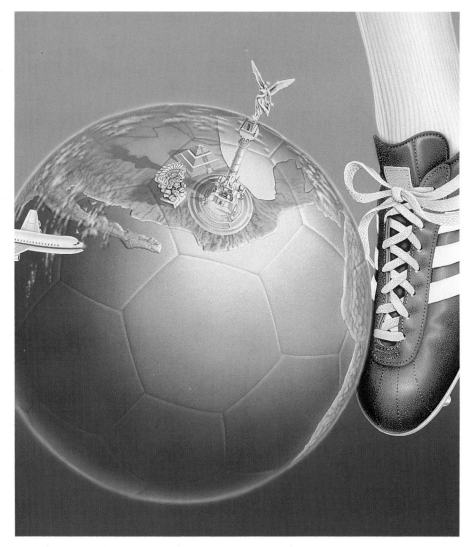

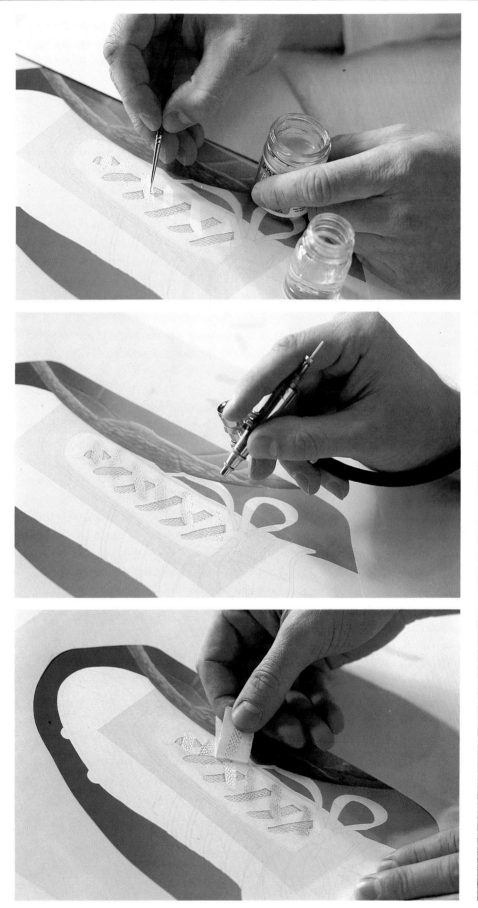

13 **Shoelaces:** The last object I painted was the shoe. First I cut a new protective sheet out of paper and acetate as before, this time leaving only the shoe area exposed. I started with the shoestrings. I left exposed areas of the shoestrings that were not directly touching each other. Then I painted liquid frisket on the board with a no. 000 brush to mask out the light areas of threads on each lace.

14 I made sure the liquid frisket was dry before spraying the darker tone of the shoestrings a bluish-gray color.

15 After the paint was dry, I burnished low-tack tape with medium pressure onto the liquid frisket area, then peeled it up. When you try this remember that if you have sprayed a lot of paint on top of the frisket you may have to very carefully nick the tiny lumps with a point of a knife blade before positioning the tape; this creates a rough spot that the tape can adhere to. I repeated this procedure for the rest of the shoestrings, adding tone after the texture was done.

16 You can see the final shoelace texture below.

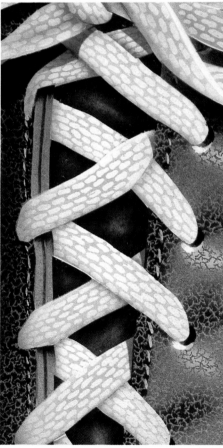

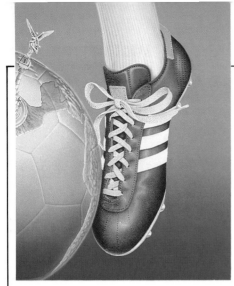

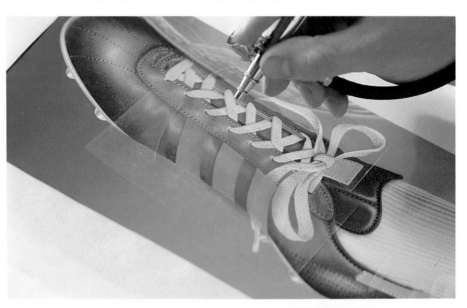

17 **Shoe Leather:** The leather texture of the shoe is probably the most interesting aspect of this illustration. I airbrushed the black leather first and then the yellow.

18 I saved the red leather for this demonstration because I thought it would be easier to see. (The black and yellow were done in the same way as the red.) I cut the frisket so that the areas to be red stripes were exposed, and sprayed this area a mid-value of red. I also sprayed a small swatch the same mid-value of red on a separate piece of white paper, one inch square. I saved this so that I could easily compare this tone with the darker red I would be using later to check the contrast.

19 I made sure the paint was dry, then burnished down over the entire red area a sheet of dry transfer that had a texture similar to leather. Be careful when using dry transfer texture. If there is an acute perspective on the object, such as a dramatic change from large grain to small, you can't use a standard sheet of dry transfer with an even texture. You can have custom transfers made, but this can get very involved and expensive as you have to make up your own black-and-white art from which to make the transfer. In some cases this is worth doing when you consider the alternative of painting a lot of texture by hand. The textures available commercially are flat and even, but you can add form to them to some extent with tone as I did by adding shadows and highlights on the soccer shoes.

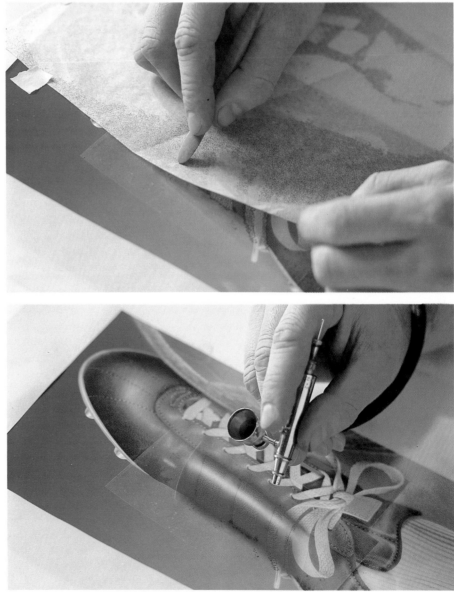

20 I sprayed the highlight and the darker red over the dry transfer. Now I referred to the one-inch swatch to check for a good contrast in values between dark red and highlight. The swatch enabled me to check this without removing part of the transfer.

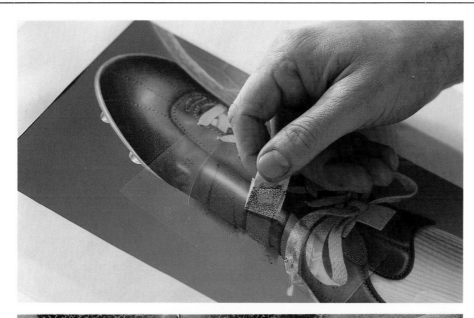

21 When the paint was dry I picked up the transfer by lightly burnishing white tape over the area and peeling it off.

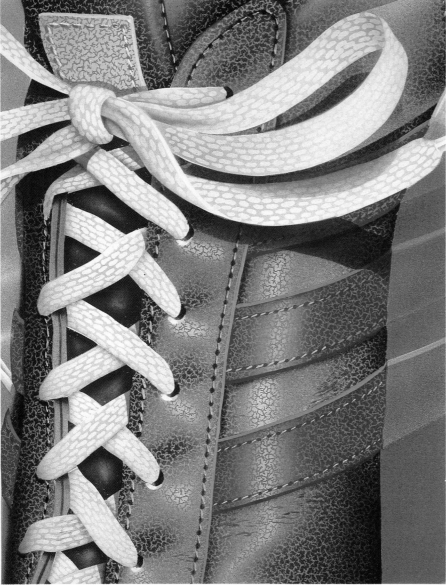

22 Finally I picked up the frisket mask and the leather texture was finished. The stitching was added with a small hand brush. For greater authenticity, I added some additional cracks in the shoe leather (where it creases) with a hand brush.

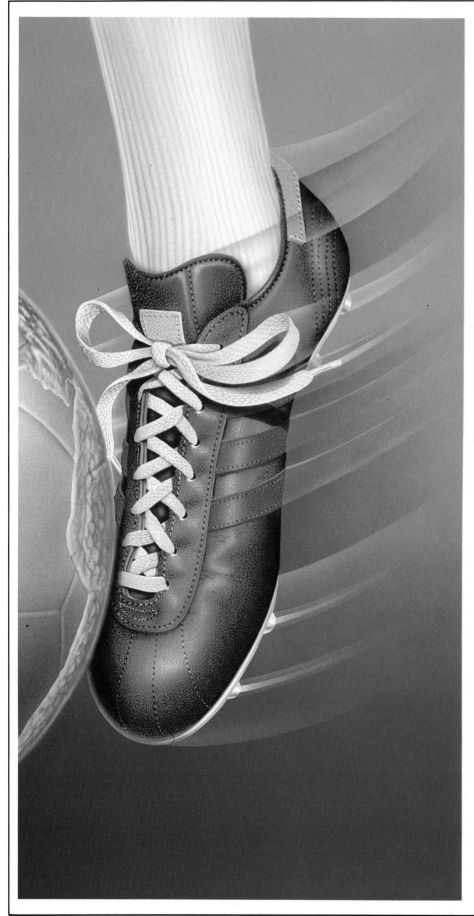

23 I drew the lines on the sock very lightly on the illustration board, masked around the sock with frisket, and then sprayed the lines in without any additional masks in order to get a soft effect.

To create the blurred motion effect, I cut acetate masks for the swishes behind the shoe. I put down a white undercoat before spraying the yellow and red swishes, to make these colors stand out. The darker black swishes were sprayed directly over the background.

At this point I looked for minor touches that might enhance the piece and decided to cast a blue tint on the left side of the shoestrings to reflect the earth's color. I touched up some small defects with a hand brush and the illustration was finished.

24 Here you can see how the different elements work together in the finished illustration.

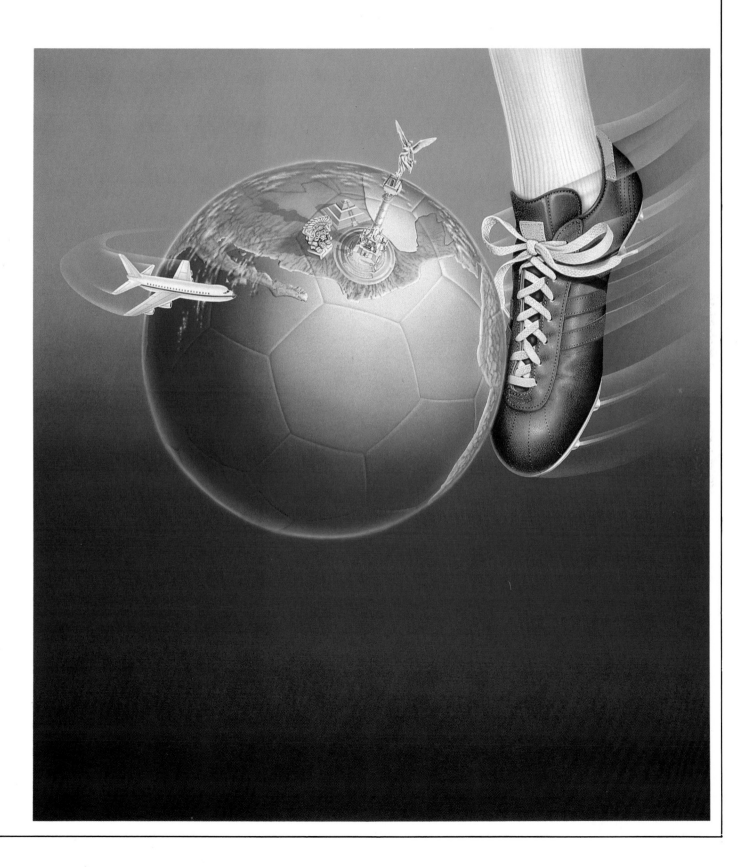

PROJECT 6

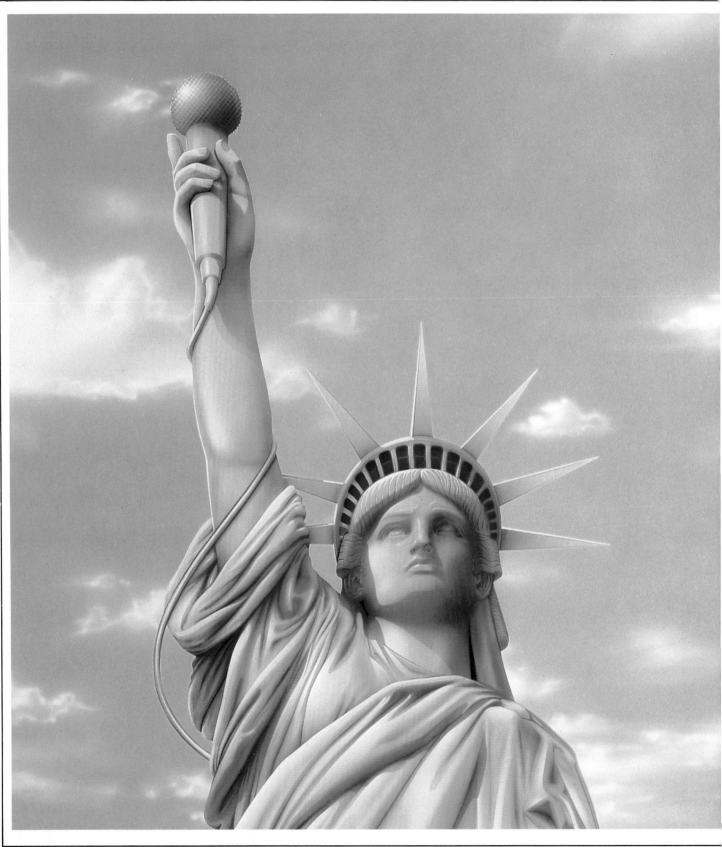

Gouache; 15³/₄" × 22"

STATUE OF LIBERTY

ASSIGNMENT
Illustration of the Statue of Liberty to be used by a television production company both on the air and in printed advertisements

ARTIST
Dave Miller

CLIENT
Sive Associates, Inc.; Kim White, art director

Multimedia Entertainment, a television production company, wanted to use an image of the Statue of Liberty to promote its lineup of television specials. Multimedia's ad agency, Sive Associates, asked us to tie together the statue, which was celebrating its centennial, and television production, so we decided to replace the torch in the statue's hand with a microphone.

The challenges of this job were to correctly imitate the color of the statue's tarnished copper and to reproduce the many folds and shadows of its cloak.

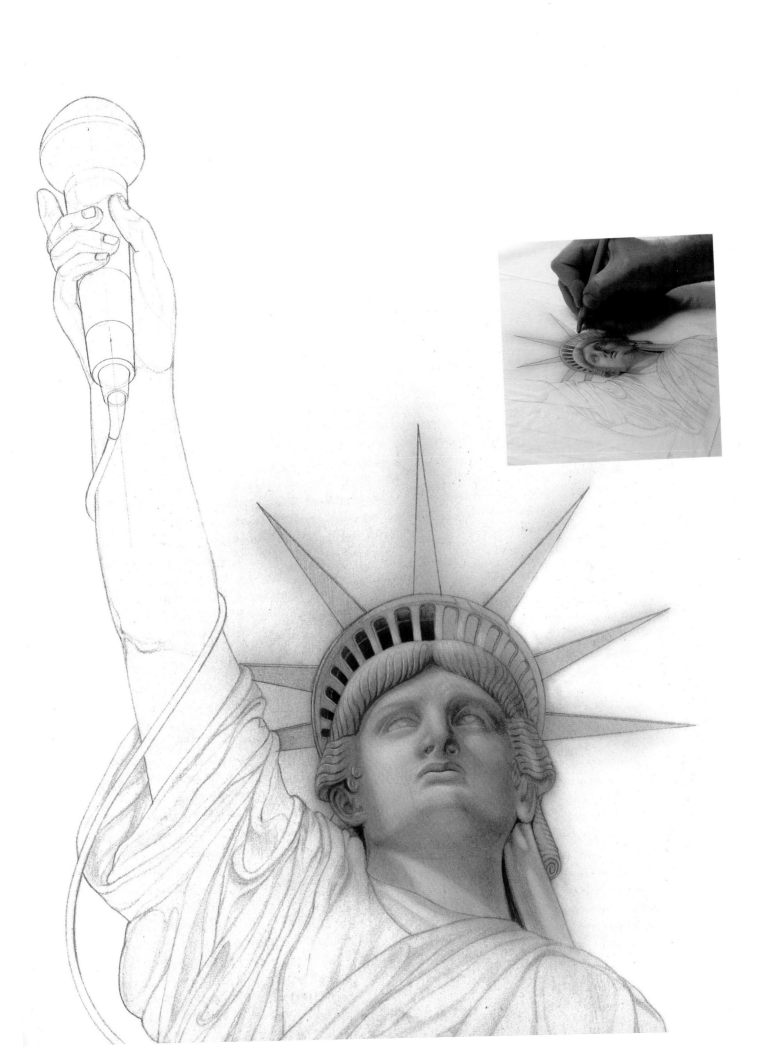

1 **Tone and Color:** For most illustrations, where I have good reference or visual knowledge, I take the pencil sketch only to the point of a good outline drawing, showing no tone, only edges and contours. But with the many folds and soft curves of the Statue of Liberty, I felt it necessary to render at least a portion of the sketch in tone to get a better understanding of how to approach the illustration. I decided to also add some color to a portion of the drawing to determine what pigments I would use and in what order. Using colored pencils and an eraser, I defined shadow and highlight areas.

2 After transferring the outline drawing to the illustration board with the use of graphite carbon paper, I covered the drawing and entire board with frisket film.

3 With a sharp blade I cut along all the outlines lightly through the frisket trying to avoid cutting into the board surface.

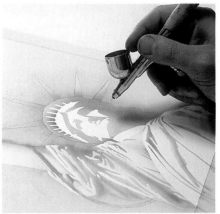

4 **Tarnished Copper:** I lifted out the pieces of frisket in areas I wanted to begin to define with tone or shadow, and began spraying lightly with cobalt turquoise watercolor. I chose watercolor because of its transparency, which allowed me to build up color density in layers. That meant I had more control over the color saturation.

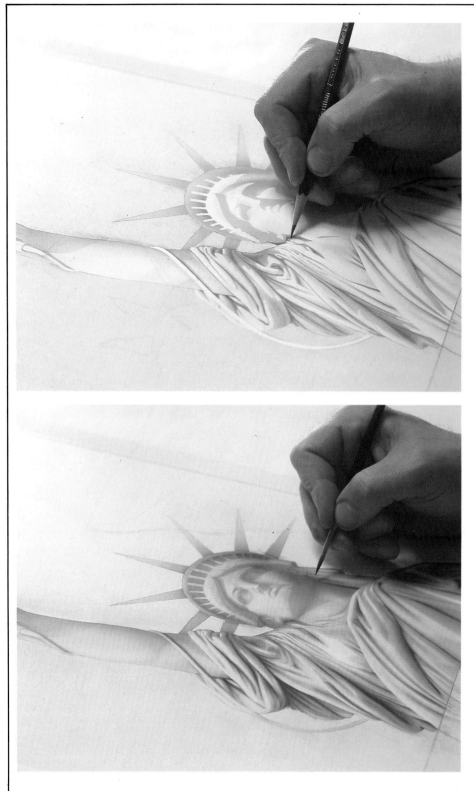

5 With the basic shadow areas defined, I began to use a dark green colored pencil with a fairly hard lead (such as the Eagle Verithin brand because it will hold a sharp point) to put in the darkest shadows and, at the same time, define some of the edges and folds.

6 **Creating Form and Contour:** Here you can see where I've gone back into the illustration to airbrush a cool bluish green tone overall and a yellowish tint to the highlight areas to accentuate the feeling of sunlight shining onto the statue from above left. I added density to the shadows using acetate masks cut to fit specific shadow areas.

While adding the overall tone increased the middle tones it also flattened the image out somewhat. To increase the contrast I used a kneaded eraser to remove color from the highlight areas and a fine no. 2 sable brush to add very dark bluish green into the darkest shadows and folds. I also did some touch-up work with the colored pencil.

7 You can see in this detail of the finished illustration the results of adding overall and shadow tones with the airbrush, erasing tone in the highlight areas, and handpainting the deep hard-edged shadows. I worked back and forth in this way until I rendered the statue nearly finished.

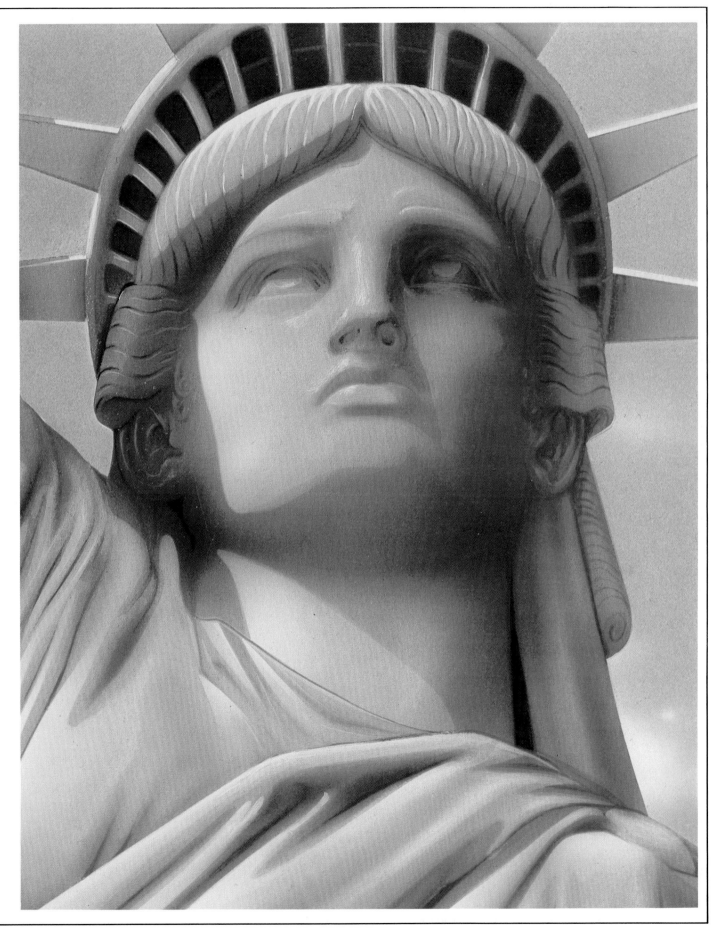

8 Sky and Clouds: I cut an acetate mask to cover the statue so I could spray the base color of the sky—a warm ultramarine blue with a slight gradation from light at the bottom to a bit darker at the top. It's best to achieve the shade you want with light tints of pure color than by adding white to lighten a color. This is especially true if you want to use erasure to create highlights or define lighter tonal areas.

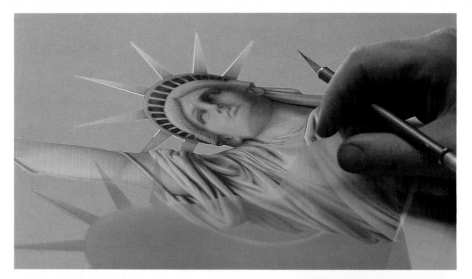

9 Here, I added fine dark edges with a sable brush.

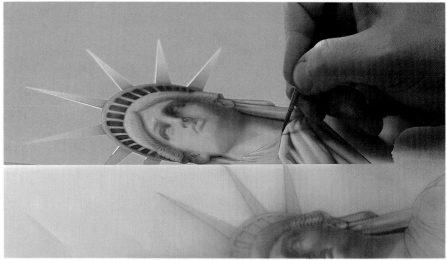

10 I erased color from the background in the areas where I wanted clouds, roughing in the size and shape of the clouds this way. (While I gently used an ink eraser to erase most of the cloud areas, I used a kneaded eraser for soft edges and a more abrasive ink eraser for the hard edges.) Pulling out the reference photo I'd selected ahead of time for the clouds, I begin to freehand spray them with permanent white gouache selected for its opacity. When I finished, the clouds were rendered almost entirely white.

With the sky and clouds finished I removed the acetate mask that covered the statue. Since this mask was held in place with a light coat of spray mount, I wiped that area with a soft pad moistened with Bestine solvent to remove any adhesive that had stuck to the illustration.

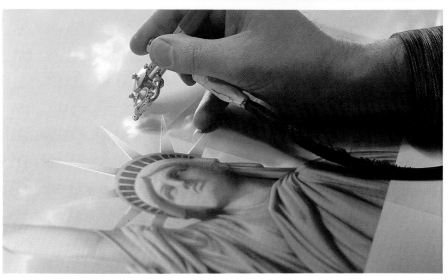

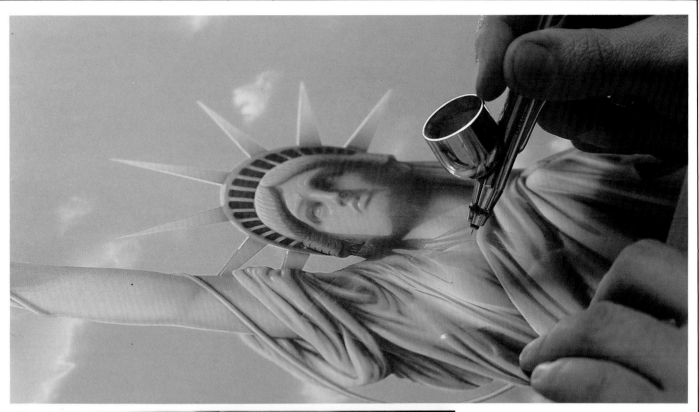

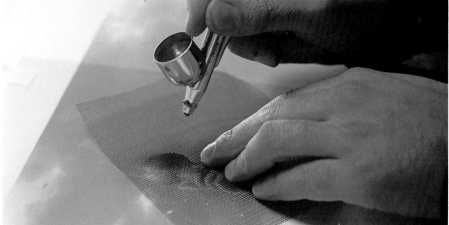

11 Once the background was finished I had only to add the finishing touches and detailing. Up to this point I had added lights by removing the pigment with an eraser. Now in the final step I sprayed white highlights very selectively, careful to keep them relative to the metallic surface. Thin white highlights were also applied to some of the finer detail areas. The result was a satiny sheen that gives the statue a look that is not too slick or coarse but just right for weathered copper.

12 **Window Screening:** After I sprayed the microphone the same bluish green as the rest of the statue, I masked the area around with frisket. I created the texture by spraying through a piece of window screen. I started with the shadow side and emphasized the sphere shape as I sprayed. The white "hot" spot was added to the sphere to complete the look. Because the screen is flat and the lines don't curve around the microphone it is best not to over accentuate the texture but rely more on tone gradation and highlight to define the form.

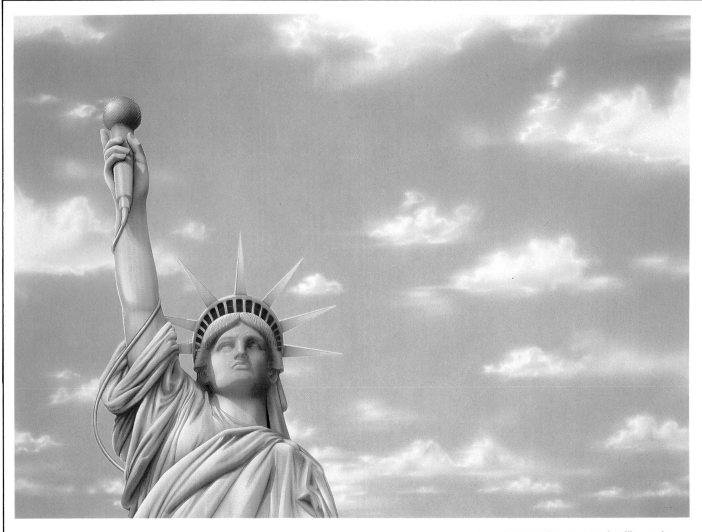

13 I generally go over the illustration at this point to spot any small spots where masking was not perfect or a highlight was missed. The last touch is an overall light spray coat of gum arabic and water to set any pigment that may be loose on the board.

14 The art was used for a two page magazine ad. Ad copy was sur-printed over the sky to the right of the statue on the second page of the ad.

PROJECT 7

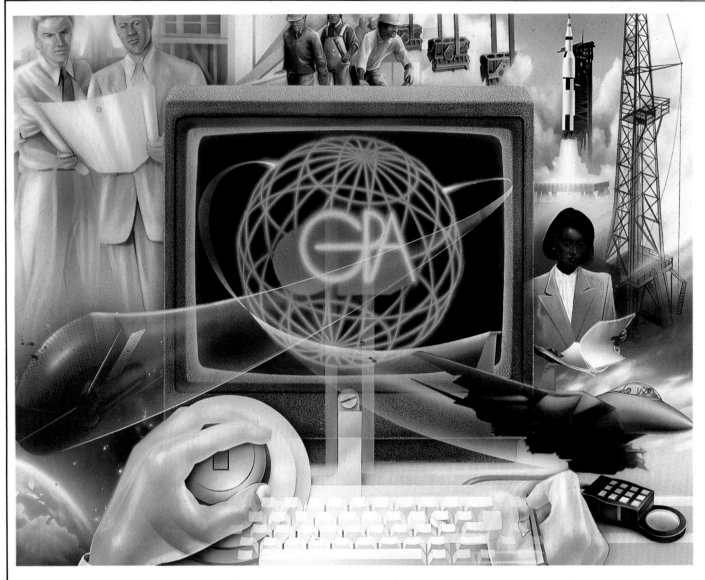

ASSIGNMENT
Illustration for a promotional brochure for a technical consultant company

ARTIST
Dave Miller

CLIENT
Pete Kurles, freelance art director

This project shows very well the difficulties in designing a complex illustration that must incorporate a lot of technical elements. GPA Technical Consultants, Inc.—a company that places and contracts professionals such as engineers and technicians—needed an illustration

to use on a promotional brochure that would encompass the entire scope of its business. The company wanted the brochure to illustrate three key occupational areas—computer technology, aerospace technology, and energy exploration—as well as several other aspects of the business.

The challenge was to find appropriate ways to represent these rather technical concepts in a visually pleasing design, while at the same time present an accurate portrayal of the company's involvement in each field. To do that, we had to experiment with the design

more than usual. To begin with, we presented the company with three preliminary drawings that showed different approaches to the problem. In addition, the company made additions and alterations to the design even after the piece was finished.

Gouache and dye; 10½" × 13"

GPA BROCHURE

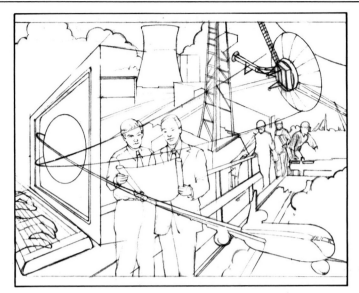

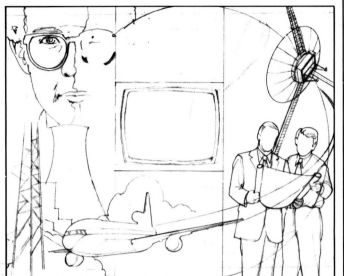

1 **Research and Planning:** There were two primary objectives in composing and designing this piece: to make the size of each image in proportion to the company's involvement in the particular field and to tie the myriad elements together so they would make an aesthetically pleasing unit.

Some of the considerations in selecting the images to be represented in the drawing were the number of people GPA employs in each area and the significance of growth to certain of these occupations. In the end, we chose images that quickly conveyed the fields they represented and were graphic: a computer terminal, airplane, engineers, oil rig, satellite, and so forth.

Photo references for these images were assembled from many sources, especially stock photo books that contained industrial situation photos. I used an instant camera to shoot reference photos of the hands in the studio and of the computer "mouse" in the GPA offices.

Looking at the three drawings on this page, you can see how we proposed to use these elements. All three designs incorporated the same images, but each was a fairly different composition. The art director chose the bottom drawing because of its prominent computer theme and the central focus on the GPA symbol on the computer screen.

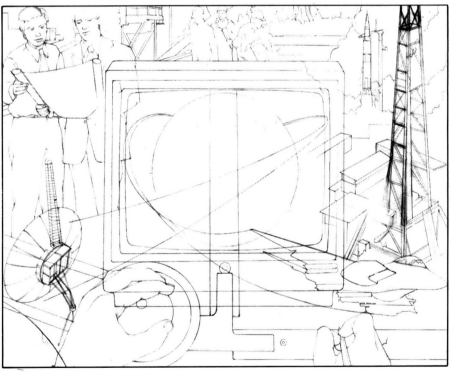

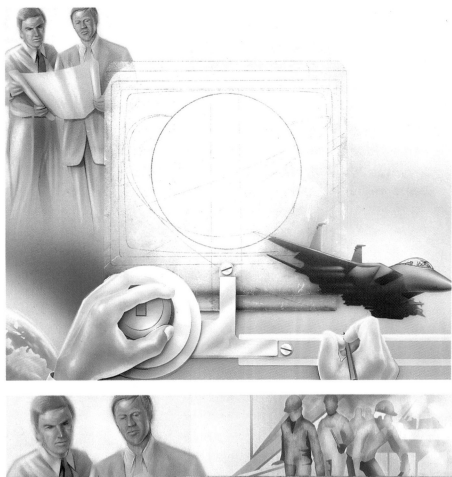

2 **Building a Montage:** Starting with the areas surrounding the computer I put the main compositional elements in first. The hands working with a drafting machine formed the base, onto which I painted the jet fighter. The sky would become the base for the oil rig, satellite, and so forth. I began by removing frisket pieces where I would spray general color tones, such as the fleshtones on the hands, the green for the drawing board, the metal parts of the parallel rule—basically the areas where I wanted hard edges. I sprayed the rest of the necessary base colors, where I wanted softer edges, using acetate masks and holding them loosely on the surface so that I could move them slightly as I sprayed. I then erased tones in the highlight areas, which you can see in the hands, figures, and rule.

3 Here you can better see how each area was sprayed in roughly first, and the highlights erased to create form and volume. By keeping many of your edges soft in a montage like this, it's easier to blend one element into another and add detailing as the image evolves.

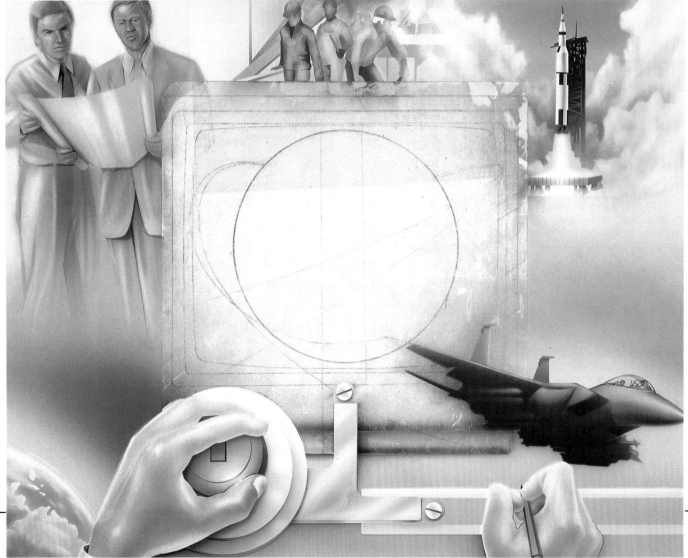

4 By examining the two illustrations at right you can see how the group of industrial workers developed. After the basic images were laid down, most of the detail on these small figures was done with a hand brush. The detail in the cockpit of the jet fighter was done much the same way.

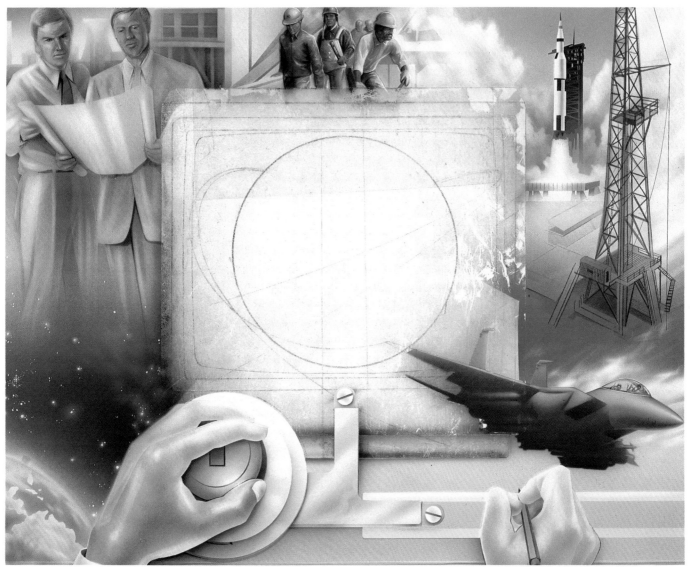

5 At this stage you can see how the separate elements of the illustration come together as backgrounds fade into foregrounds.

6 These two stages show how the relative softness or sharpness of elements can add depth to an illustration. The figures are somewhat crisper than the background, which helps pull them into the foreground. Notice the way the figures relate to the background—light shoulder colors against darker horizon.

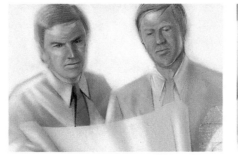

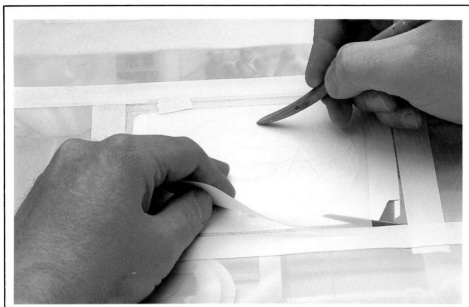

7 **Computer Graphics:** To create the computer graphic image on the terminal screen, I burnished down a dry transfer mask of thin, circular lines, being careful to avoid getting any excess adhesive from the transfer sheet onto the painting surface.

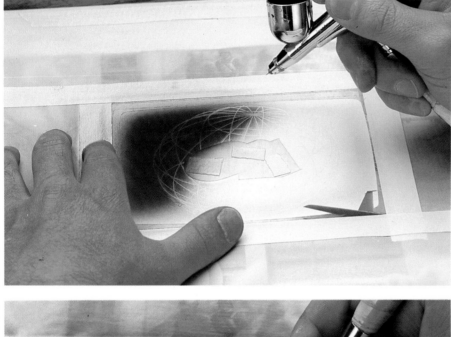

8 Next I sprayed the screen's black background slowly to keep the color from bleeding under the mask's edges. I covered the GPA logo with an acetate mask while spraying the background. After I achieved the right color density, I removed the dry transfer circular lines from everything except the GPA letters. I then removed the acetate, leaving the dry transfer over the lettering, and sprayed a 50 percent black tint over the dimensional part of the logo.

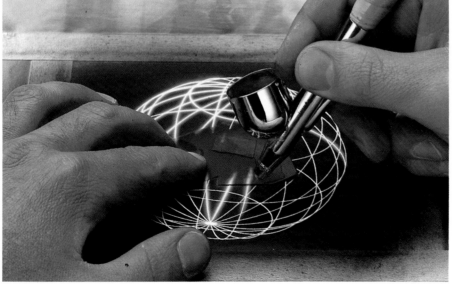

9 To make the circular globe lines glow, I painted each line individually with a fine spray of white pigment. To create the lines I held the airbrush very close to the board and reduced air pressure from 23 to 15 pounds.

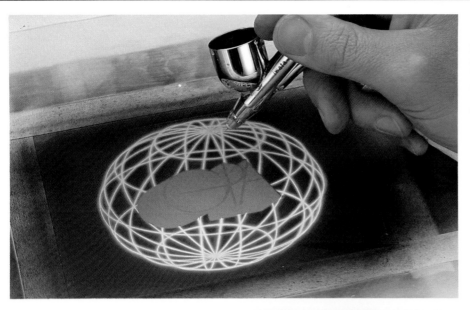

10 At this point I wanted to spray the globe lines green, add some green color to the tinted logo area (the letters are still covered with dry transfer), and increase the density of the black background. To achieve all three objectives, I used transparent green dye, rather than the more opaque gouache.

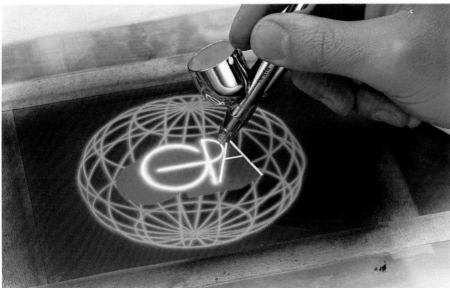

11 After picking up the dry transfer from the lettering, I sprayed two layers of white in the same manner as I sprayed the globe lines white. This added depth and emphasis to the logo.

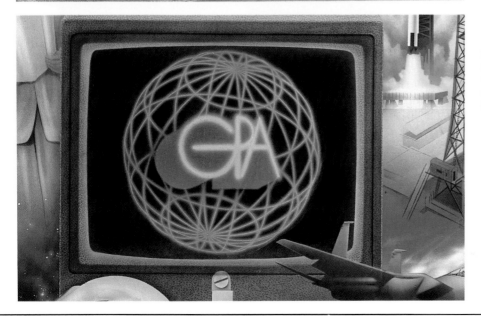

12 I finished the screen image by spraying a single layer of transparent green dye over the GPA lettering and, again, the globe lines. Having two coats of green on the globe and only one on the lettering made the logo stand out on the screen.

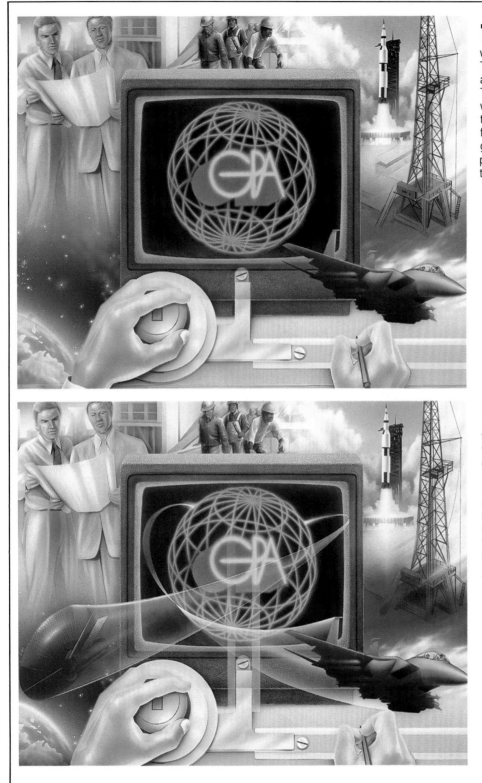

13 In this illustration you can see how the completed computer terminal works with the surrounding elements. The job now was to make it *more* interactive with the surrounding background. The same green dye used for the screen was sprayed on portions of the hands in the foreground and the tail of the jet fighter to make the screen appear to glow. Note that the texture of the computer's housing was created with the dry transfer method described on page 82.

14 Tying the Elements Together: The computer terminal was further tied in with the other images by the addition of white sweeping speed lines. To create the speed lines I cut an acetate mask using a ship's curve (which is a long, clear plastic, irregular drafting curve) as a guide to insure a smooth sweep. Using bleed-proof white, I sprayed lightly, giving added attention to the edges. (Bleed-proof white was appropriate here to prevent the dye on the screen from bleeding through the white.) The satellite was rendered prior to the addition of the sweep. The order in which the different elements of the illustration are layered made it impossible to do the sweeps at any other time but last.

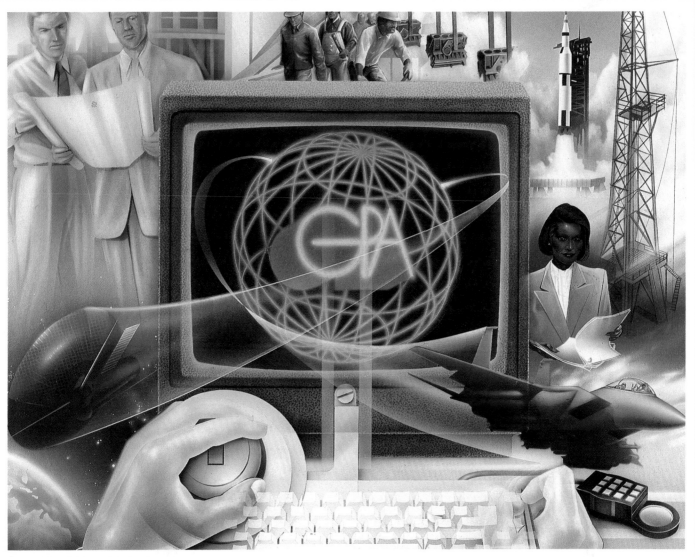

15 The finished illustration shows additional elements that the client decided to add after I had completed the piece. The female executive was added over the drilling rig's base, which required that I spray a light color base to cover the area the figure would occupy. I rendered the woman and the red engine blocks above the computer screen using a combination of hand brush and airbrush, similar to the method used on the three industrial workers. The keyboard at the bottom was added over the darker background using acetate masking and spraying permanent white. The top, highlighted portions of the keys received the most white coverage, the sides of the keys less since the dark base color helped define these areas. Fading off of the keys on both sides was easily accomplished with this method. The final element to be added, the computer "mouse" on the right side, was sprayed in also using acetate masking with ivory black for the body and permanent white for the lens and highlights.

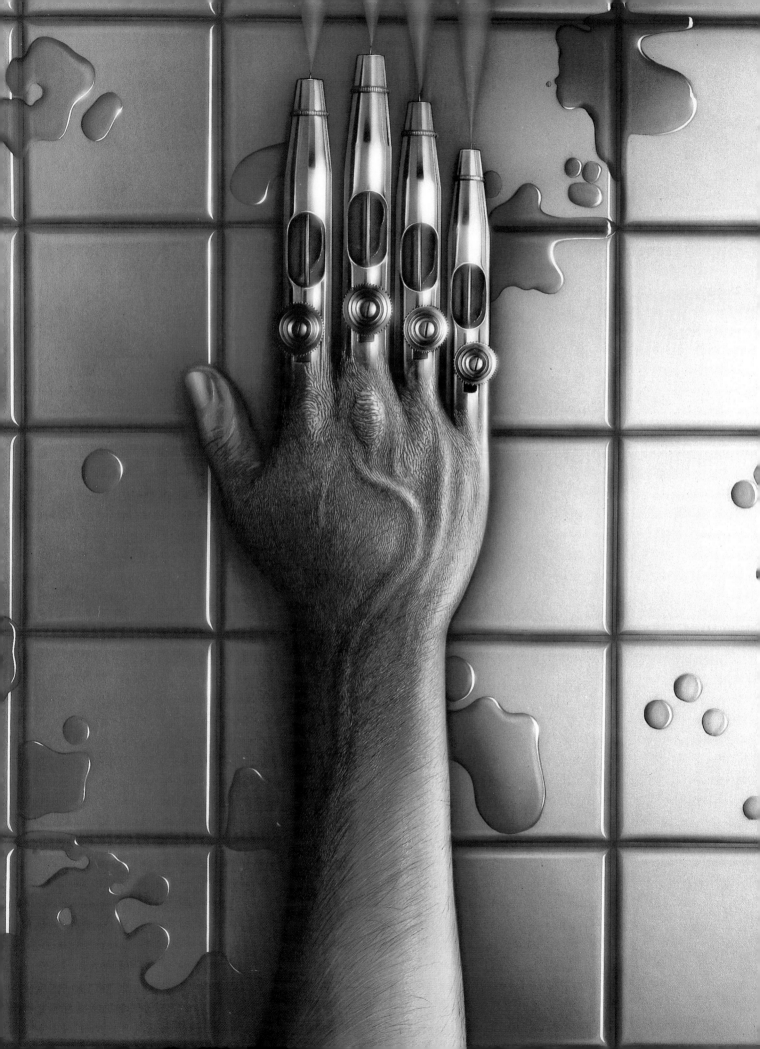

PROJECT 8 DYNAMIC AIRBRUSH

ASSIGNMENT
Jacket illustration for *Dynamic Airbrush*

ARTIST
Dave Miller

CLIENT
North Light Books

When I designed the illustration for the jacket of this book, I wanted to emphasize the fact that the airbrush is a tool, not a style. And that the "trick" to airbrushing is gaining hand control over the instrument, just as you would over a pencil or paint brush. The obvious solution for the jacket illustration, to portray the impression I wanted, was to show the airbrush as an extension of the artist's hand. I also decided that I wanted the piece to be very realistic, and thus more convincing, but *not* so realistic that it would be mistaken for photography.

The trickiest areas of the illustration were the chrome finish on the airbrushes and the skin texture, both of which had to be realistic and convincing.

1 **Drawing Directly on the Board:** I started by drawing the illustration directly onto the board surface since I planned to paint over the pencil and felt the graphite lines would help define the form.

2 After I had the basic outlines drawn in, I airbrushed freehand directly over the pencil lines with a gloss brown watercolor, essentially redrawing the image. This provided a nice warm base with form and shaping starting to show.

Gouache; 13¹⁄₄″ × 18¹⁄₄″

3 The final background tile color was to be cool turquoise, so I freehand airbrushed over the brown with blue watercolor. The arm was sprayed with golden yellow gouache to give it opacity and, by concentrating the light spray in shadow areas, further define the form.

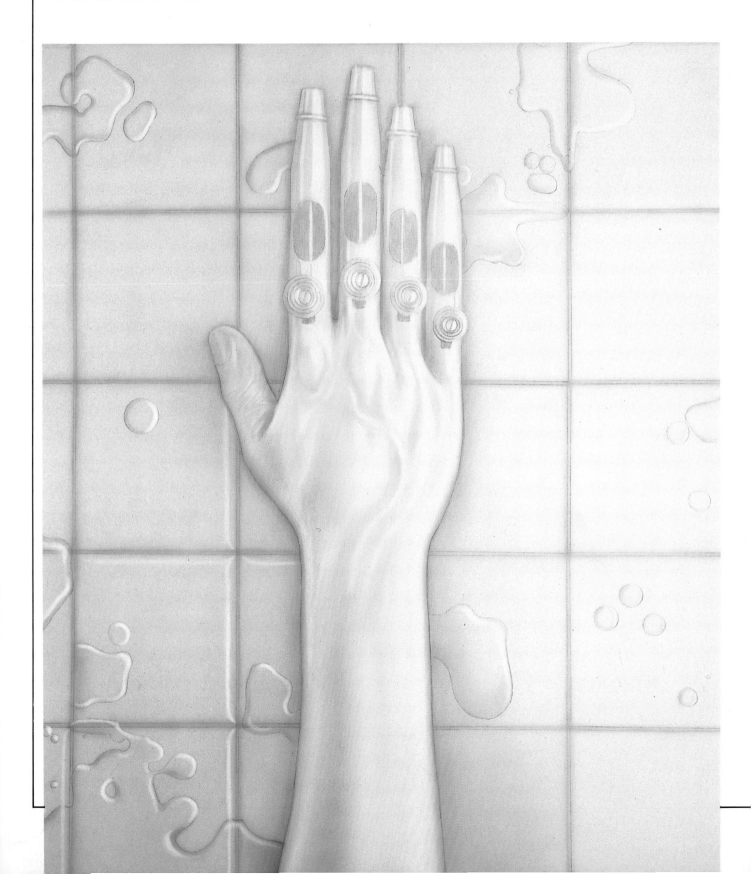

4 At this stage I continued to spray the brown and blue tones freehand, following my photo reference of an arm and hand. This added tone and density, defining the muscles in the arm and the beveled edges of the tiles. I also began now to remove tone with an eraser to create soft highlights. To give the piece depth I masked the arm with frisket and sprayed a light shadow along the outline of the arm and between the "fingers." By making the shadow darkest right along the edges of the hand, I intensified this effect.

5 By comparing these two steps you can see how I worked the illustration—first adding tone and then lightly removing some of it each time to more accurately and subtly create the contours of the arm and the tiles. Also notice I've added a dark blue pencil line around the tiles to increase their separation and contrast. I continued to add tone into the shadow or dark areas, but now I used acetate masks cut for specific areas such as the beveled edges of the tiles.

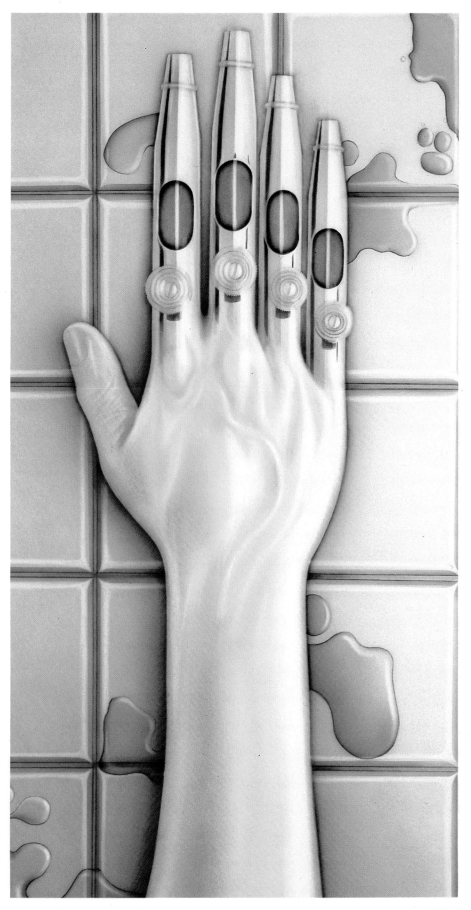

6 **Matte Chrome:** In these three steps you can study the development of the chrome in the early stages of the piece. Here the basic form of the air-brushes has been defined using mostly acetate that's been cut to define shadow areas and dark reflections. A kneaded eraser was used to keep the highlight areas clean and light with soft edges.

7 The small detail areas and edges were indicated with a dark blue pen-cil. Some of the same acetate masks were used to add more contrast to the forms.

8 Subtle colors were worked into the chrome for increased realism. Not much of the color I added to the air-brushes at this stage will remain in the finished art, but some of the subtle color-ing will show up in the midtones, giving a realistic impression of chrome.

9 Here I've added more color to the
arm and hand. The eraser is still
helpful in defining form; I also used it to
develop texture in the forearm by erasing
in a crosshatch motion.

10 **Skin Texture:** At this point I'd reached the appropriate density and color saturation, and the contour and form was complete. All the remaining work involved detailing and adding texture. I hand brushed individually each dark arm hair and used a very sharp blade to gently scrape out the light hairs. The detailing on the airbrushes mainly

consisted of adding thin, crisp whites and darks with a hand brush and some white "hot spots" with the airbrush.

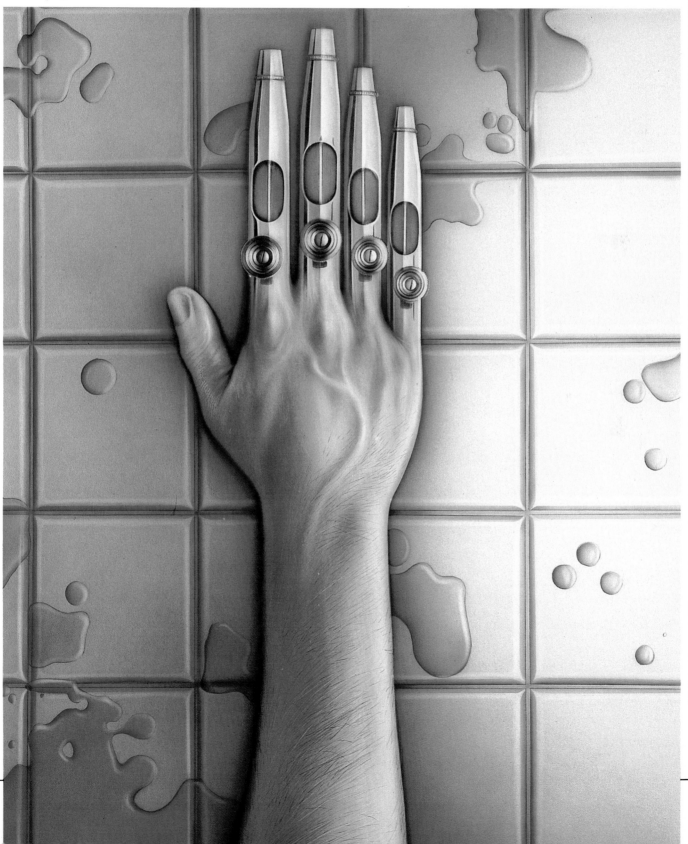

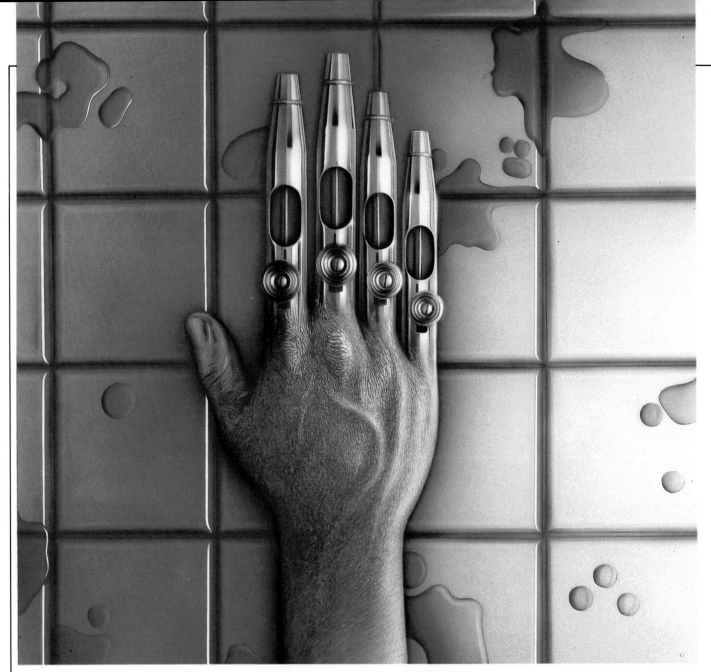

11 The edges of the tile facing the light source got a hard white highlight as did the water puddles. This was done by spraying through a thin slit cut into acetate.

The skin texture was very time consuming. It was done by *removing* color using a small no. 1 sable brush. By slightly wetting the tip of the brush I could scrub color out of the illustration board in tiny areas, varying their size and shape. This was done across the back of the hand, fading out across the arm to the right and also where the fingers met the airbrushes. This procedure added a great deal of surface texture and contrast in a way not usually associated with airbrush.

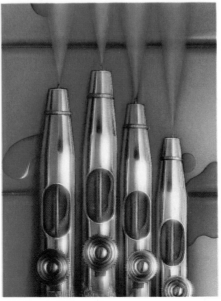

12 The final details added were the pink paints in the color cups of the airbrushes and the spray emanating from the needles. I first cut an acetate mask with openings the shapes of these areas. I taped it in position and used a pink pearl to erase as much color as possible from these areas. I used acetate as a shield to protect the surrounding areas as I erased. I then sprayed a soft, consistent coverage of permanent white, concentrating the spray in the center and letting it fade out on the sides. I then sprayed carthamus pink over the white allowing some paint to overspray onto the blue tiles. (By using this method rather than masking to render the pink, I achieved an effect that is softer and more realistic.) The last step was to spray a touch of pink onto the chrome reflections and hand brush hairline highlights on the paint in the cups.

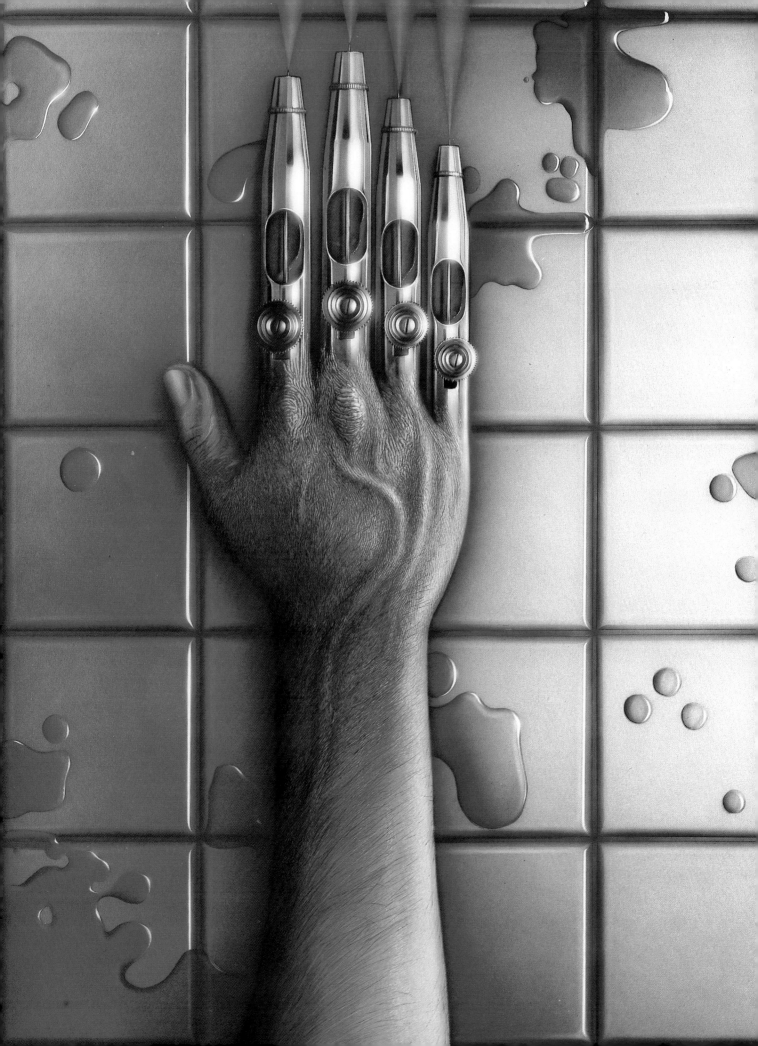

PROJECT 9

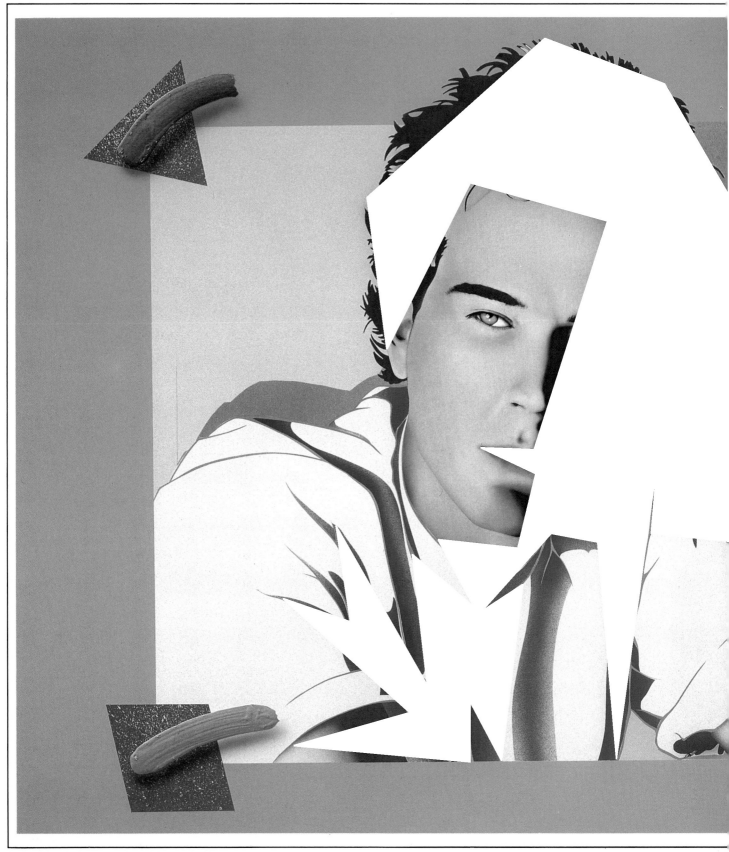

Acrylic, gouache, and dye; 13″×18″

TIMOTHY HUTTON

ASSIGNMENT
Portrait of actor Timothy Hutton

ARTIST
Derek Rillo

CLIENT
None. This is an experimental project the artist did to explore airbrush portraiture.

I did this illustration because I was interested in doing a self-directed, experimental piece that would give me the freedom to combine some unusual images and techniques. I did that in the border of the illustration, contrasting flat, graphic shapes with loose, dimensional brushstrokes. Rendering the brushstrokes intrigued me. I knew that because of the "tightness" and control inherent in the airbrush proc-

ess, it might be difficult to capture a spontaneous or loose feeling.

My second objective with this piece was to experiment with portraiture using the airbrush. I wanted the portrait of actor Timothy Hutton to have a photographic feeling, but I didn't want people to mistake it for a photograph. Essentially, I was after the truthfulness and mood of a photograph.

1 **The Sketch:** Once I have an idea for an illustration, the first thing I do is a small sketch in which I work out the composition and indicate the colors I intend to use. I try to be spontaneous with the sketch and put down ideas as they come to me; this is perhaps the most creative part of my work process. This is also the stage where most major decisions are made, as you can see in this illustration.

2 **Floating Brushstrokes:** It appeared that the best way to achieve a loose brushstroke for the border would be to paint it by hand rather than with my airbrush. Because this was a critical step in the illustration, it was logical to paint the brushstroke before doing any airbrush work.

To give the brushstroke dimension, I needed to use paint with a thick consistency. Another consideration was the color of the paint. I needed to be able to distinguish it from the white board surface, but it also needed to be a good undertone since it would later be painted over to achieve the final color.

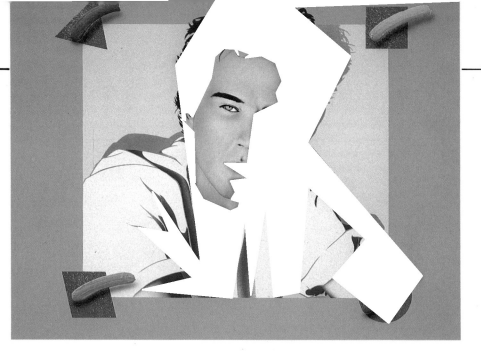

3 Acrylic paint mixed with a little gouache gave me both the proper consistency and a sprayable surface; you can see the consistency above. To solve the problem of distinguishing the brushstroke from the board I tinted titanium white acrylic with a small amount of red that I thought would be compatible with the final color. This pink tint wouldn't muddy my final color. I used a no. 5 watercolor brush to apply the brushstroke. (It's a good idea to practice making brushstrokes on a spare piece of board before approaching your illustration.)

4 The next step was to paint the area behind the brushstroke, being careful to keep the stroke properly masked with frisket. I removed the acetate mask so you could see this step completed here, but the mask must be in place for the next stage. When choosing the background colors I wanted them to complement, not compete with, the brushstrokes. For immediately behind the brushstroke I chose dark gray because this color recedes and helps push the strokes forward. The other colors in the background, mauve and aqua, were grayed down to keep them from becoming too bright.

5 Since I was attempting to achieve a spontaneous feel to this area, I wanted an "active" texture behind the brushstroke. To get this effect I used a spattering technique. For this I found that the brush on the end of an ink eraser worked perfectly. It gave nice directional spatters when flicked at a low angle to the board.

6 After the background was completely finished and the acetate masks removed, I removed the mask from the brushstroke and re-masked the immediate surrounding area with frisket. The large piece of acetate you see here protected the rest of the piece. The next step was to give the brushstroke its final color and enhance the texture. To color the strokes I used a combination of Luma watercolors, because of their intensity and transparency, and a little gouache to help the colors dry quickly and avoid any smearing. To emphasize texture and form of elements like these brushstrokes, spray at an angle almost parallel to the surface of your board. You can also spray near the brushstroke (not directly on it) allowing the overspray to hit the surface of the stroke.

7 The airbrush is useful for making the texture of the brushstroke more apparent, as you can see here. Adding shadows and highlights reveals all the surface irregularities. To give added dimension to the illustration, I used two different colors on each of the four brushstrokes. On this stroke I sprayed a red to indicate the shadow and a much lighter yellow from the top for the highlight. Now there is both a value change in the stroke, from top to bottom, and a color change.

8 Now for the final step in creating the illusion. I carefully removed the acetate from the background and masked the brushstroke with frisket. (It saves time if you can just reposition the piece you cut out when masking off the background earlier.) Using fairly thin lamp black watercolor, I sprayed an even shadow beneath the brushstroke to give the illusion of levitation. If you want the object to seem to be floating higher off the surface, simply spray the shadow farther away from it.

9 Once the mask was carefully removed, the brushstroke was complete. The most interesting part of a project like this is experimentation. Don't be afraid to use different paints, brushes, masks, or techniques. Remember there is no *one* right way to do this type project. Achieving spontaneity such as this brushstroke requires imaginative experimentation to get the results you want.

10 When dealing with fleshtones in an illustration such as this, it's a good idea to minimize pencil lines on the spraying surface. So after I enlarged the sketch to size (15″ × 18″), I didn't transfer the full drawing to the illustration board, but instead drew just enough lines onto the tracing paper to position the head. Later, I'd lightly trace some details of the face onto the board as I needed them, making sure they wouldn't show in the finished illustration.

11 **Developing Facial Values:** I began by building values in the face, since developing these tones evenly would be the most difficult part of the portrait. I mixed a very opaque mixture of dark gray using blue and violet gouache, making sure I mixed plenty since matching this color would be difficult if I ran out. I then cut out the frisket from the areas that would have the most density, and sprayed these areas solid with the dark gray.

12 Next I removed the frisket from the entire face area, leaving the background, clothes, and eyes covered. As you can see here there are no pencil lines on the face.

13 Using graphite and the original drawing I transferred some details of the lips, nose, and cheek very lightly onto the board as a guide for light freehand work. I made sure they could hardly be seen, since I didn't want them to show in the finished illustration. Working from dark to light I began spraying these detail areas, slowly building up the face. I used the same opaque dark gray mixture I used to establish facial values. At this stage I was only developing dark and light values, no skin color.

14 I sprayed freehand around the darkest areas to soften the hard edges before darkening the middle value areas. I used thinner gouache so these areas wouldn't get too dark too fast. Finally, I added an overall light tone to the entire face.

15 For skin tone I used a combination of acorn brown and flame red transparent dye that allowed the base values to show through. I sprayed this mixture over the entire face area, adding a slightly redder tone to the lips. To lighten areas of the face, and give it more form, I used a kneaded eraser to erase some tone above the eyebrows and around the nose, eyes, and cheeks.

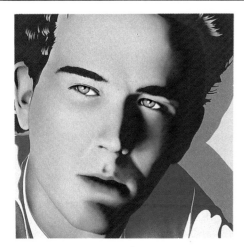

16 Working in this manner—dark and light values first, then fleshtone on top—gave the illustration the look of a tinted black-and-white photograph. I was pleased with this final effect because it revealed the photographic influence behind the illustration. Remember that it is important to be patient and not try to develop facial tonality too fast. Work slowly in thin layers and you'll achieve smooth, controlled shading.

17 **Eyes:** The eyes were done using a variety of masks. First frisket was used to mask the flesh around the eyes, then liquid frisket was applied to mask the highlights in the eyes. I sprayed the blue of the eyes through a circle template. After spraying the blue, I sprayed the black of the pupil, again spraying through the circle template. Next I sprayed the shadows in the white part of the eyes, and to finish the eyes, I removed the frisket and painted the eyelashes using a sable brush.

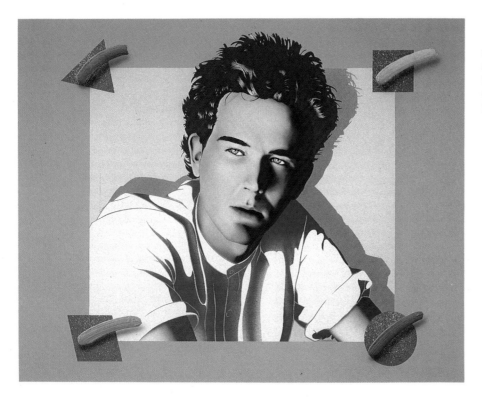

18 As you can see, I followed the sketch fairly closely, although I did change the color of the outside border and the shapes of the brushstrokes. Remember that the sketch is by no means an absolute, but rather a reminder of your original ideas.

PROJECT 10

Gouache, 5" × 8"

ASSIGNMENT
Rendering of a banana split to be used on a greeting card

ARTIST
Jim Effler

CLIENT
Gibson Greetings, Inc.

In doing this appetizing illustration, I discovered that one of the hardest things about dealing with ice cream models is that they don't last very long. But the good news is that you can eat your mistakes!

Gibson Greetings, Inc. had created a series of greeting cards with ice cream themes, and turned to us for an illustration of a banana split. The greeting card dictated what shape and size the illustration could be, and the art director supplied me with both an outline of the card and a fairly tight marker rendering of a banana split. Rather than struggle to make the marker rendering look more re-

BANANA SPLIT

USING A SEQUENCE OF PHOTOS

The first thing to do was, of course, buy all the makings of a banana split—ice cream, toppings, bananas, nuts, whipped cream, and cherries. For the initial shooting session I put all these ingredients together into a specially shaped glass bowl, only to discover my creation melting. As I devoured the evidence from my first inauspicious attempt, I decided the only approach to this problem was to photograph one item at a time—first the banana, then a scoop of vanilla ice cream, then the topping, then two more scoops and their toppings, followed by whipped cream, nuts, and a cherry. Although the resulting photos weren't technically great, they showed enough detail, reflections, and highlights to work well for reference.

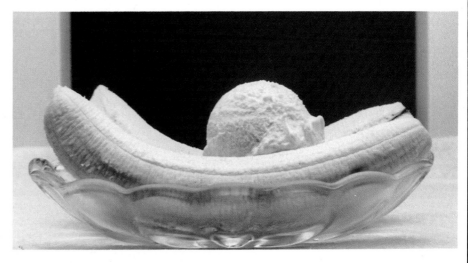

1 In this first photo, I lit the single scoop of ice cream and the bananas from overhead because that created the most even lighting and, throughout the shoot, would provide the nicest highlights. The brown background made the ingredients stand out and the white tabletop insured that no color reflected into the glass. The white surface also reflected light into the dish. Although the prints came out cool blue from working under the fluorescent lights in my kitchen, I planned to warm the colors up in the final illustration.

alistic, though, I decided that shooting my own reference photos would give me more accurate information for my pencil drawing.

2 At this stage I shot the ice cream as chocolate syrup was poured over it. This approach gave me the thickest possible syrup because, as you can see in the next photograph, by the time I moved on to the strawberry syrup, the chocolate had already begun to thin and run.

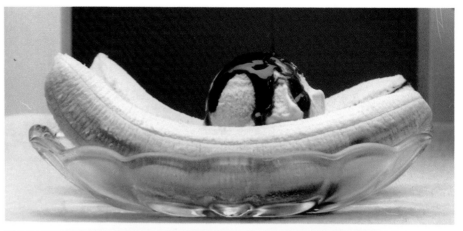

3 Although the scoop of strawberry ice cream had, by this time, lost its shape, I was able to utilize this photo for reference in creating the thickness and translucency of the strawberry syrup.

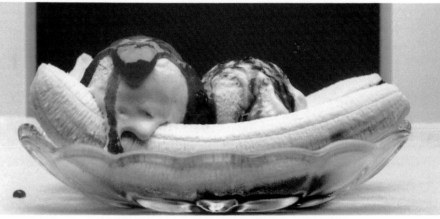

4 The problem here was that the marshmallow topping, when put on the chocolate ice cream, tended not to stick, preferring instead to slide off completely. You can see the results of leaving the marshmallow topping under the lights too long in the next photo. I had to work very quickly to avoid this problem.

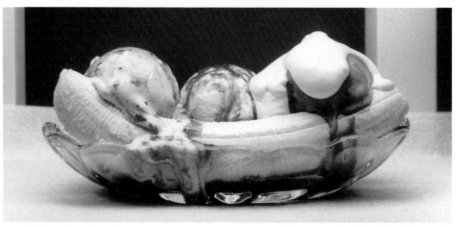

5 Here I added whipped cream, nuts, and a cherry, all of which were more cooperative than the marshmallow topping. Even though at this point the banana split looks pretty disastrous, this photo worked fine for additional highlight reference.

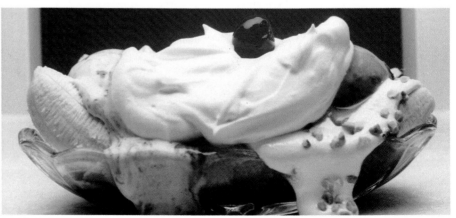

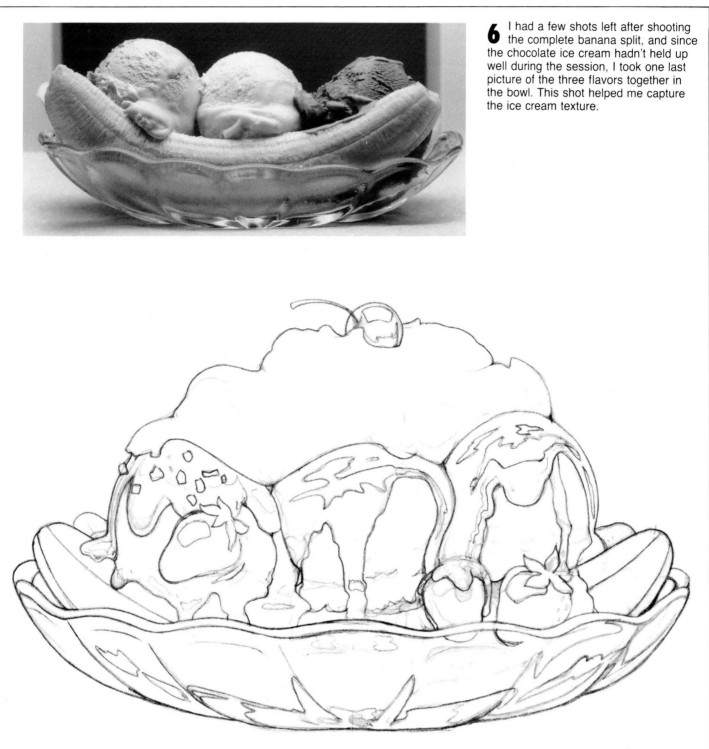

6 I had a few shots left after shooting the complete banana split, and since the chocolate ice cream hadn't held up well during the session, I took one last picture of the three flavors together in the bowl. This shot helped me capture the ice cream texture.

7 I utilized bits and pieces from all six photographs to do my pencil drawing. So that the illustration would fit the card format, I made sure the outline remained as the art director had originally indicated. But for the sake of impact, I did exaggerate one aspect of the banana split slightly—in reality it wasn't this tall.

8 **The Bananas:** Creating the thin, white wiggly lines that ran the length of the foreground banana was the trickiest aspect of rendering the banana texture. In these three diagrams you can see how I did it.

The first step was to mask the areas surrounding both ends of the banana with frisket film. I then lightly cut along the outline of both ends in .003mm clear acetate. I scored two wiggly lines lengthwise through the acetate to create the three masks you see here, labeled A, B and C.

Beginning with the left end of the banana I broke out the top mask from the acetate. I placed the remaining acetate masking over the bottom two-thirds of the banana, sections B and C. I then sprayed a yellow tint over the exposed area using a double-action airbrush. To create the soft texture and fine lines running both the width and length of this area, I sprayed over the tint using a turbo airbrush, which to save time was attached to a second CO_2 tank. (Your equipment will dictate whether you can use this same method. If you have only one tank and one regulator you may have to spray the yellow tint over the entire banana first and then use a turbo for the texture, re-masking the three areas as you go.)

9 To create the top thin white line, I broke out center piece B and set it aside. I taped mask A onto the sprayed area so that it overlapped slightly into the *center* portion of the banana. I broke out the bottom mask C from the acetate and moved it up slightly, again overlapping somewhat into the *center* area. I then sprayed the yellow tint over the center area. Next I went back into this area with my turbo airbrush to add the soft, fine textural details.

10 To complete the banana and the bottom white line, I removed mask C, and replaced mask B—overlapping it into the *bottom* area—and sprayed the yellow tint and the textural detailing in this last area. At this point I increased the contrast in certain areas to further define the banana's texture and shape. I repeated these same steps for the other end of the banana.

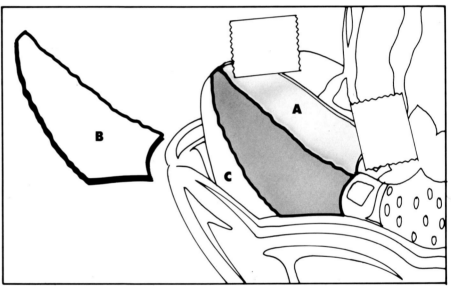

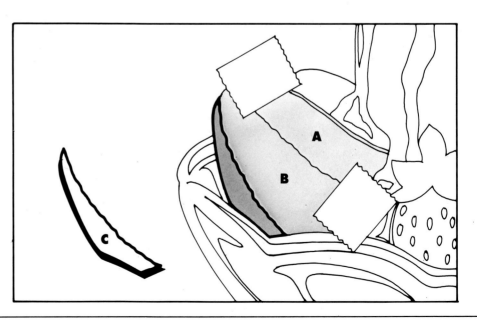

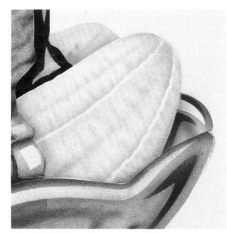

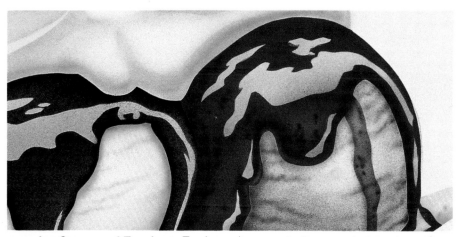

11 The finished banana looks deceptively easy. And with experience it *is* easy, I suppose. To make it easier for you, there are three pieces of advice I can offer. First, always use clear acetate for your masks. This is always a good idea, but more so in this case since you must make the thin white highlights even, and this is easier to do since you can see them through the acetate. Second, practice using the turbo to render the soft, fine detailing; control of this tool is critical here. Third, the right amount of contrast is important for creating the banana's texture and shape. Think this through before you spray.

12 **Ice Cream and Toppings:** To give the toppings, in this case the strawberry syrup, a wet look, I used hard-edged highlights. Note a couple of techniques I used to define the thickness of the syrup. First, the placement of the highlights was important. The further from the edge you place highlights, the thicker the syrup will appear. Second, by decreasing the color density in portions of the topping, I was able to add dark flecks of strawberry and increase the impression of a thick syrup.

You'll notice that the highlights aren't pure white; to keep them from contrasting too much with the syrup, which would have made the syrup look too hard, I sprayed a little of the red topping color over the highlight areas.

On the whipped cream, I held an acetate mask above the board to airbrush soft-edged shadows and emphasize its softness. I used a blue-gray in the shadows of the whipped cream, rather than a realistic brown-gray, to keep these areas clean looking. Reflecting the reddish cast of the strawberry topping onto the white whipping cream tied them together within this space. In the finished piece you can see the same treatment with the chocolate topping.

13 There are three ways I could have rendered the ice cream. The first would have been to paint it in with a hand brush, but that creates a look that's too hard and crisp.

A second method would have been to actually cut a pattern of the ice cream texture out of acetate and airbrush color very lightly through this mask, shifting the acetate ever so slightly to keep the edges soft.

But the method I used was to freehand soft, fine lines with my turbo airbrush. This approach was not only faster than cutting a mask, but it resulted in a softer, slightly melted, more appetizing look.

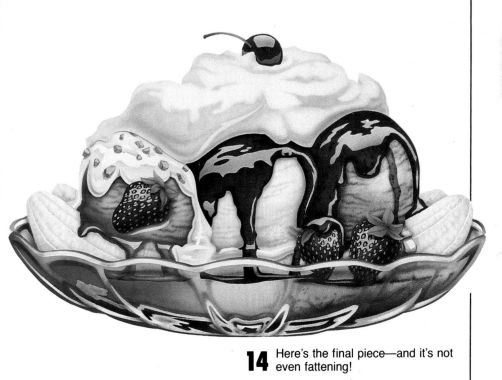

14 Here's the final piece—and it's not even fattening!

PROJECT 11

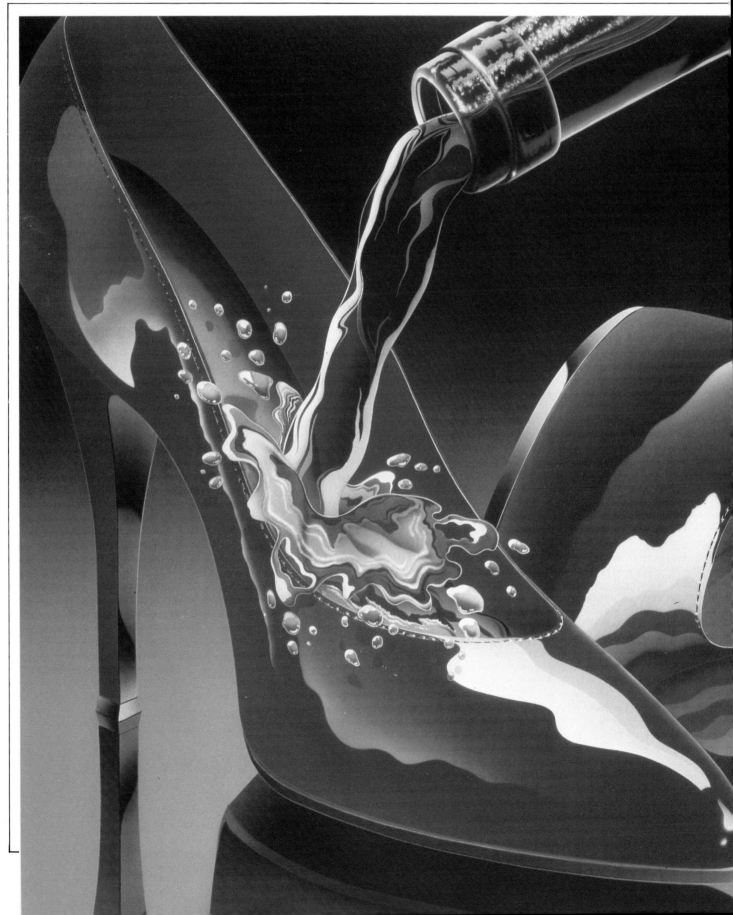

CHAMPAGNE FANTASY

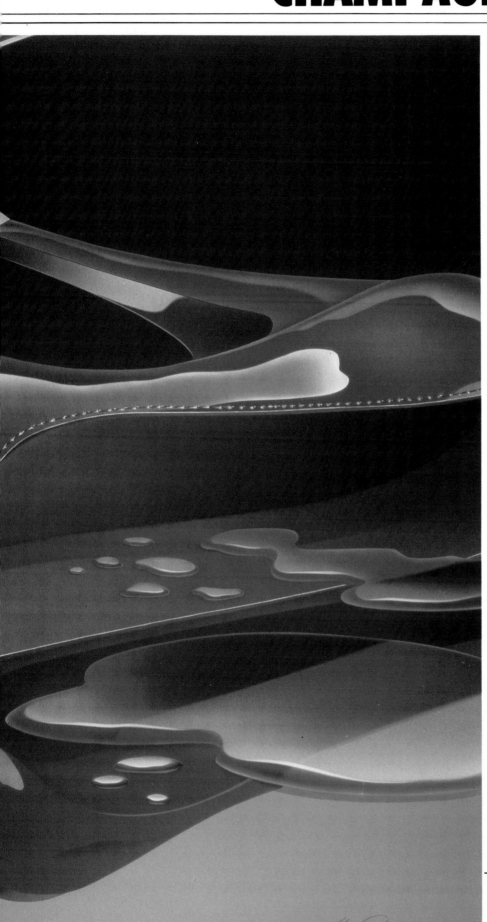

ASSIGNMENT
Poster showing champagne being poured into a high-heeled red slipper

ARTIST
Toby Lay

CLIENT
None. This was done as an experiment with reflections, and later was used as a promotional piece for the studio.

What began as a simple self-initiated exercise in rendering reflections eventually turned into a promotional piece for the studio and Christmas presents, in the form of the poster on page 131, for our clients.

The design's concept originated after I saw an interesting magazine clipping of a red shoe. I liked the shoe's exciting, red visual appeal and decided to combine it with the classic fantasy of drinking champagne from a high-heeled slipper. I thought that giving these objects a very slick, contemporary, and sophisticated look might make an eye-catching illustration. By combining frisket film and airbrush I could render the crisp-edged reflections I needed to create the impression of slick, highly polished surfaces. Brilliant red dye would provide the saturated shoe color, and transparent watercolor the translucent color of the liquid.

The three major concerns that required good preliminary research and planning were the numerous reflections, the liquid puddles, and the wine splashing into the shoe, which I wanted to render as realistically as possible.

Gouache and colored pencil; 15¾″ × 22″

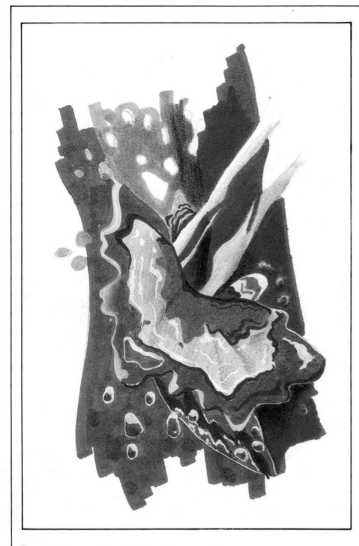

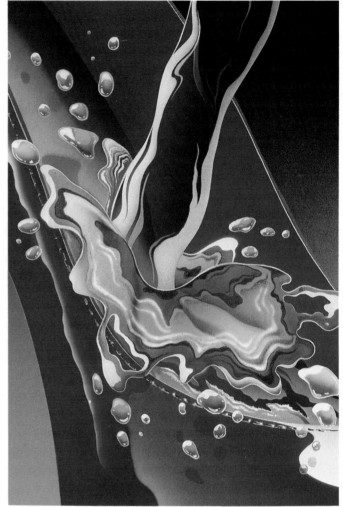

1 **Making a Color Study:** To get a better idea of what liquid looks like when it's being poured and splashed, I first gathered a number of reference materials—illustrations and advertisements—that showed this. Then I worked up a pencil sketch to determine the general shape of the splash and approximately where the highlights and reflections would be. This was followed by a rough color study using markers and colored pencils, which helped me envision the splash with color and detailing.

As in this case, if there is some uncertainty as to how to render a specific area, I prefer working out layouts of that area in advance, rather than jeopardize the illustration by trying to solve the problem on the finished art.

First I wanted to create the overall shape of the splash. I masked the surrounding area, using frisket film to create the hard-edged overall splash shape and acetate to create the softer, irregular-shaped edges of the splash.

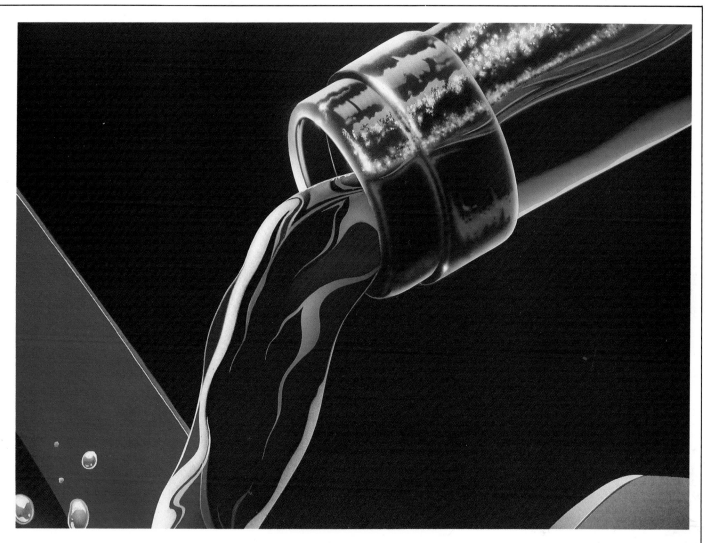

2 **Reflections on Glass:** The wine bottle obviously required a very glassy look. Two tricks I used to render this effect were to carry over the background color and utilize lots of flat and sparkling highlights. The first step was to mask off all the areas to be green and spray the darks (where background showed through the bottle) using the same color I had used on the background. I then exposed the green areas and sprayed transparent watercolor, which allowed the white of the illustration board to give highlights to these areas. It also gave a slight greenish cast to the darks.

The highlights on the bottle's lip and the reflective highlighting running along the top and underside of the bottle were applied by airbrush using opaque white. Opaque white makes the highlighting brighter and the surface it's on more substantial. I painted the glistening white hot spots first with a hand brush and again with an airbrush to soften them.

To render the wine in the lower half of the neck and pouring into the shoe I sim-

ply repeated the glass procedure—spraying dark background colors first, and then the lighter red areas. The curving highlights create the impression of flowing liquid; note the distortion of the shoe as seen through the liquid, which enhances the wine's transparency.

You'll also notice that the color of the wine inside the bottle is more muted and the edges are softer due to the density of the glass. The wine's reflections are a bit more subdued inside the bottle because the light hitting the wine is diffused by the glass. Another point: the neck of the bottle is less dense than the head, so the reflections are more pronounced in the neck area.

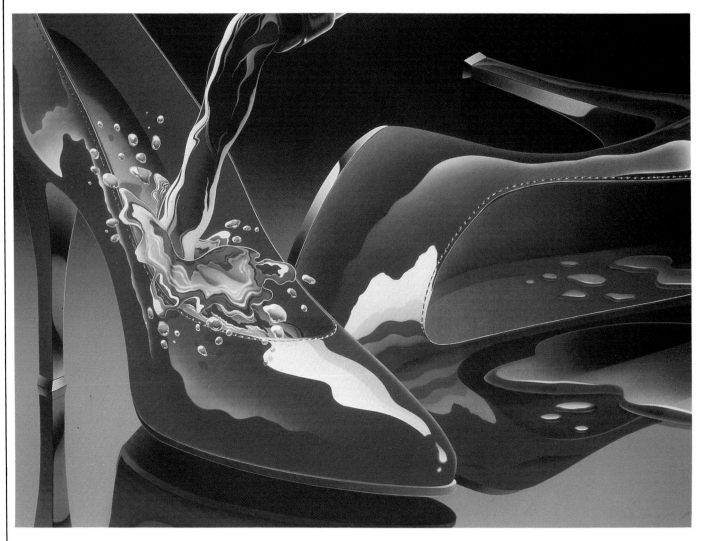

3 Since the foreground was intended to be a highly polished, mirror-like surface, I knew it would show a lot of reflections from the shoes. To understand how an object reflects on a mirrored surface I arranged a pair of borrowed shoes on a piece of Plexiglas and studied the reflections. This is what I learned:

● Because a shoe's sole isn't completely flat, the reflection of the curve of the toe is larger than if the shoe were a flat object sitting on the same surface.

● Since the right shoe curves inward on both sides, the inside of the shoe shows in the reflection.

● The reflected colors aren't the same as the colors of the objects themselves. Instead, they pick up color from the reflective surface. In the reflection of the shoes, I added more blue and purple, a result of the foreground color.

● Although the reflections are important, they don't have to be super-accurate. They should be secondary to the overall design. For instance, I shortened the width of the right shoe's reflection to improve the design of the piece.

● The highlights and reflections on the shoes themselves had to be considered when working out their reflections in the foreground.

Although I had the magazine clipping to follow as a reference in drawing the pencil sketch of the upright shoe, I didn't have any resources that showed a similar shoe lying on its side. To solve this I used the drawing of the left shoe and maneuvered it so it appeared to be lying on its side. I had to foreshorten the toe area and drop the heel angle slightly to get the proper perspective for the shoe.

4 **Flowing Liquid:** I poured some water onto a piece of Plexiglas to see what the droplets would look like sitting on a flat surface. I found that puddles of liquid resulted from this experiment, the largest being not only bigger in diameter than the smaller, but also thicker.

Before you render areas of liquid, such as the wine puddles in front of and inside the right shoe, you should consider several things: how the colors of the liquid and of the surface affect each other, how much less light will pass through the denser droplets, and how the reflections in the liquid will vary according to the density of the liquid.

In this illustration, notice how in the largest wine puddle the shoe's reflection appears slightly raised off the mirrored surface, and curves to follow the depth of the puddle before resuming its normal place on the surface.

When I thought I was done with the puddles, I stepped back and realized they were too light, which made them seem less real than I wanted, plus their color was too similar to that of the shoes. I darkened the puddles and added the white highlights through acetate masking.

5 Here you can see the finished poster. The puddles of wine and shiny, hard-edged reflections give this piece a very contemporary look.

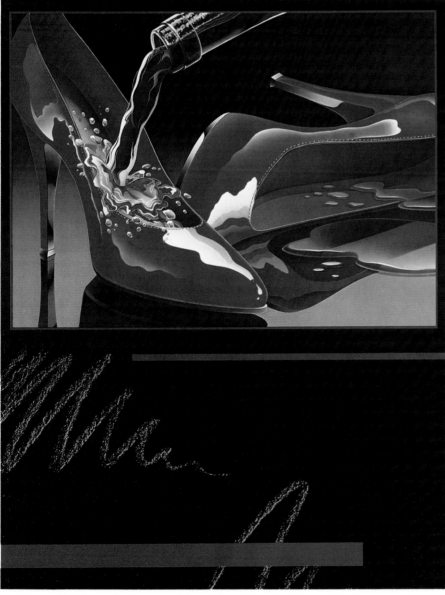

PROJECT 12

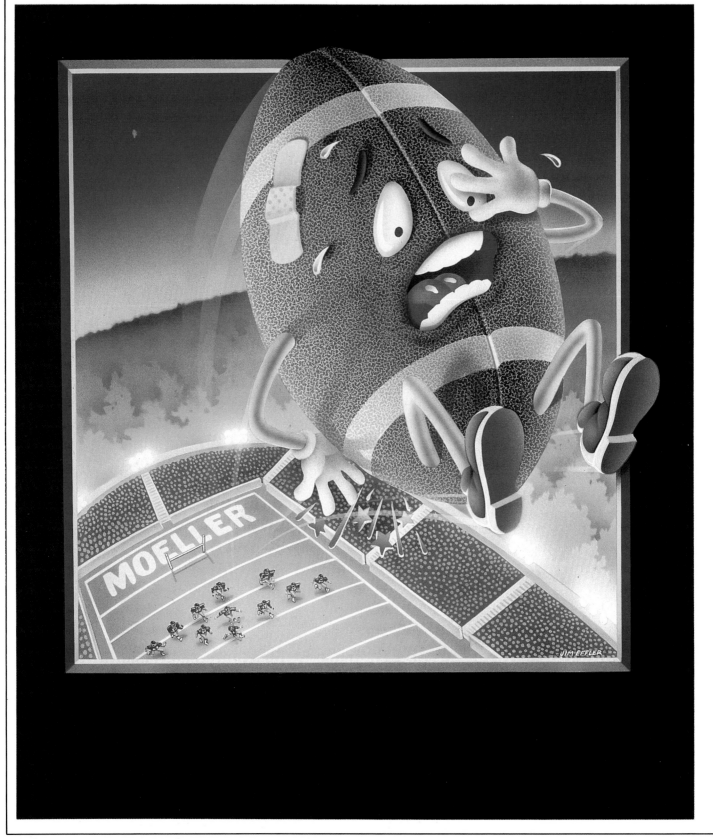

Gouache and watercolor; $8^{1}/_{2}'' \times 11''$

MOELLER'S FOOTBALL

ASSIGNMENT

Illustration for the cover of a high-school football team's program

ARTIST

Jim Effler

CLIENT

Moeller High School

For this assignment, I was given almost complete creative freedom. The client's only specifications were that the illustration be full color and proportional to the 8½″ × 11″ program. I opted for a cartoon illustration that looked at the sport from the *football's* point of view.

Even though there would be a "cartoony" look to the piece, I wanted to work in some realism for added believability. Two techniques that added to the realism were the use of two light sources and of dry transfer texture. The two light sources—a warm light from the stadium below the football and a cooler light from the moon above it—not only added atmosphere, but resulted in a three-dimensional look. The dry transfer created a re-alistic texture on the football itself.

Once I'd decided I wanted a car-toonish yet realistic illustration, I worked out some other aspects in my mind before actually starting to work:

- The beaten-up football would be the main subject. The back-ground—the crowd, stadium, play-ing field, etc.—would be there just for support.
- The perspective of the whole piece would be a dramatic, aerial one, to add visual excitement to the piece.

1 Making a Crowd with Liquid Frisket: When doing the crowd, I masked off around the surrounding areas and painted down small dots of liquid frisket to represent the people. After the frisket dried, I sprayed a dark blue for the background. I picked up the frisket with low-tack tape, and sprayed a pinkish col-or to indicate fleshtone; the background picked up the pink and became slightly purplish, which complemented the flesh color. I used only one color, rather than several, for the people because I wanted the crowd to blend into the piece and not compete with the football.

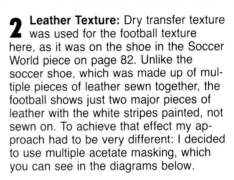

2 **Leather Texture:** Dry transfer texture was used for the football texture here, as it was on the shoe in the Soccer World piece on page 82. Unlike the soccer shoe, which was made up of multiple pieces of leather sewn together, the football shows just two major pieces of leather with the white stripes painted, not sewn on. To achieve that effect my approach had to be very different: I decided to use multiple acetate masking, which you can see in the diagrams below.

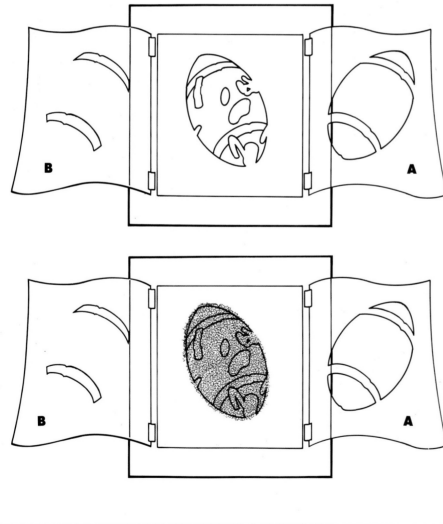

B A

3 The first step was to mask all non-leather areas with frisket. I then cut two acetate masks: Mask A would be used to cover the white stripes when I sprayed the brown color and mask B would protect the brown areas when I sprayed the stripes. You can see these two masks in this diagram, which shows exactly how they were taped to the board.

4 The next step was to put the dry transfer texture down over the entire football shape. Remember, the area surrounding the football was masked with frisket during this stage so the transfer could extend slightly over the edge of the football's outline.

With mask A covering the stripes, I sprayed a light beige color over the football. Then I reversed the masks, laying mask B over the football and spraying the stripes a light blue. I then removed the transfer texture with low-tack tape.

The football was now covered with tiny white cracks where the transfer had been. Again covering the illustration with mask A, I sprayed a darker brown to fill in the cracks and also to shape the football and indicate highlight and shadow sides. I reversed the masks again and sprayed a slightly darker, blue gray over the stripes to fill in the white cracks. Mask B was removed and the football texture was finished.

B A

5 **Adding the Seam:** To render the highlighted side of the football seam, I cut a curved slit in a piece of acetate to use as an erasing shield and removed some of the color with a kneaded eraser. This made that side of the seam glow as if lit. Note that details such as making the white stripes dip in at the seam add to the realism. I cut a second acetate mask for the shadowed side of the seam and sprayed a bluish gray.

5A **Finishing Touches:** I added motion lines to show action and movement. I wanted to make it obvious where the football was coming from, so the lines lead to the players down on the field.

5B I used acetate masks to create the tree areas. After masking off everything but the trees, I sprayed a light green base color over the areas nearest the lights, making the green darker and darker towards the horizon. (Generally, objects do get lighter as they recede to the horizon; here, however, the stadium is the illustration's primary source of light.) Once the base color was down, I cut tree shapes out of acetate and held them just off the surface while I sprayed soft, thin layers of green, in varying densities, around the edges of the masks, just enough to define the tree shapes. Since I sprayed only around the edges, the "front" portions of the trees nearest the stadium remained light and the dark layers created shadow areas behind the trees.

5C To keep your highlights as clean as possible, mask them with frisket film or liquid frisket before painting the object they're on. You can blend one end of the highlight into the object or tint it with the same color as the object; both techniques help integrate the highlight with the object. Here, I tinted the ends of the highlights on the tongue pink.

5D The football players were added with a hand brush, and gouache after the field and players' shadows were complete.

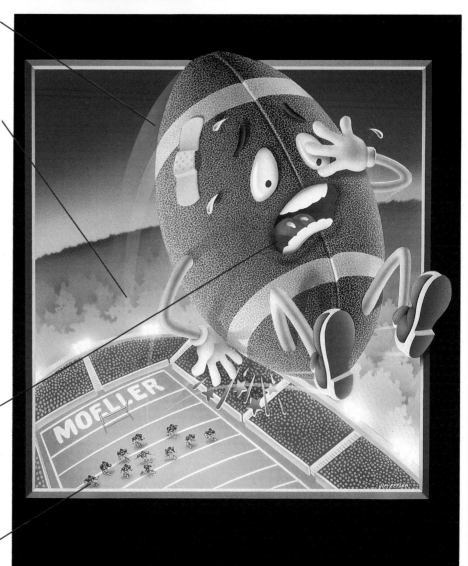

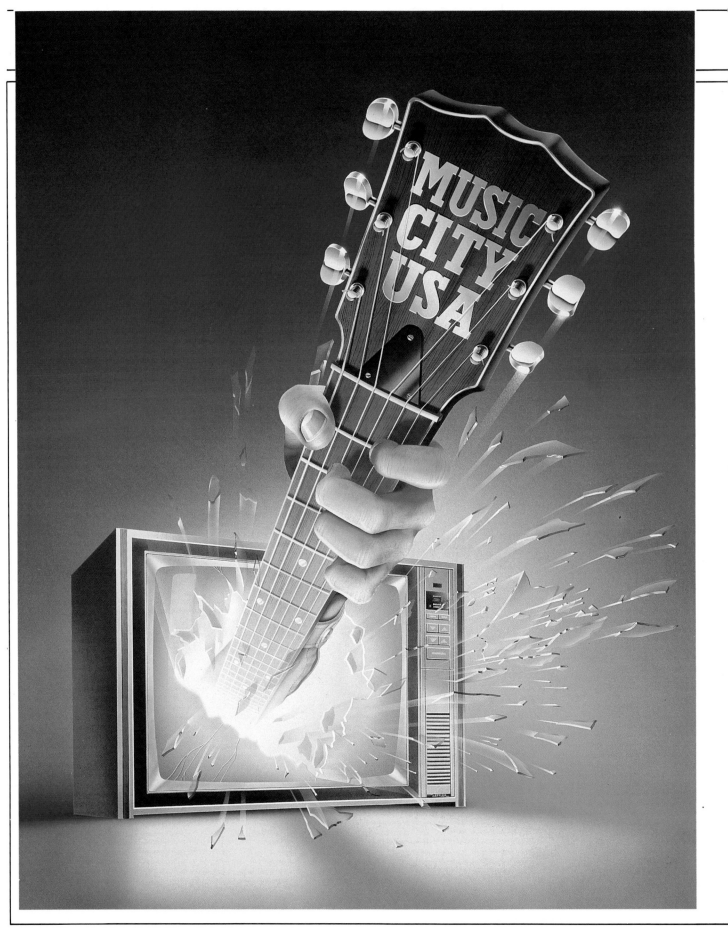

Gouache and watercolor; 15¹/₂″ × 19″

PROJECT 13 MUSIC CITY USA

ASSIGNMENT

Magazine advertisement for a country music television program

ARTIST

Jim Effler

CLIENT

Sive Associates; Kim White, art director

The dramatic use of perspective and the flying shards of glass combine to make this illustration dynamic and powerful. Used on an 8½" × 11" magazine advertisement for Multimedia Entertainment's syndicated television program Music City USA, this illustration shows how you can use symbols that might at first seem unexciting—in this case a guitar representing country music and a standard television set—to make a strong visual statement.

1 **Manipulating Perspective:** The concept began with the art director, who gave me a very simple compositional layout showing the neck of an acoustic guitar bursting through the screen of a contemporary television. The art director's concept was well ordered and we went with it with very few alterations.

To enhance the dramatic effect, we decided to foreshorten the neck of the guitar and fade it into the smashed television screen. We decided to have a very brilliant white light emanate from inside the television through the screen. Since the guitar head was far more important than the television, the television would be unspectacular in design and kept in the background. Finally, the blue background on the top left had to be dark enough so that white type would show up on it.

2 Nearly all my research was concentrated on the guitar and the hand. I already had a lot of magazine tearsheets depicting guitars, their necks and heads. But to get the right reference I photographed the head and neck of an electric guitar with a hand playing an actual chord, not just grasping the strings at random. The photograph was lit from below, and although you can't see it very clearly here, it did give me some idea of the lighting effect.

3 I constructed a careful drawing of the head and neck of the guitar to work out the shapes of all the elements involved. I changed the top of the guitar head so that it looked similar to an acoustic guitar but wasn't exactly identical. (An acoustic guitar wasn't available for the photo.) I also widened the head of the guitar so that I'd have enough space for the words Music City USA. As you can see, I also moved the machine heads (the knobs to which the ends of the strings are attached) out to the edges of the head to give the lettering enough room.

I changed the plane of the head and the neck and narrowed the perspective of the neck all the way down to enhance the effect of it coming out straight at you.

4 For the finished drawing I concentrated primarily on the construction (and destruction) of the television. I wanted a clean-looking new television set without any striking features that would draw attention away from the guitar neck and head. I also wanted to keep the screen fairly large and not have too many knobs and buttons taking up valuable screen space. So I pulled together various tearsheet pictures of television sets and from them invented the television you see here.

You'll also notice that the television is not floating in space but is grounded. I decided that the guitar would be more arresting if it was crashing through a stationary television set rather than one that was already moving, as in the art director's rough.

Fragments of glass were drawn in and arranged so that they radiated from the center of the smashed television screen. This adds dramatically to the effect.

5 **Flying Glass:** I completed all air-
brush rendering on the guitar, televi-
sion, and background before I started on
the glass. I had to complete the back-
ground objects first, since the back-
ground had to show through the glass
shards. Otherwise they wouldn't look like
pieces of real broken glass.

To render the glass shards I first cut a
piece of acetate so that it covered the
entire drawing and extended about two
inches beyond the border on each side.
To register the acetate to the illustration I
outlined the top of the guitar and drew a
couple of lines on the TV set. I then laid
the acetate over the final drawing and
cut through it to produce the shape of
each piece of broken glass. I then laid
the acetate back over the artwork,
matched the register marks, and the out-
lines of the broken pieces of glass were
in position. However, I didn't pop out
every piece of acetate immediately, but
began by removing just three or four of
them at a time. I sprayed white over the
area where I had removed each piece of
acetate, taking great care not to produce
an even surface on each piece of glass,
so that the denser coverage created the
edges of the glass shards. Remember,
the screen of the television is curved
and the bigger shards must look curved
in the picture.

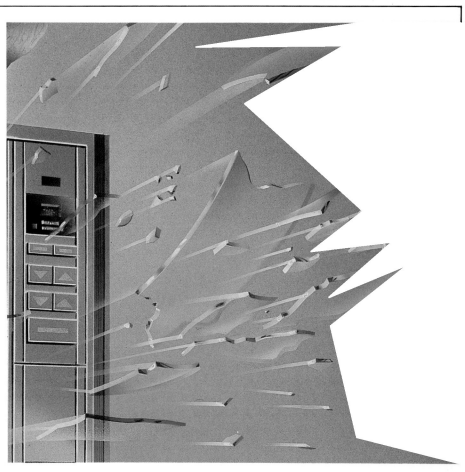

6 If you look closely at the edges of
one of the larger pieces of glass,
you'll notice that it is white where it re-
flects light coming from the television
and dark green on the shadowed side.
The diagram at right shows you how I
created this effect.

I first popped out the acetate mask
(A) over one of the shards, and taped it
over its opening, leaving a gap (B) be-
tween the opening and the mask to rep-
resent the thickness of the glass.

Then I taped another piece of acetate
(C) over the portion of the shard that
would be green and sprayed the ex-
posed gap white. To spray the green
edge, I flopped C to protect the newly
sprayed white edge and airbrushed the
green.

In reality I worked on about ten pieces
simultaneously. If I'd done just one piece
at a time, I would have had to keep
changing the color in my airbrush.

At this stage you can still move one or
two pieces of glass to make a better
grouping if you like; you just have to cut
a new hole in the acetate sheet.

You'll notice that some of the pieces
of broken glass overlap. For this I cut the
shape of the overlapping piece out of an-
other large sheet of acetate and used the
same procedure. Some of the very small

particles of glass were painted in by
hand and in one or two places along the
shadow edges, I put in some even dark-
er touches to indicate the edge was in
even deeper shadow. I used a hand
brush to do this.

To produce the white tails that come
off the ends of the pieces of broken
glass, I used acetate masks. For the
larger pieces I used just one acetate

mask and positioned the tail so it pointed
directly towards the glow coming from
the television. I sprayed in the tail, taking
care to fade it out towards the television
set. For the tails on the small pieces of
glass I cut one or two slits out of acetate
and moved this around from piece to
piece, spraying a tail on each as I went.

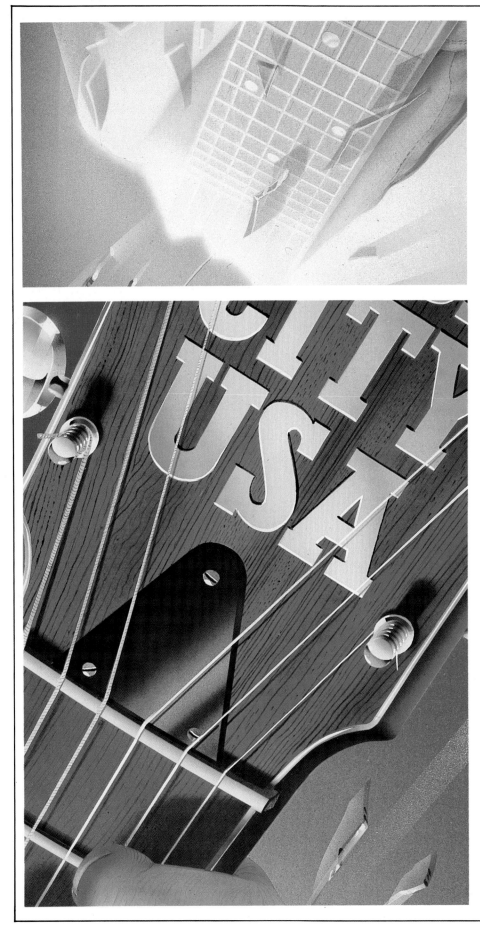

7 In spraying the glow of light from the TV set, I took care to create a soft edge on the lower left-hand side of the broken screen, but produced a hard edge on the right-hand side that showed the reflection of the light coming from below and also defined the thickness of the screen better.

8 **Fine Wood Grain:** To create wood grain like that on the guitar head you begin by masking off everything, except the wood area. Here, that included the guitar strings. Then with a no. 0 sable brush, hand paint the dark wood grain lines with a very dark brown. Simulate a natural wood grain by painting the lines almost parallel to each other but with a variety of curves and bends in them. You can put small breaks between the lines, but at all times be careful to not let the lines touch as this would lessen the look of real wood grain. In some areas split a line into two and start a new line.

With this done, spray a slightly lighter brown color over the top of the grain to hold the whole image together. It's important to note that by spraying after you've done the hand-brush work, you'll knock back the lines and keep them from seeming too dominant.

Another way to create wood grain is to cut the actual grain pattern into acetate; this method takes a lot of time and in this case, since this was a dark grain, I didn't think this approach was necessary because the grain wasn't going to show so clearly that it required precise rendering.

Yet a third method for doing wood grain is to use the dry-brush technique that's illustrated on page 22. Take a bristle brush with some undiluted paint and render the grain in one stroke. This is a common practice for watercolor painters, but in a piece of art like Music City USA it's risky because this is a one-shot—you have to get it right the first time. My handpainting method is slower than dry-brush, but you have control over each line, and I think it produces a nicer effect.

After finishing the wood grain, and with the mask still in position, I sprayed the shadows from the machine heads.

9 **Fleshtone:** I sprayed the finger as one smooth fleshtone. Then I sprayed in slightly darker color on the top side of the fingers where they're in shadow. To lighten the fleshtone that was directly in the television's glow I used a pink pearl eraser and gently removed color to produce highlights. I decided against using white paint for the highlights as these tend to muddy the fleshtones and the white board underneath gives a better tone. You can see these highlights very clearly along the lower edges of the fingers, in the light cracks in the knuckles, and in the lower part of the little finger.

I hand painted the dark cracks and lines with a very fine sable brush. They are very soft details and are only really noticeable if you look for them.

10 Here's how the illustration appeared in the advertisement. You can see that the guitar seems to burst through the television screen with a lot of force, creating an energetic feeling.

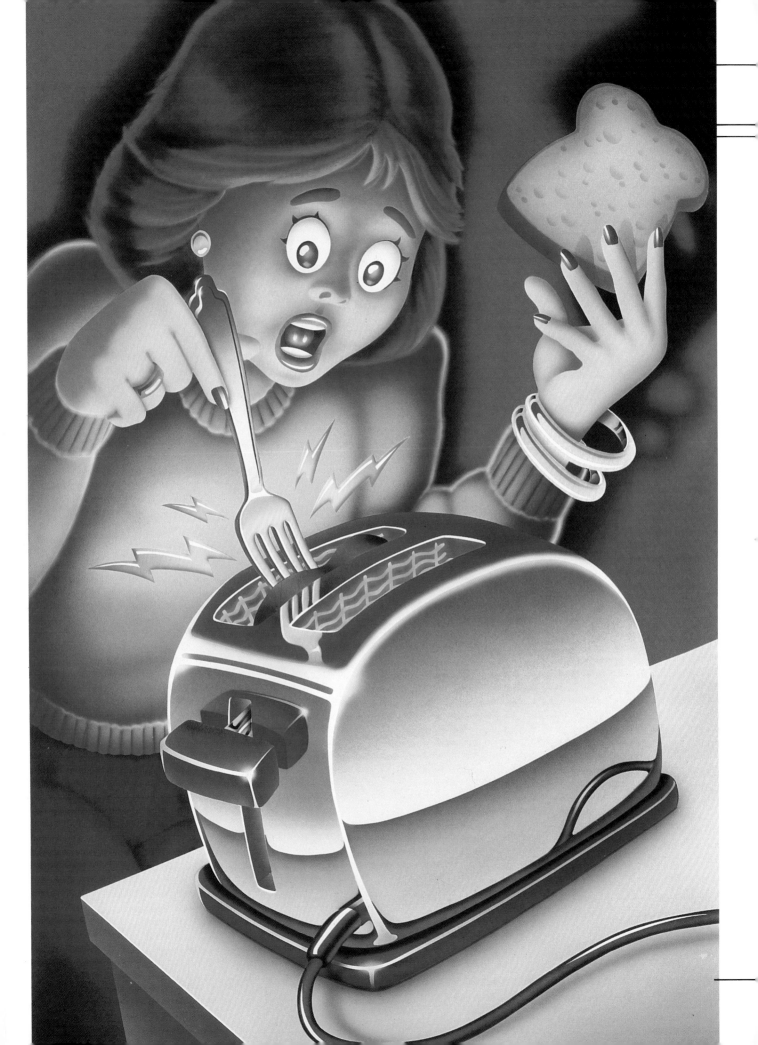

PROJECT 14

ZAPPED!

ASSIGNMENT
Illustration to be used in school displays to warn children about electrical hazards

ARTIST
Jim Effler

CLIENT
Lawler Ballard Advertising; Joe Stryker, art director

The assignment to produce artwork for a display in local schools that would demonstrate the dangers caused by the misuse of electrical appliances gave me the chance to put more of myself into the project than usual. Because the illustration was to be done in cartoon style, I had more room to be creative and have fun with the project.

The nature of the illustration and its intended use dictated much of the way I planned to render the piece. To really emphasize the girl's action it was important to have a strong center of interest— the girl's expression, the fork and toaster, and the slice of bread flying out of her hand—and simple foreground and background areas. To intensify the scene's drama, I would use the glow from the toaster's elements as a fictitious light source to underlight and emphasize the girl's expression and cast spooky shadows on the back wall. Other elements, such as the contrast of light and dark values and warm and cool colors would further spotlight the center of interest.

The illustration was one of four panels Cincinnati Gas & Electric Company used in its school display. It was used 3′ × 5′, but to save time and money I rendered the art a third of that size. Photo enlargements were then made to fit the art to the final panels.

1 I drew the pencil sketches at half the final art size (one-sixth the panel size) because it's much easier to work up the entire composition and design in a 6″ × 10″ area initially, and add small details later. No reference materials were necessary for this project.

As I began the first drawing, I kept in mind that the final illustration had to very clearly show the dangers of putting a metal fork into an electric toaster. I made the girl's shocked expression, the fork, and the glowing toaster elements the obvious centers of interest. At this early stage, I decided to have a light come from this area to draw the children's attention to it quickly. You will notice that even at this preliminary stage I worked out details such as rounding off the edges and corners of the toaster so they would fit in with the cartoon style of the art better than would the sharp, square-edged design of a contemporary toaster.

2 One of the client's primary concerns when reviewing the first drawing was that the young girl didn't look female enough. The characters featured on the other three panels in the series were male, so it was important that this figure be unquestionably female. In my second drawing, which incorporated all the client's suggestions, you can see that I made the girl's eyelashes longer, her lips darker to indicate red lipstick in the final artwork, her fingernails longer and more femininely shaped, and her hair restyled slightly. Note also the addition of earrings, bracelets, and a ring.

The client's second point was that the fork's prongs should show more prominently in order to emphasize the girl's mistake, so I made them longer. Finally we made sure that the dark toaster cord would be set against a lighter contrasting color so that it would show prominently.

Gouache, watercolor, and dye; 12″ × 20″

Courtesy of the Cincinnati Gas & Electric Company

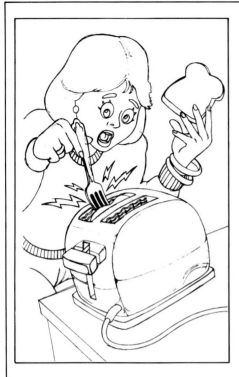

3 This is the final drawing scaled up to a working size of 12″ × 20″. I traced this down on the board.

4 The Centers of Interest: To keep to a cartoon style, I carefully simplified all the girl's features and kept color and value variations within them simple. The pop-eyed look is exaggerated to enhance the shocked expression, and I left out all detail in the teeth and eyebrows—don't draw attention to any features that are not of prime importance in conveying a poster's message.

5 The red-hot heating elements were another center of interest. First I masked the elements with frisket film, leaving the glowing area immediately around them exposed. I sprayed a warm red over this part. Next I sprayed a dark brown between the elements to strengthen the intensity of the red directly next to the elements.

After removing the film covering the elements themselves, I sprayed a yellow-orange dye over the insides of the toaster. By using a translucent dye rather than an opaque gouache I was able to create an orange glow over the entire area without dulling the already sprayed red.

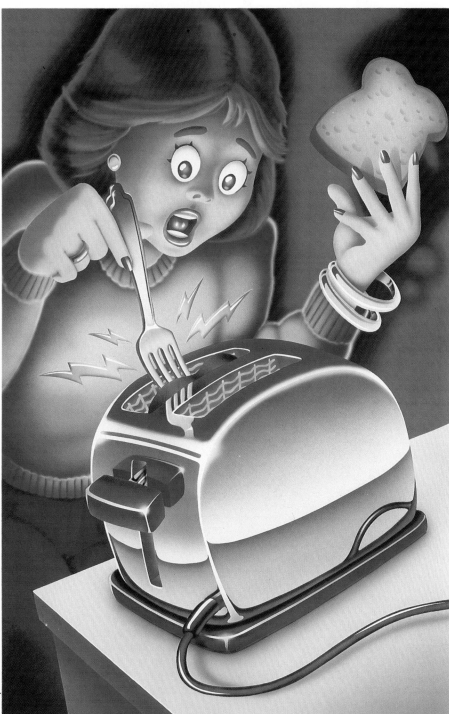

6 The dark shadows on the back of the girl's hand and bracelets add a dramatic element to the illustration. The shadows between her fingers and the toast emphasize the fact the toast is flying out of her hand because she has just been shocked.

7 Use of high contrast values in the reflection of the table top makes the chrome surface appear very shiny. The hard edges also suggest a smooth polished surface.

8 **Adding Drama with Light:** The lighting is basically fictitious, intended to dramatize the expression on the girl's face just as she was zapped. The light appears to come from the toaster elements, although they would never really give off light of this strength. Notice how, with the underlighting, the areas on her face that would normally be dark are now light and the places that would be light, such as her cheekbones, are now dark. I included an unseen light source in the foreground to illuminate the front of the toaster and the cord as my client had requested. To define the shape of the girl's head I reflected some light off the back wall and put a highlight along the edge of her hair to separate it from the shadow and create a more three-dimensional look. The spooky shadows on the back wall help dramatize the scene.

I made the background colors *and* the sweater dark in color to contrast against the light and warmth of the electric shocks. Also by keeping these background colors dark, I further emphasized the center of interest.

When rendering shiny metallic surfaces, it's important that you render the reflections of objects close by. In this poster I was careful to include reflections of the handle, cord, and fork prongs. I didn't include the girl's reflection on the top of the toaster as it would have distracted attention from the heating elements and made them harder to recognize.

PROJECT 15

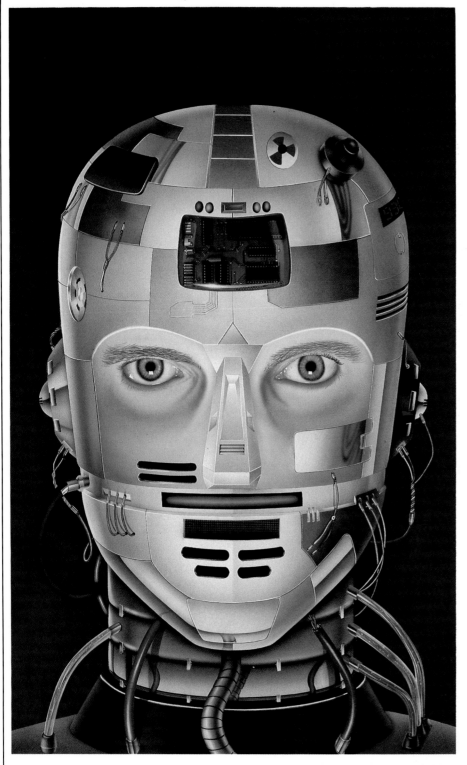

ASSIGNMENT

Poster to promote a science fiction festival that would explore the possibilities of artificial intelligence

ARTIST

Tom Chung

CLIENT

Horwitz, Mann & Bukvic Advertising, Inc.; Dave Bukvic, art director

In this illustration, the robot head was designed to attract and then "shock" viewers through its combination of cold, mechanical realism, mesmerizing human eyes, and multiple light sources. The challenge was to combine a convincing robot head with piercing human eyes, and to make the unusual combination believable.

Since the image was to be used by the University of Cincinnati's Science Department to promote its science fiction festival, the robot had to be believable. To achieve this, I used electronic devices such as wires and tubes. It was also important that the robot look contemporary, rather than futuristic, so I rendered both new and slightly tarnished metallic surfaces. The use of a strong reference photo and underlighting helped make the eyes look real, yet eerie.

The tight time-frame for completing this project presented another challenge, because it didn't allow enough time to do a lot of detail work. Since I couldn't simplify the design without making the robot look less persuasive, I added details by using a photograph showing computer chips.

I completed the entire project—from first pencil drawing to finished art—on a very tight deadline. The first drawing, shown on the next page, took two days to do. The revised drawing, which included the art director's changes and is also shown on the next page, took two days. I completed the finished illustration in the four days that were left on the art director's schedule.

Gouache and acrylic; 17″ × 25″

SCIENCE FICTION FAIR

1 The art director's first idea was to render the eyes on a strip laid in position on the robot's face.

2 This second sketch shows the revised concept, which laid the groundwork for the illustration. The human eyes are now actually *part* of the robot's head, rather than separate elements.

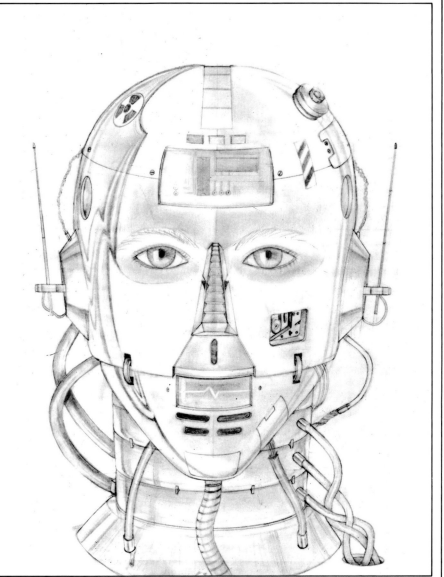

3 In my first pencil drawing I basically added my own ideas to the art director's sketch, while also drawing ideas from magazines such as *Heavy Metal* and *Omni*.

The art director had two main concerns about this drawing. The first was that the robot looked too comic-bookish, particularly in the mouth and ear areas. The second was that the eyes gave the impression that someone was *inside* the robot, rather than *part of* it. To eliminate the comic book effect I narrowed the whole face, squared up the chin, and added more jaw. I also added more wires and other devices to give the face a more traditionally complex robot look.

Courtesy of Horwitz, Mann & Bukvic Advertising, Inc.

4 The art director furnished this contact print of twelve different facial expressions photographed under lighting conditions that approximated the planned illustration. He selected frame six because it offered the harsh, piercing eyes he wanted in the piece.

5 The art director then cropped in on the eyes and gave me this 8″ × 10″ print to use as reference in rendering the robot's "human" eyes.

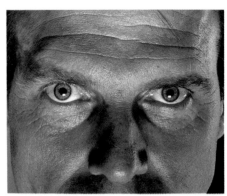

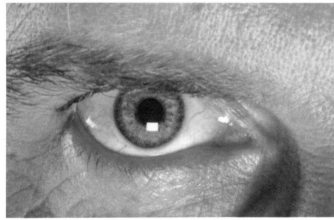

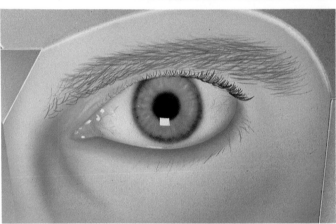

6 **Eyes:** Underlighting and a very strong reference photo helped me make the robot's eye area eerie, realistic, and hypnotizing. After I'd rendered everything but the computer panel, I began the eye and cheek areas. I first masked the eyeballs, then freehand sprayed the green metallic tone to the top of the cheeks and above the brows, leaving the designated flesh areas white. After achieving the desired shape of the cheeks, I sprayed the fleshtone, blending it into the metallic tone.

Having completed this stage of the fleshtone, I moved on to the eyeballs. I used the enlarged photo of the human eye, shown at left, to render the pupils and irises. I first used frisket to mask the flesh area surrounding the eyes and the hard-edged white highlights on the irises. Liquid frisket was applied for the smaller highlights around the edges of the eyes.

Working freehand with the turbo airbrush, I sprayed the black pupils first, and then added the dark blue tone around the outer edge of the iris, being careful to spray in towards the pupil. To give a realistic, diffused look to the irises,

it was critical that I spray a minimal amount of color. I sprayed pale green and the brighter blue last.

To give more contrast and shape to the iris, I lightly erased lines using a soft eraser. I then sprayed a light gray over both eyeballs, gradating the tone to give them form and emphasis.

I re-masked the eyeballs before I sprayed the soft-edged orange tone under the eyes and, finally, hand brushed in the eyelashes, eyebrows, and blood vessels in the eyes.

7 **Liquid Flowing Through Tubes:** To create the effect of liquid moving through the tubes in the neck I first laid down the green, brown, and blue base colors. Over these colors I sprayed thin "rivers" of the dark background color using an acetate mask for the hard edges. You see more background color in the middle of the tubes since more highlights occur along the outer edges. I also used an acetate mask to render some of the elongated hard-edged highlights and a hand brush for the long, soft-edged highlights and air bubbles.

8 Metal Panels: Determining the type of metal each panel would be was an arbitrary decision. The gray-green surfaces were sprayed first, followed by a dark brown coloring over four of these areas to create a tarnished appearance. The lavender-tinted chrome panels were unmasked and sprayed, followed by the gold-plated panels. The nose, masked throughout this process, was completed next. After rendering everything else on the head—excluding the eye areas and computer panel, which you can learn about below and on the facing page—I hand painted all the wiring.

The highlights between each metal panel were done by hand brush, again using acrylic white because it's easy to control and flows smoothly. I concentrated the highlights on the shiny surfaces—such as the chrome and gold panels—putting more intensity there because they reflected more light than the other, duller, metals. Where the light source was more direct, I rendered stronger highlights.

9 Using a Photostat: The glass-enclosed electronics panel in the robot's forehead was one of the most challenging parts of this illustration due to its intricate detailing and the project's tight deadline.

The solution was to use a color photograph of computer chips. First I made a color photostat of the photograph and retouched it. I created the vertical highlights by masking those areas while I sprayed white gouache over the stat. You can see the original bright green color in the vertical highlight on the left. The highlight on the right was created the same way, but where it overlapped the largest, dark chip, the contrast turned out too weak. To strengthen the contrast I sprayed a thin layer of white gouache.

When I spray-mounted the retouched panel onto the illustration, the edge of the photostat was evident. I used a dark gray to eliminate the edge and blend it into the illustration.

The final effect, right, was realistic and very effective.

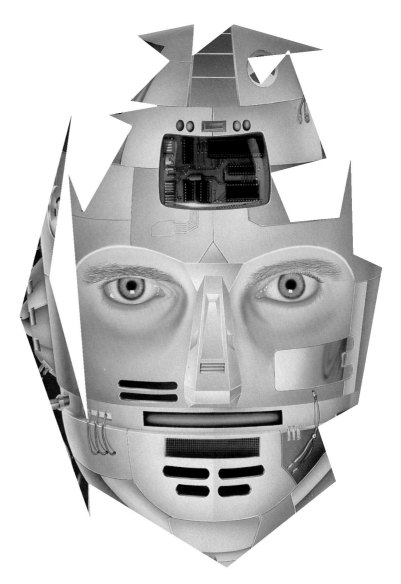

PROJECT 16

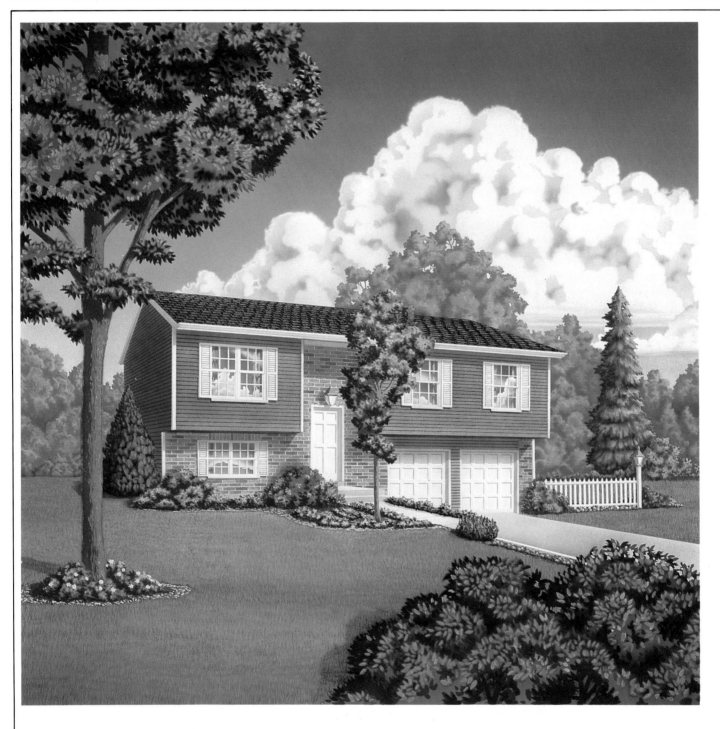

Gouache and watercolor, 20" × 20" Courtesy of Horwitz, Mann & Bukvic Advertising, Inc.

RYLAND HOMES

ASSIGNMENT

Architectural rendering to be used on a pamphlet and poster to promote Ryland Homes, a company that builds homes

ARTIST

Jim Effler

CLIENT

Horwitz, Mann & Bukvic Advertising, Inc.; Dave Bukvic, art director

In rendering architecture, the most important aspects are the seeming-ly incongruent ones of realism and flattery. You need to render the scene and building as accurately as possible, and also make it look inviting.

For this project, which would be used full page in a 12″ × 12″ pamphlet and on a poster along with three other house designs I paid particular attention to giving the illustration a strong sense of light to help define the building's form. (I had to be careful not to get too carried away with the sun/shadow principle on this job because the client wanted the siding to remain a consistent color, which in normal sunlit situations is not the case.)

I was also interested in providing the client with a scene that would provoke a viewer into wanting to know more about my client's business. So the setting was made as inviting as possible, but still keeping in realistic parameters.

1 This was the black-and-white line art supplied by the client. Since the perspective was accurate and what the client wanted, all I had to do was have a photostat made to the size I was going to work on—20″ × 20″. The pencil drawing was done right over top of the photostat.

2 You can see in this drawing that the changes from the client's architectural drawing were mainly in the setting; I left the house alone for the most part. This is actually the first and second drawing; after reviewing the first one (which had only the lone tree in the front yard) the art director felt that the lawn and surroundings looked too stark, too barren. To remedy this, I added foliage in the lower right-hand corner, a tree directly in front of the house, and bushes around that tree. The styles of bushes and trees in the architectural drawing were changed to make them look more realistic.

If you look closely at both sides of the drawing you'll see where an additional inch was added. The original framework of the piece included a one-inch bleed, which when cropped in reproduction would have put the tree on the very edge of the illustration. This was aesthetically unattractive so we expanded both sides.

3 **Siding:** The siding was the most involved aspect of rendering the house because it was critical that the width of the siding strips be equal. I planned to render the siding by first putting in the shadows between the strips and adding brown tone on top. The first step was to mask the surrounding areas with frisket film, leaving the siding on the front and side of the house exposed. I then established the vanishing points by extending the top and bottom lines of the front and side walls until they met at a single point.

The original line art indicated the number of siding boards necessary for the side and front of the house. I divided the height of the wall by the number of boards and marked this measurement lightly along the corner of the house. To indicate each piece of siding, I placed one end of a straightedge on a vanishing point and the other end on one of the marks I'd made along the corner of the house. I drew the lines directly on the board.

I next cut two pieces of acetate, one for the front and one for the side wall and put a single thin slit in each, narrowing the slit slightly at the end farthest away from the viewer. This helped establish a feeling of depth, since objects appear smaller the farther away from you they are. This was particularly important on the side wall, since it extended farther into the distance. Starting with the side wall, I laid its acetate mask over the first pencil guideline and sprayed a cool blue-black mixture through the slit. By repeating this technique over each pencil line, I defined the shadows between each strip of siding. (Remember as you're spraying the lines to keep the unpainted, exposed siding area protected with acetate.) I repeated the process on the front wall.

With all the shadows rendered I sprayed transparent brown watercolor over all the siding areas, followed by the blue-black mixture over the entire shaded side and under the front eaves.

4 **Shingles and Brick:** In the pencil drawing, I had done only a section of the roof, just enough to indicate what the shingles would look like. The art director provided me with a piece of the actual roof shingle (as well as a siding sample and trim colors) so I could match the red-brown color and texture.

I penciled the shingles directly onto the illustration board, then inked them in with a no. 00 Rapidograph pen. After masking off the area surrounding the roof, I speckled a black pattern across the roof (airbrush pressure about eight pounds). On top of the speckles, I sprayed reddish-brown transparent watercolor.

The light reflections on the shingles were put in with a gouache and a no. 0 sable-hair brush.

5 To create the bricks, the vertical and horizontal lines were penciled in, and then the window and surrounding areas were masked off. I speckled a pattern of rust brown over the brick area, and then a second brown color. For the darker bricks I cut a couple of brick shapes out of acetate, moved the shapes around at random and sprayed either a bluish or reddish brown.

To emphasize the warmth of the sunlight hitting the front of the house, I added cool, blue-gray shadows from the bushes and siding over the brick. *All* the shadows in this piece were put in at the same time, after all other elements were nearly complete. This ensured uniformity throughout the illustration.

6 **Creating Grass with Dry Brush:** The grass was created using the dry-brush technique demonstrated on page 22. I first sprayed a middle tone of green over the lawn to establish the base color and to make the lawn look as if it had been mowed recently. I dry-brushed over the tone with very short strokes of dark green. Something still didn't quite say "grass," so I mixed some light green with the dark green and went over the whole yard with light strokes, again using a dry brush.

The shadowed areas (see the finished piece on page 155) were sprayed over top of the green tone and strokes; I did have to replace some blades of grass that were obliterated by shadow.

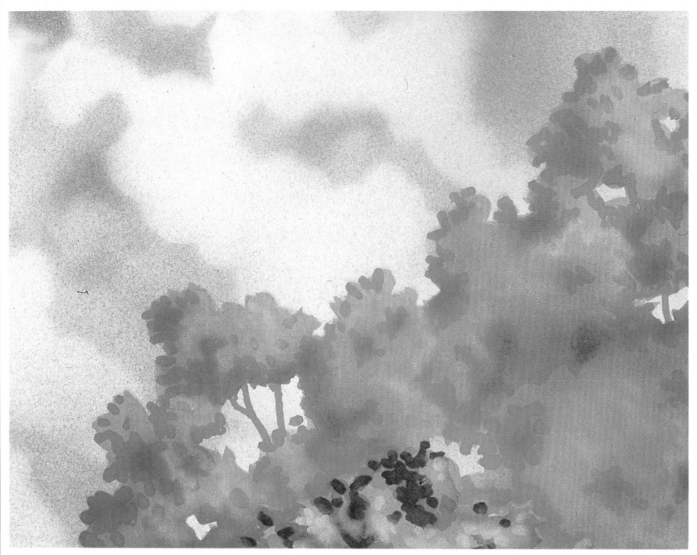

7 **Quick Trees:** My main consideration in painting the trees was that they look more realistic than those you saw in the Bike Tour poster (page 48). The technique I used in rendering these trees is not only more effective for realism, but also the quickest and most cost effective I know to get this kind of detailing.

Both the foreground and the background trees were handled in the same way: I first sprayed down a middle-green base color through a frisket mask, and then went back with a hand brush to put in the darks and the light leaves.

The foreground tree was done with three different shades of green; the background tree had only two. I put less contrast in the background tree because it was the foreground tree I wanted to "pop" and draw attention to the house. It became apparent after completing the trees that the hand brush work was too hard-edged to work with the rest of the illustration. I freehand airbrushed the trees with dark and light greens to soften these edges.

8 **Clouds with Form:** I moved the cloud formation slightly to the left in the finished art to allow more of it into the frame. I liked the way it repeated the shape of the tree below it, but compositionally it needed to balance with the tree better than it did in the final pencil sketch. The method used to render the clouds differs from my usual, where I put in the sky and apply the clouds on top of the blue. To give the cloud well-defined shaded sides and light sides, as I had done with the house, I masked the clouds before spraying the sky. Then I uncovered them and cut an acetate mask for the shadowed side of the clouds. Freehand airbrushing softened both these dark areas and the white edges of the clouds.

9 The finished illustration shows an attractive yet realistic view of the home.

PROJECT 17

Gouache; 12³/₈″ × 12³/₈″

THE PLANETS

ASSIGNMENT
Album jacket for a recording of Gustav Holst's *The Planets, Opus 32.*

ARTIST
Toby Lay

CLIENT
Telarc International Corporation; Ray Kirschensteiner, art director

The challenges I encountered in doing my first outer-space illustration were in rendering the planets realistically and in detail, although not necessarily accurately, and creating enough depth to make the piece believable. The illustration was reproduced on the cover of an album featuring Andre Previn and the Royal Philharmonic Orchestra performing Gustav Holst's *The Planets, Opus 32.*

The company's art director specified that all nine planets in our solar system be depicted, along with the sun. Compositionally, I had no restrictions, except that the art fit within the 12⅜-inch-square album cover.

Existing illustrations and photographs of the solar system and the individual planets gave me a broad base of visual reference for selecting colors and positioning the planets. The patterns on the planets are basically combinations of the reference materials.

1 Since time and creative freedom, which are usually somewhat rare commodities, were available on this assignment, in-house illustrator Maurice Mattei was able to spend the time originating five pencil drawings. This also gave the client a larger selection of designs.

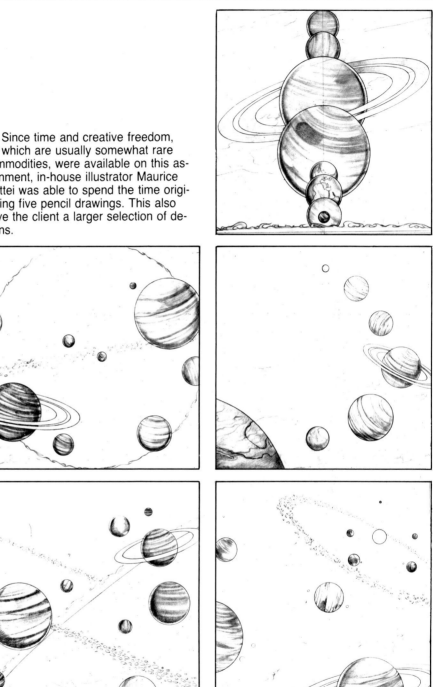

2 **Starbursts:** I masked off all the larger stars with liquid frisket before spraying black over the background space.

I carefully removed the liquid frisket, using low-tack tape, and sprayed scarlet red, yellow, and blue transparent watercolors on most of these stars. I let the spray on some of the stars overlap into the background to create a glowing effect. I used five pounds of air pressure to stipple the tiny white stars throughout the background.

To create the red glow around the largest starburst, I first cut a circular acetate mask. Laying the mask directly on the board, I sprayed red gouache around the outer edge of the acetate, fading the color into the background to produce the "glow."

The actual starburst was created by cutting a cross shape out of acetate and spraying white opaque gouache from the center of the cross outward, letting the white fade into the background. The large white burst of light emanating from the center of the starburst resulted from spraying the white densely in the center, and gradating it into the background.

3 **Earth and Other Planets:** I used liquid frisket to mask the white clouds on the earth's surface because the hard edges and patterns that result from this masking method would define the planet's strong cloud patterns. The next step was to lay acetate masking on the illustration to define the hard-edged land and sea areas, in contrast to the soft edges on the surfaces of the other planets, created with liquid frisket. After I sprayed the land and seas and pulled the liquid frisket up with low-tack tape, I sprayed a light blue tint over the cloud areas. The shadows on the left side, added last, gave the earth its form.

To achieve the red atmospheric haze, I freehand sprayed red watercolor, going over the area four to five times until I reached a richness and density that intensified the enormity of outer space. To allow the paint to diffuse I held my double-action brush (which I used throughout this piece) approximately six inches above the board.

4 I rendered the remaining planets freehand giving a distinctive look to each one, such as you see in this detail.

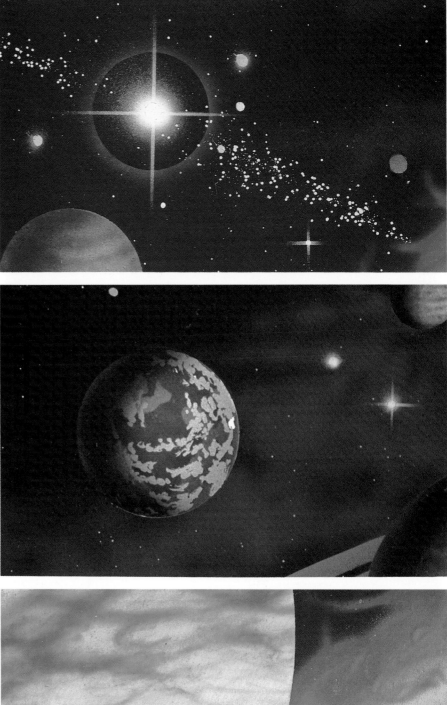

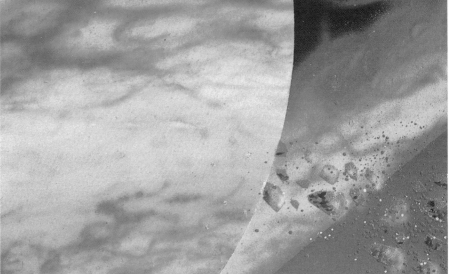

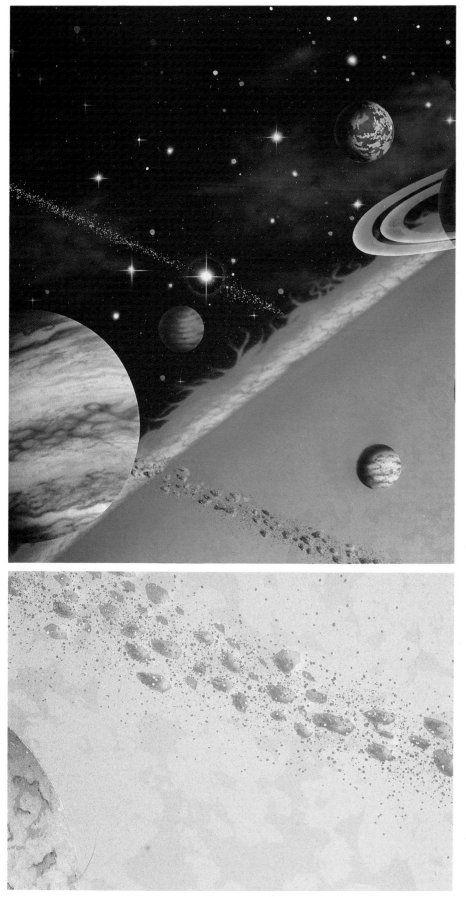

5 **Sun, Moon, and Meteors:** I began work on the sun by first covering all the lightest areas, which you can see in the detail below, with liquid frisket, before spraying transparent, thinned light red gouache. (All other areas of the illustration, including the sun's gassy perimeter, were also masked during this process.) After pulling up the liquid frisket, I went back over the red tone and the exposed board surface with a thicker yellow gouache. Using liquid frisket here added a nice subtle texture to the sun's surface. A stronger red followed, starting at the sun's outer edge and gradating towards the center. This gradation of color resulted in the glowing effect you see around the sun's perimeter.

To render the outermost edge of the sun, I removed the mask from this area and first airbrushed in yellow; the hard edge where this yellow met the body of the sun was softened somewhat by freehanding red over it. I continued to apply red in fine, irregular lines throughout the yellow to create the gaseous effect.

There was also a hard edge where I had masked the sun to spray the background black. I eliminated that edge by freehand spraying the same red gouache repeatedly, blending it in towards the sun and trailing gassy tails into outer space.

For the foreground body of meteors, shown in the detail below, I cut the larger meteor shapes from a single piece of acetate and sprayed a base of gray gouache. To show the glowing reflections from the sun, I added yellow randomly to some of the meteors. The smaller dust particles, scattered throughout the meteors, resulted from stippling a varied pattern. The gray stippling provides contrasting relief to the sun, while the light pink stippling pops against the gray meteors. The stippling effectively adds to the sense of depth vital to this piece.

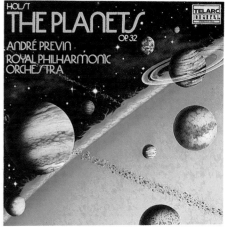

PROJECT 18

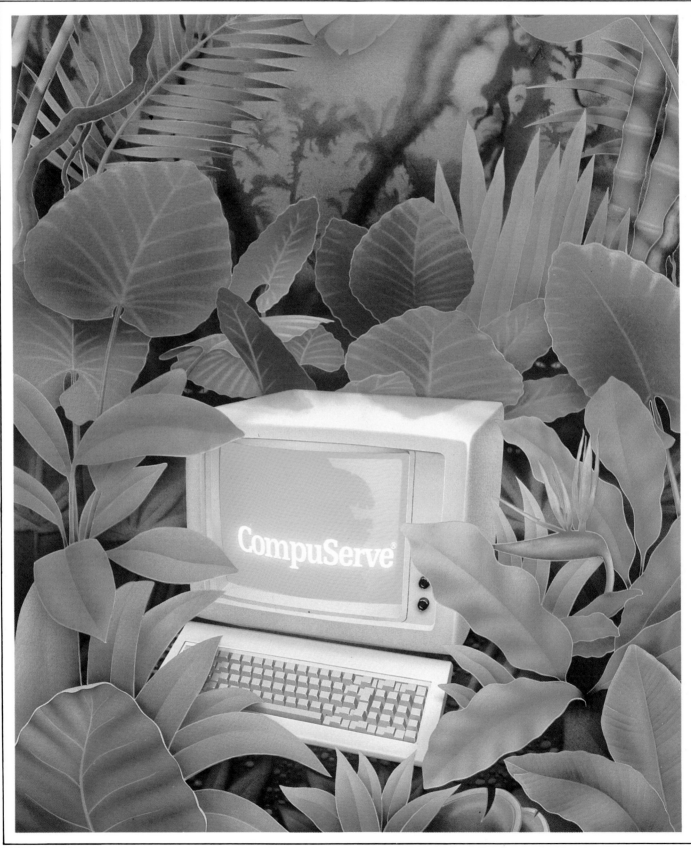

Gouache; 17" × 22"

TROPICAL COMPUTER

ASSIGNMENT

Illustration for a mailer advertising a computer database service

ARTIST

Derek Rillo

CLIENT

Sive Associates, Inc.; Tom Tarvin, art director

Rendering the hundreds of jungle plants in this illustration was quite challenging. The foreground plants needed to look dense and lush, and the tropical, humid feeling of the background foliage required special masks cut with a stencil burner.

The illustration was to be used on the cover of CompuServe's informational pamphlet. The art director wanted to communicate that the pamphlet would guide its customers through the "jungle" of information services it offers (CompuServe subscribers have access to more than 1,000 computer databases). The cover concept would complement the interior design, which imitated an old explorer's map.

After compiling my reference materials—which included everything from photographs of computers to Rousseau's mystical jungle-like painting *The Dream*—I completed the preliminary sketch and transferred it to the board.

1 **Tropical Plants:** I painted all the foreground plants in basically the same manner—using a hard frisket film mask for the outside shape and then spraying a dark blue or violet base color to give the plant its form and definition. Acetate masks were used to delineate within the plant form. At this point I added transparent layers of gouache to give the plant its final color. I also brought out details in some plants using a hard rubber eraser. To give the jungle a more lush and colorful look, I used layers of yellow, blue, and aqua, and once in a while a straight green. To add more variety and contrast between plant forms, I sprayed reds, oranges, or violets on certain plants to create a warm green. I used no white in any of the painting and used the more transparent gouaches because I was layering colors.

2 **Using a Stencil Burner:** After painting all the major plant forms in the foreground, I moved to the background. First I masked off all of the plants and the computer with frisket film. (In the large painted areas I first put down tracing paper to protect the paint from the adhesive of the frisket film.) Because the background was to be out of focus, I used a combination of acetate masks (moving them slightly as I sprayed) and freehand spraying for this area.

I also wanted the background to have a misty rain-forest feeling to it, so for the background tree and vine forms I used a stencil burner to create masks. (The stencil burner is an inexpensive tool, similar to the wood burner you may have used as a child. By touching its fine tip to acetate you can create any type of modeled edge. Its best use is for rounded forms, rather than straight lines.) Place your drawing under a sheet of glass to prevent burning your drawing. Lay the acetate on the glass and trace the drawing with the burner to create your masks. To fully burn through the acetate, which can be difficult since the hot acetate tends to meld back together, you have to go over your mask guidelines a number of times. The masks created with a stencil burner create a slightly blurred edge, which enhances effects such as this steamy jungle foliage.

PROJECT 19

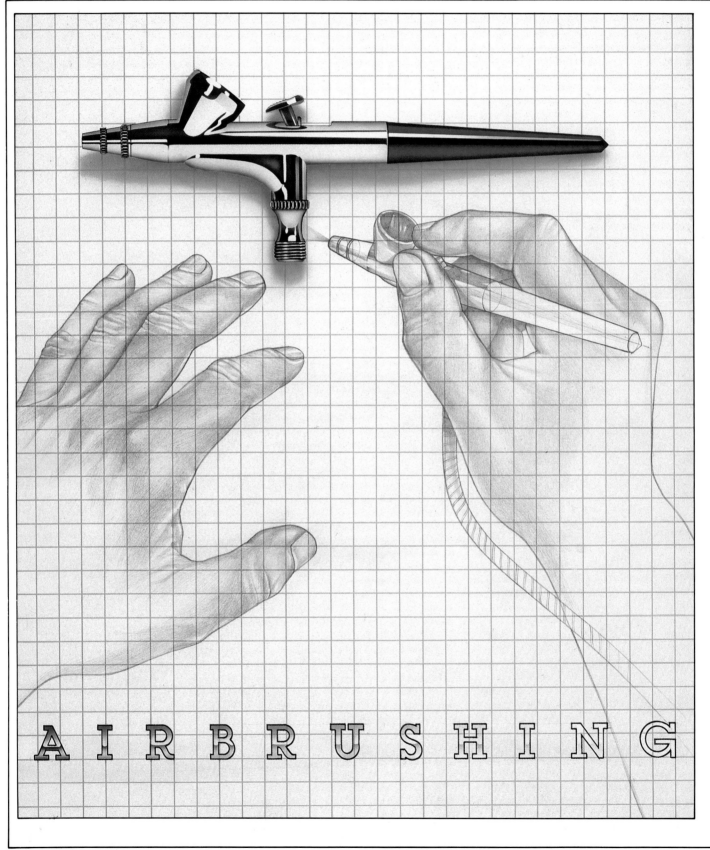

AIRBRUSHING

Gouache, watercolor, and graphite; 16½" × 12¾"

SIGNS OF THE TIMES

ASSIGNMENT

Cover illustration for *Signs of the Times* magazine issue featuring air-brushing

ARTISTS

Jim Effler, Maurice Mattei

CLIENT

S. T. Publications

The success of any airbrushed illustration depends on the strength of its design concept, and this illustration shows how refining and experimenting with a good design can make it even better.

Signs of the Times is a monthly magazine published for the sign-making industry. For an issue that would feature an article on air-brushing, the magazine's art director wanted an illustration that incorporated an actual airbrush, the word *airbrushing*, and graph paper, which would represent the technical end of the medium. She had two rough ideas for the illustration. One was to show an airbrush blending in with and then disappearing into the background. Another was to show a drawing of an airbrush with some frisket being picked up.

We began experimenting with the elements and the art director's concept. The first concept, by illustrator Dean Miller, was to show a hand airbrushing an illustration of an airbrush. That got the ball rolling.

1 I was given two past covers so I could work the magazine's logo into the design and familiarize myself with other cover designs.

2 Maximizing Your Design Options: Miller's pencil drawing shows our first concept—a realistic, three-dimensional hand holding an airbrush, spraying a mirrored image of itself onto the graph paper.

3 I photographed this hand holding the airbrush so it would fit into Miller's concept; it was flopped to get the left hand in the above drawing.

Courtesy of S. T. Publications

SIGNS
OF THE TIMES

AIRBRUSHING

4 The second concept, shown in the drawing at right, also featured realistic hands and an airbrush working on an illustration of an airbrush; again, the background was graph paper. The left hand was holding down an acetate mask and the right hand was getting ready to spray. (I conceived both the second and third designs.)

5 In these three photos below you see the images we shot for the second design.

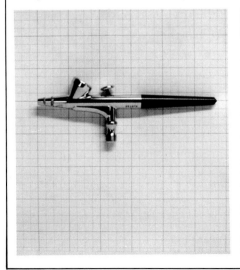

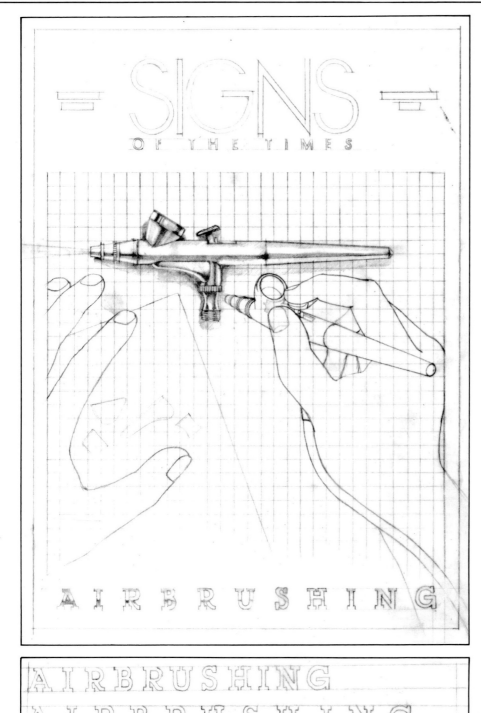

6 While the first two concepts were good, they were somewhat ordinary. The third design was chosen because it had a twist—instead of the *hands* being three-dimensional and realistic-looking, they were to obviously be drawn two-dimensional images, more and more unfinished as you moved up the arm. Rather than show the airbrush as a drawing, *it* became the three-dimensional, representational image. The client liked the twist, but we decided in the final art to leave out the acetate because we felt the myriad shapes might cause some visual confusion. We planned to do a lot of detailing and shading in the top airbrush, but keep the hands ghost-like and the second airbrush flat.

7 To determine letter spacing for *Airbrushing* we sketched the word on tracing paper making the second and third versions airier. Using tracing paper let us maneuver the lettering on the drawing for final spacing and positioning.
 We decided that the capital A in *Airbrushing* would appear very chrome-like, and each consecutive letter would become closer to line art until, finally, the G would have no tone at all.

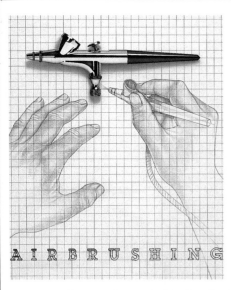

8 In preparation for beginning final art, the elements were drawn up separately—the hands and airbrush, the dominant airbrush, and the lettering, which you can see on the previous page. Having all the elements on one tracing was not necessary. It was easy to trace the top airbrush first, then ink the grid lines of the graph paper around the airbrush, and draw the hands and second airbrush in pencil last, after the rest of the piece was completed. The graph lines were drawn directly onto the illustration board. The other elements were transferred from the drawings.

After the airbrush was transferred to the board, and the outline of the graph paper penciled in, I inked up the ³/₈-inch grid lines with a mechanical pen and an opaque blue tint, relying on a T-square and a triangle for guidance. The final grid lines would be ¼ inch when reduced to 66²/₃ percent and printed. I avoided inking over the pencil transfer of the top airbrush because it would have been impossible to spray over the lines later on.

After inking the blue lines, the next step was to spray a buff color onto the paper; I gradated it from dark at the bottom to light at the top to emphasize the form.

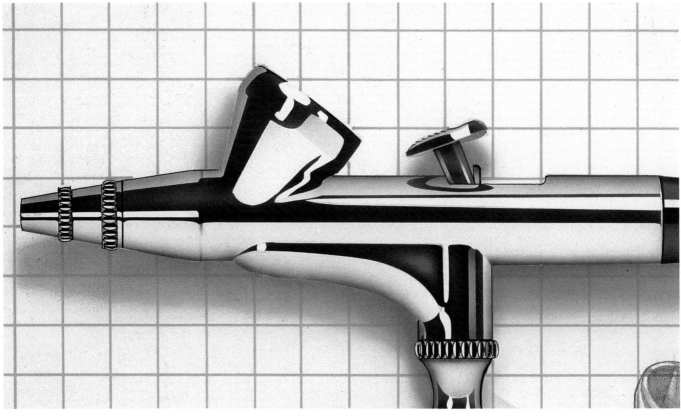

9 I wanted the shadow under the airbrush to be soft to increase its realism, but I had to be careful not to go too dark. Often when you get a shadow too dark you can simply lighten it up by spraying a lighter-colored opaque paint over it. But since this had a grid pattern that needed to show beneath it, a second layer wouldn't have been a good idea because it might have obliterated the grid. To make sure that the shadow was very transparent and the graph paper would show up within the shadow, I used a light mixture of blue and black watercolor.

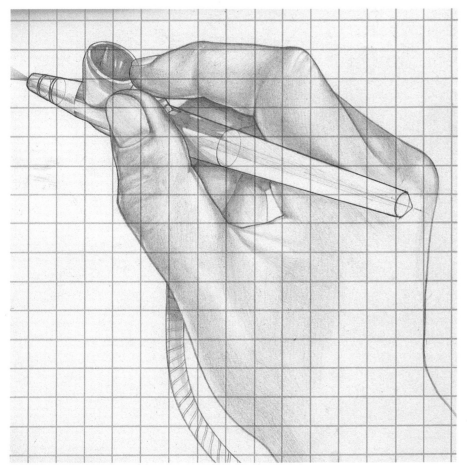

10 The image of the two hands and second airbrush was rendered by Maurice Mattei, who is very experienced at doing pencil work. He did preliminary drawings on tracing paper, transferred the final versions onto the board after the rest of the illustration was completed, and then put in the tone working from the original reference photos.

11A **Detailing:** The shadowed sides of the hose-connection threads were inked in with a mechanical pen, then filled in by hand brush with a black wash. Then the area surrounding the thread area was masked off and I graded a gray tone over it, putting the greatest density on the left side. This gave the white highlighted side of the threads some tonality.

11B To determine the type of reflections I needed to render in this area I set my own airbrush down and studied the way the studio's light hit the threads. Because of the uniformity of the threads, the highlights fell consistently on the threads. So I cut a tiny elliptical opening in acetate and sprayed white through it, moving the mask from thread to thread in a vertical line from top to bottom. Using a hand brush (spraying would have been too time-consuming) and white paint, I put a little dot in the center of each elliptical highlight to intensify its brightness.

11C I used a no. 000 technical pen and an ellipse template to create the elliptical-shapes on the tightening threads, just above the hose-connection threads, shading the dark side in black and leaving the light side white. The tiny areas of orange watercolor along the lower edge of the ellipses reflect the warmth of the paper below. The blue at the top of the ellipses the sky behind and above the graph paper.

11D There's also a harder, different type of reflection—just a tiny dot—on the right side of the threads. I put these on with a hand brush also.

INDEX

air pressure, 4, 100, 153, 158
airbrushes,
 double-action, 2, 4, 124, 158
 single-action, 2-3
 turbo, 3, 25, 124-25, 148

Bestine solvent, 6, 12, 48, 92
brushes,
 bristle, 140
 camel, 8
 dust brush, 8
 nylon, 6, 8, 48, 81
 sable, 8, 22, 23, 63, 70, 71, 80, 90, 92, 112,
 119, 140, 141, 153

colored pencils, 9, 12, 39, 50, 89, 90, 109,
 128

dry-brush technique, 5, 8, 22, 23, 140, 153
dry transfer, 5, 69, 73, 82, 100, 101, 102,
 133, 134

edges, types, 7
equipment,
 burnisher, 5, 16, 81, 83, 100
 French curves, 46
 markers, 120, 128
 mechanical pen, 166, 167
 plastic triangle, 48, 166
 Rapidograph pen, 153
 ship's curve, 102
 stencil burner, 161
 straightedge, 35, 46
 templates, 46, 57, 58, 119, 167
 toothbrush, 4
erasers, types, 5
erasing techniques, 5, 39, 51, 80, 90, 92, 93,
 98, 107, 109, 110, 112, 116, 118, 135,
 140, 141, 148, 161

freehand spraying, 7, 25, 38, 92, 105, 106,
 107, 118, 125, 148, 154, 155, 158, 159,
 161

hand brush work, 42, 50-3, 62, 63, 69, 71,
 83, 99, 103, 111, 112, 116, 125, 129, 135,
 139, 140, 141, 148, 149, 154, 167
hand-held acetate mask, 7, 22, 66, 68, 98,
 125, 161

illustration boards, types, 9

lead pickup technique, 16, 33, 57
lettering, design, 30-1, 40-1, 70, 94, 163, 165

masking materials,
 acetate, 7, 24, 26, 39, 49, 51, 52, 53, 57,
 60, 62, 70, 71, 78, 80, 81, 90, 92, 100,
 108, 109, 112, 117, 128, 131, 134, 135,
 139, 148, 153, 158, 161, 167
 cloth, 4, 6
 frisket, 7, 9, 11, 12, 16, 22, 24, 35, 48, 51,
 57, 60, 78, 80, 83, 84, 89, 107, 116, 117,
 118, 119, 128, 144, 148, 154, 161
 gauze, 6
 liquid frisket, 4, 6, 8, 48, 58, 59, 66, 119,
 133, 135, 148, 158, 159, 161
 mesh, 6
 window screen, 6, 11, 93
 wrapping paper, 21, 78, 81

masking techniques, 21, 22, 23-6, 35, 37, 41,
 49, 61, 62, 65, 66, 68, 80, 89, 98, 116-17,
 124-25, 134, 139, 152, 155, 158
motion or speed lines, 84, 102, 135, 139, 159

overspraying, 6, 58, 65, 66, 117

paints,
 acrylic, 2, 11, 116
 dye, 11, 12, 59, 60, 101, 102, 114
 dye on gouache, 11, 118
 gouache, 9-10, 12, 22, 24, 38, 58, 61, 70,
 106, 116, 117, 118, 135, 149, 153, 158,
 159, 161
 tints, 22, 26, 57, 58, 59, 60, 61, 66, 100,
 116, 124, 135, 158, 166
 watercolor, 10, 12, 22, 24, 35, 80, 89, 105,
 117, 129, 152, 153, 158, 166
paints, white,
 acrylic, 149
 bleed-proof, 12, 24, 102
 Gamma, 12
 Instant Aero, 12
 opaque, 129, 158
 permanent, 12, 38, 62, 70, 71, 92, 103, 112
 zinc, 12
pencil drawing/layout, 14, 16, 19, 20, 30, 33,
 45, 46, 74, 76, 78, 89, 97, 105, 115, 118,
 121, 123, 128, 137, 138, 143, 146, 151,
 153, 157, 161, 163, 165

reference materials, 13-15

spatter technique, 116
stipple technique, 2, 3, 4, 159
subject treatment
 airbrush, 105-13, 163-67
 animals, 19-23
 balloons, 19, 26
 birds, 19, 26
 bridges, 45-46, 51, 52
 buildings, 51, 52, 151-55
 cans, 66
 clouds, 21, 24-25, 52, 76, 80, 92, 155
 computer, 98, 100, 102, 103, 148-49, 161
 crowds, 6, 21, 99, 133
 eyes, 119, 143, 144, 147-48
 face, 118-19, 147-48
 flowers, 20, 21, 24, 26
 football, 133-35
 fruit, 56-66, 124
 girl, 143-44
 glass, 121, 129, 137-39
 globe, 75, 76, 78, 80, 100, 101
 guitar, 137-38, 140
 hands, 30-31, 98, 102, 106, 107, 108, 110,
 137, 145, 163-65
 ice cream, 121-25
 landmarks, 19, 21, 45-46, 74, 75, 76
 landscape, 19, 45, 50-53, 150-51, 154-55
 liquid, 128, 131
 microphone, 6, 93
 plants, 21, 24, 161
 planets, 157-59
 rainbow, 68
 robot, 30, 42, 146-48
 roller coaster, 30, 32
 shiny metal, 30, 38, 68
 shoe, 74, 77, 81, 129-30
 sky, 21, 24, 38, 52, 92, 94

soccer ball, 74, 80
starbursts, 4, 6, 158
Statue of Liberty, 87-95
tile, 106, 108, 112
trees, 19, 21, 26, 48, 49, 68, 135, 154, 161
water droplets, 63-66, 71, 112, 131

tape,
 low-tack, 5, 6, 81, 133, 134, 158
 white artist's, 49, 83
texture, 4-6, 116
 aluminum, 5
 asphalt, 4, 12
 bricks, 153
 chrome, 109, 145, 149, 165
 concrete, 4, 12
 fabric, 3, 5, 6
 fruit, 58, 66, 124-25
 fur, 5, 22
 grass, 5, 12, 68, 153
 gravel, 4
 hair, 5, 12
 ice, 14, 15
 ice cream, 123
 leather, 5, 82, 83, 134
 metal, 5, 15, 92, 145, 148
 plastic, 5
 sand, 4
 shingles, 153
 shoestring, 81
 skin, 12, 102-3, 112, 118-19, 133, 141, 148
 stars, 4, 6
 tarnished copper, 5, 89, 93
 trees, 6, 48, 50
 wood grain, 5, 12, 140
tracing paper,
 graphite coated, 16, 20, 21, 46, 89
 heavyweight, 33

window masking technique, 52